MASTERPIECES OF CALLIGRAPHY

MASTERPIECES OF CALLIGRAPHY

261 Examples, 1500-1800

Edited by
PETER JESSEN

DOVER PUBLICATIONS, INC.
NEW YORK

Published in Canada by General Publishing Company, Ltd.,
30 Lesmill Road, Don Mills, Toronto, Ontario.
Published in the United Kingdom by Constable and Company,
Ltd., 10 Orange Street, London WC2H 7EG.

This Dover edition, first published in 1981, is an unabridged
republication of the second printing, 1936, of the work originally
published by the Julius Hoffmann Verlag, Stuttgart, in 1923, with
the title *Meister der Schreibkunst aus drei Jahrhunderten*.
The original German text has been specially translated for the
present edition.

International Standard Book Number: 0-486-24100-9
Library of Congress Catalog Card Number: 80-69157

Manufactured in the United States of America
Dover Publications, Inc.
180 Varick Street
New York, N.Y. 10014

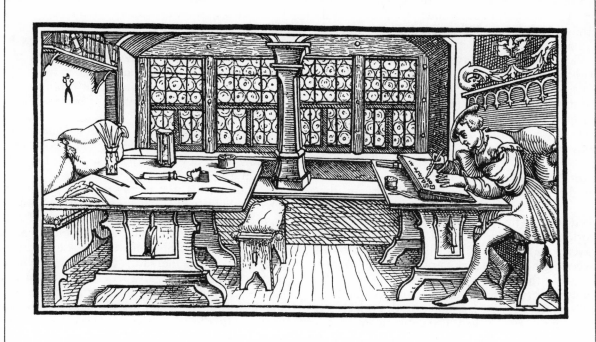

From Wyss, *Libellus valde doctus*, Zurich, 1549

INTRODUCTION

ANDWRITING could and should be the most direct personal expression of human visual creativity. The hand that wields the pencil, pen or brush (as directed by local tradition) is stirred so vigorously by the moods, temperament and even the character of the writer that we are able to distinguish and interpret the features of a man's writing just as we do the features of his face. Creative people feel the urge to go beyond the purely necessary, beyond mere legibility, and to arrange the letters, words, lines and sections into a surface pattern, to enrich them with linear flourishes, the overflow of their high spirits. Writing becomes art.

Today the charms of a thriving calligraphy—expression and beauty—are in danger of perishing. More and more we are confining ourselves to shorthand for note taking, to the typewriter for our messages. Handwriting in everyday life is disappearing or becoming superficial or coarse. With it, thanks to our highly praised civilization, yet another branch of honorable human artistic endeavor is dying out. Therefore, the art lover as well as the artist will surely welcome a selection of examples of fresh and unspoiled calligraphy from eras in which personal script was still appreciated and cultivated. This is intended as a joy to the beholder, and as encouragement to the calligrapher to follow in the steps of the earlier masters.

THE SOURCES. The period in which individualized calligraphy flourished comprises the first centuries after the rise of printing. From the time when the number of literate people began to increase, thanks to Gutenberg's invention, more and more people also learned how to use the pen. Writing was no longer, as in the Middle Ages, a privilege reserved for scholars and professional scribes. It became the indispensable basis of all types of education and assumed numerous forms varying with the nationality, the social standing or profession, and the personal talent of the writer.

From this many-sided activity, documents of all sorts have been preserved: decorative and archival pieces, business papers and letters, artistic and ordinary items. From all this, it would be possible to compile a charming anthology of colorful examples. But the most impressive image of intentions and achievements is to be obtained from the printed sources. Beginning with the sixteenth century, there

is a voluminous literature of writing manuals that gracefully reflect the calligrapher's will and skill. For the period from 1500 to 1800 the number of such books and pamphlets may be estimated as about 800. Lately they have been collected for the good of both scholarship and art. One of the richest gatherings of this type of material is the ornamental-print collection of the National Library for Fine and Applied Art in Berlin (formerly known as the Library of the Applied Art Museum). All the illustrations in the present volume are from this collection.

In order to make the content of these old woodcuts and copper engravings clear to the present-day viewer, it is inadequate to reproduce the writing in reduced form. The calligraphers who once created the originals for the woodblock cutter or the engraver were very careful in selecting the scale and the accessories for each script and each page. When reproducing them, we should therefore retain the original sizes (which has been done as much as possible in the present volume). Also, we feel it is most useful to arrange the illustrations according to script families. At some later time we hope to discuss the individual books and calligraphers separately. Here we can only sketch in the most essential basic facts.

CALLIGRAPHY AFTER GUTENBERG.

Writing practice in the period from which our examples are drawn had changed thoroughly from medieval ways. Up to the invention of printing the most important field of scribal activity was the book. On parchment or paper, many changing calligraphic styles, ornaments, spatial arrangements and formats had been developed for the classical poets and philosophers, the holy scriptures and Church fathers, the books of hours, law codes, chronicles, poems, etc. By and by the monastic scriptoria had been supplanted by secular workshops that carried on a lively business and employed well-trained personnel whose firm stroke, sure sense of space and cheerful sense of fun we still admire today.

This profitable sphere of activity was wiped out by the printer, who produced first the text, then all the ornaments, on his press. Now the handwritten book became an expensive toy, a rare luxury. Here and there a prayerbook or book of hours, an occasional poem for some lofty patron, or a family chronicle would be calligraphed by a nonprofessional; but as a commercial object the handwritten book was finished.

For calligraphers there remained only individual sheets, documents, certificates. This area had been the second in importance for medieval calligraphers. The papers issued by the chanceries of large and small rulers and officials, with their sturdy parchment and weighty seals, were to have their own solemn appearance, if only to scare off forgers. The chancery scribe had sufficient leisure to revel in drawn-out ascenders and descenders, striking initials and complicated flourishes; he adhered desperately to tradition and let the new fashions in book types and letter hands evolve as they might.

WRITING TEACHERS AND STUDENTS.

The calligraphers who had been so badly hurt by the printing revolution now took refuge in this world of documents. Treaties, patents of nobility, legal papers continued to be written by hand, along with a mass of corporate and civil documents down to journeymen's indentures. All these demanded an impressive and attractive form, a holiday dress; the opening lines, at the very least, were the province of the calligrapher.

Alongside this, the handwritten word was conquering wide new realms. As international commerce grew, merchants used it extensively for their bookkeeping and business correspondence. The educated of all professions and classes, both men and women, took increasing pleasure in exchanging letters about their own experiences, current events or serious problems of their mental life; here personal writing styles were developed. People would write sayings in their friends' albums, and children were obliged to write neat messages for birthdays and other occasions; we members of the older generation still fulfilled that duty as children.

To meet such demands, the penmanship learned in early school years, as though from primers, was insufficient. Stimulation and instruction were necessary for older students too, not to mention the many people who had to use handwriting in government and business offices or practiced amateur calligraphy at home. Thus the calligrapher found a new calling as a writing teacher.

These schoolmasters prepared some of the script models for their lessons with their own pen. Such handwritten model sheets and exercise books are still extant. But even outside the lesson plan, the would-be calligrapher needed standard guides by which to try his hand at ornamental scripts or newly created practical scripts. He sought not only the individual letters and their combinations, but above all entire pieces of writing, paragraphs and groups for their current assignments; not only beautiful sayings, but also examples for documents, business letters, bills, labels and addresses—not to mention effective capitals and witty ornaments for these different purposes.

WOODCUT WRITING BOOKS.

It was a natural step to supply this need by means of printed models, by reproducing the handwritten examples. The first means of reproduction thought of was woodcut, which was used by printers everywhere in those days. Like pictorial illustrations and like the patterns in the embroidery books that began to appear about 1525, writing could be cut in wood, although a sure hand was needed to work the delicate lines and swirls out of the fragile woodblock for relief printing.

The Italians were first in the field. They began by taking measurements of the severely chiseled letters

of ancient inscriptions. Some thoughtful people made the effort to construct the forms of these letters with straightedge and compass, such as the friar Luca Pacioli in 1509; these experiments were later continued by Albrecht Dürer in Germany and Geoffroy Tory in Paris. The first self-standing pamphlet on the problems of writing is just such a letter-construction theory, the *Theorica et practica de modo scribendi* of Sigismondo de' Fanti in Venice, 1514. The earliest writing book for practical use was published in Rome in 1522 by the papal chancery calligrapher Vicentino [Arrighi]; it was substantially devoted to the rounded cursive that had recently come into favor. As little as two years later, the Venetian publisher Tagliente profited from a more versatile little book with ornamental and practical scripts of all kinds. This was soon followed in Florence, Rome and again in Venice by similar copybooks in the same small format until, after a few decades, woodcut was supplanted by copperplate.

Of the writing and arithmetic teachers in Germany, the enterprising Johann Neudörffer of Nuremberg, to whom German art history is indebted for his important notes about the artists of his native city, produced a few woodcut sheets as early as 1519. Later this active man even made experiments in etching for the benefit of his pupils, and in 1538 published an etched *Anweysung einer gemeinen Hanndschrift* (Method for a Lower-Case Script). But his colleagues adhered to the more common woodcut in their pretty writing books, generally called *Fundamentbüchel*, *Schatzkammer* (Treasury) or *Formular*; industrious teachers were especially active in Cologne, Zurich and Strasbourg. Some of them worked with woodblock cutters whose work compares with the finest done for pictorial woodcuts. The extremely decorative capitals were favorites well into the seventeenth century, when the copperplate had long ousted the woodcut elsewhere.

In other countries there were fewer woodcut writing books. The skillful Spaniard Yciar based his 1548 work on Italian models. To the best of our knowledge today, the copybooks in the Low Countries, France and England were simpler, for the most part nothing but small groups of verses in the current cursives, generally enlivened by a larger initial.

WRITING BOOKS IN COPPERPLATE. Woodcut could not long remain the favored method for reproducing the pen strokes and curlicues of handwriting. The increase and decrease in thickness of a given line, the contrast between the powerful basic strokes and the thin hairlines, were captured much more easily and securely by the engraver's burin. Moreover, the fuller and more variable coloration made possible by this intaglio process came closer to the fluidity of india ink than did the uniform pressure of the woodblock. Even the plate tone contributed to a pleasing graphic effect. As the copperplate replaced the woodblock in the entire realm of graphic arts from about the middle of the sixteenth century, for ornamental sheets and for pictorial illustrations, so it did also in writing books. This meant an improvement in quality and individuality. Whereas the woodblock cutter identified himself by a monogram only rarely, now the engraver felt entitled to be named on the individual pages or on the title page of the book. Among the names that occur are some of fine repute; by and by specialized script engravers, virtuosos in their field, entered the picture. In addition, the larger copperplate made it possible to go beyond the modest dimensions of the woodcut booklet and to approach the letter and sheet size of the handwritten originals. Oblong formats were especially favored. Thus it was the copperplate that from the sixteenth century on gave writing books their well-known form throughout Europe; some were more modest, some more ambitious, as the need in the various countries required.

In the seventeenth and eighteenth centuries, too, Germany led in the number of books produced, because of the great number of separate regions, localities and ministries that took pride in individuality and also because of the inborn pleasure in capriciously toying with forms. As is well known, the Germans retained allegiance to the black-letter (Gothic; "broken") script of the late Middle Ages, and took great delight in its lively angularity of form not only in ornamental scripts for special occasions but also in the different gradations of everyday epistolary hands. At the outset, charming additions created by the ornamental engravers found their way into the copybooks. But after the great war [Thirty Years' War, 1618–1648] both calligraphy and engraving became more careless; the original correctness never returned, despite ardent attempts at reform, like the one led by Baurenfeind of Nuremberg around 1716. The general execution remained strong and picturesque until about 1800, when the harder engraving style of the English writing books became a prejudicial model.

On the other hand, in Holland, a nation historically akin to Germany, the art of the calligraphers and calligraphic engravers blossomed out remarkably in the years around 1600. In the Netherlandish linguistic area, where the most diverse people met in business and other activities, merchants had to be up on local and foreign scripts. The Flemish calligraphers in Antwerp and Brussels had already taught ornamental and practical scripts of all sorts and had found well-trained engravers and ornamental artists for the text and for pretty borders. When the center of gravity of business and culture was displaced northward into the free cities of Holland, a delight and skill in writing developed there which had no equal anywhere. From the most luxuriant decorative forms of medieval origin to the most volatile tachygraphy, all imaginable styles from home and abroad were mastered with admirable insight and woven into an inimitable tissue of beauti-

fully arranged lines and strokes. Splendid, brilliantly engraved books from all the major cities testify to this, above all the works of the ingenious Jan van den Welde of Rotterdam, later of Haarlem, who as far as we can tell was never surpassed by any colleague.

In the Latin countries the rich possibilities of black-letter were abandoned at an early date, and thus the copybooks could contain only the rounded practical scripts based on ancient lettering, adorned with decorative curlicues. Often, too, the letter forms were unfortunately eccentric, of a wantonly figurative nature. At any given time the copybooks reflect the political character of the country. Italy, with its mosaic of separate states, produced numerous useful and skillfully done books, but no outstandingly personal work. The Spanish writing books, few in number, presented the dignified, powerful practical script with perfect taste. In France about 1600 several subtle masters published graceful books of small dimensions and originated the development of two national writing styles that were especially to occupy the scribes of the royal chancery before and during the reign of Louis XIV. Even in the eighteenth century extensive works teach a neat, moderately ornamented script.

In England copybooks reached their flowering later than on the Continent. Only after 1650 did an active native school form, with the more bustling than brilliant schoolmaster Cocker at its head. He was followed by a long series of talented calligraphers, supported by virtuoso engravers. Holding piously to tradition, they based their work on antiquarian archival scripts and extravagantly ornamental scripts, but at the same time they developed the mercantile roundhand scripts to such a degree of simplicity that they conquered the entire Western world at the close of the eighteenth century. Now the numerous scripts that arose in this long period of travail must be examined according to their formal relationships.

SCRIPT FAMILIES: BLACK-LETTER SCRIPTS.
The script forms according to which we have organized the plates in this book are of two origins. The angular black-letter forms that prolong the style of the late Middle Ages have been retained by the Germanic nations temporarily or up to the present day. In the Latin countries the ancient Roman models and their developments were victorious as early as the fifteenth or sixteenth century; they all have a rounded stroke in common, so that we can classify them in general as roundhand scripts. We shall start with the first-mentioned, older group and begin our survey with Germany, which has remained faithful to black-letter up to now.

Medieval scribes had developed various scripts for their different purposes, more severe ones, freer ones, phlegmatic and mercurial ones. The most common fifteenth-century sort, as we find it in Gothic-style inscriptions and serious books of that

time, had lost its primary sphere of activity once Gutenberg had translated it into cast types. Fortunately the chancery calligraphers kept some place open, at least in documents, for these impressive, closely meshed, powerful strokes, so that throughout the history of German copybooks they are rarely absent (Plates 1 ff.). Squat at first, later more loose and open, this "beautiful but slow" script gradually moves from its originally austere nature into more supple characteristics. The main strokes swell and swing, the serifs and thorns begin to twist and to grow into ornamental adjuncts. The ascenders and descenders expand into curves and loops; everywhere one senses the more delicate nervous system of a younger and more active generation. All sorts of hooks, arcs and loops are attached to or inserted into the individual letters and the lines of lettering. The calligrapher applies his cheerful inventiveness to the capitals especially. Here he gives his pen free rein almost without regard to legibility. He dissolves the classical framework into a free interplay of flourishes which are often in direct opposition to the original lines of the letter; thus there arise the hard-to-read configurations that we Germans are barely able to translate into their ancient original form, and that so readily block the foreigner's access to the German language. But despite all this, admirers of happy creativity will appreciate these extravagant outgrowths of the calligrapher's caprice and will envy the men of old who had so much leisure and love to spare for the noble art of writing.

Now and then contemporaries used to call this ornamental script *Textur*, but it was chiefly called *Fraktur*, i.e. broken script. Gradations lead from this script to the smaller, more flowing styles, whose name *Kanzlei* (chancery) designates their origin and purpose (Plates 12 ff.). They were primarily used not for single introductory lines but for entire texts of important papers. Therefore the scribe was more concerned with the characteristic strokes of the letters than with accompanying ornament. He invented a great variety in the direction and form of the letters. He let them stand upright (*gerade*), he wrote them sloping to the left (*gelegt*) or tipped them over to the right (*geschoben* or *hangend*). He handled them as "vaulted," "twisted," "broken." No other kind of script has served as theme for so many witty variations.

From this *Kanzlei* one can trace transitions to the handier everyday scripts, the current cursives (*Kurrent*; Plates 16 ff.). It would be a tempting task to compare them with the epistolary hands of the late Middle Ages and to track down their origin and evolution. The pens are cut to sharper points, the short strokes and the "breaks" in the letters become thinner, the framework looser, the loops bolder: a wonderful instrument of great individuality in the writer's hand until the nineteenth century, when the sharp, dry engraved English models with their pointed strokes put an end to all the pleasure.

The Teutonic neighbors of the Germans—the Flemings, Dutch and Scandinavians—retained the

black-letter styles in both calligraphy and printing even in the eighteenth century and into the nineteenth. Fraktur as an ornamental script was never handled in a more masterly fashion than by the great calligraphers in Holland (Plates 26 ff.). Their basic letter forms are like those in Germany, but the delightful way in which the chief strokes gradually swell and diminish, the way in which the ascenders and descenders expand into precise rounded elements, the way in which bold curves accompany and enframe the letters, all with a noble and sure sense of spatial organization: all this produces a high point in calligraphic history. These great masters are equally victorious in dealing with the cursive black-letter forms in the style and language not only of their own land but also of the neighboring peoples, especially Germany, England and France; the Dutch merchants wished to master all these tongues and scripts. It is impossible to view the strength and splendor of these creations, of which we can offer only a scanty selection, without constantly renewed awe and admiration.

The English were the third to appreciate and make use of the decorative charm of black-letter. Tradition-bound fogies in the royal chancery and courts of law retained an eccentric "court hand" that still appears on a few pages in eighteenth-century copybooks (Plates 54 ff.) — stiff, barely legible, pretentious, with holdovers from the Norman period and here and there almost reminiscent of runes. But at the same time some calligraphers were able to handle the ornamental black-letter (Plates 58 ff.) in even more supple fashion than the Germans and Dutch, with genuine calligraphic joy, with exuberant flourishes on both initials and lower-case letters. These scripts are often expanded in width (Plates 66 ff.) and emphasize diagonals, resulting in livelier letters of a pointed oval shape. Intermingled with the increasingly popular roundhands, this ornamental script lasts until well into the nineteenth century, on title pages, for example.

In the Latin countries only the very early writing books offer a few remnants of the Gothic tradition. In Italy the old-fashioned, curlicued black-letter was felt as something from the north and was called "French" (Plates 72 ff.). The papal chancery remained faithful somewhat longer to the narrow perpendicular black-letter forms (Plate 76). Notaries (Plate 77) and merchants (Plates 78 & 79) also continued to write in a Gothic frame of mind, but the letters were already becoming more and more rounded, striving after the modern humanistic style. In France the scholar Geoffroy Tory had had a few Gothic elements drawn and cut alongside the Antiqua constructions for his famous *Champ fleury* (Plates 80 & 81); in addition, upright or sloping black-letter forms with thin ascenders and descenders were still used for a while for government papers and in countinghouses. Once in a great while the early copybooks still also include the Gothic roundhand of the Italian missals (Plates 84 ff.).

SCRIPT FAMILIES: ROUNDHAND SCRIPTS. Among the scripts derived from ancient lettering it is only right to place first the pristine form, still called Antiqua by printers today, a combination of the classic Roman capitals and the upright lower-case letters invented by the humanists to match the capitals. But it is easily understood that the forms used for inscriptions and printed books seldom appear as models for calligraphy; therefore we offer only a few examples from Italian and from later English books (Plates 88 ff.). For the practical use of scribes a sloping cursive early developed in Italy which caught the fancy of printers too after 1500. It soon gained entry into chanceries as *lettera corsiva cancellaresca* (Plates 94 ff.), and became the basis of scripts in the Latin countries and later in northern Europe as well. It is to this script that the first calligraphic instruction book, Vicentino's of 1522, is devoted. It forms the core of the older, woodcut copybooks and is prevalent, with only minor vicissitudes, in the engraved models until near the end of the eighteenth century. In firm strokes — at first broader, later delicate and fluid for the most part — the letters follow one another like evenly matched pearls on a string. Their creators, the chancery scribes, allowed their hand individual freedom here too, and extended the ascenders and descenders in the same sloping direction with a more or less expressive élan, chiefly with a dotlike or clublike element at the start and finish. These tails, which had to be carefully practiced, recur in the copybooks in various connections. The scribes were able to adapt the capitals and the abbreviations (then still very much in use) to these characteristics with great skill. There were also local differences in the directions and relationships of the letters. Curlicues were relatively little used; the ornamental and figurative line configurations appear primarily as borders or frames.

This southern type of script develops into an extravagant play of the quill in the hands of the Dutch (Plates 112 ff.). Together with their banking system, the Italian merchants also introduced their smooth, round, fluid writing into northern countinghouses and offices. There the calligraphers, at home in every style, adopted it with their outspoken creativity. Now the letters, with their vivacious ascenders and descenders, curl and expand into a tide of fluid, impetuous waves, shot through with rolling flourishes like those found in the black-letter scripts of these masters. Strong personalities, such as Boissens with his sure feeling for spacing, and the incomparable Van den Velde, are just as capriciously inventive in this area, and surpass their southern models not only in their native language but even in French and English texts. Even the Spanish derivatives of the roundhand scripts were scarcely ever handled so spiritedly.

The Spaniards had gone their own confident way at an early date (Plates 128 ff.). As early as master Yciar's woodcuts of 1548, their powerful script, flowing from a broad pen, was established in two

forms: as a full, upright *redondilla* (roundhand) and as a sloping script, which later maintained itself through the centuries in Spain and Portugal. Their proud strokes reflect the ceremonious nature of the people, their preference for a solemn bearing: broadly cut pen, decided direction, manly pressure, sober and sparely used flourishes. As late as 1776, when calligraphy was already becoming dull in other countries, the precious writing book of Palomares (Plates 134 ff.) offers an image of aristocratic dignity matched by no other roundhand.

The French were the first people on this side of the Alps to follow the Italians in their script, as also in their architecture and ornamental art. They developed two styles which can be distinguished up to a late period. One style they too call roundhand: *ronde* (Plates 146 ff.). It is a derivation of the Gothic chancery script as the merchants had preserved it; hence its other designation, *financière*. It is a vertical script, expanded, basically rounded, with an inclination toward hooklike connections; the mood is occasionally solemn, "majestueux." This script remained in use in the countinghouses for ledgers and accounts. The second style developed from the Italian chancery cursive (Plates 160 ff.), which was used in France as early as the decorative writing books of the late sixteenth century, and appeared at the beginning of the seventeenth in an influential manual by Materot of Avignon in southern France. From this the French developed a calmer, evenly flowing, somewhat sober sloping script — an offshoot (*bastarde*) — the classic script from the Louis XIV period up to the Empire, consciously stressing simplicity and correctness. In the eighteenth century it gained currency in the rest of Europe as well,

more so than the mixed scripts in which a few late reformers delighted (Plates 178 & 179). In their ornamentation the Parisian calligraphers clung to a heavy, tiresome fashion.

The European roundhand scripts come to an end with the English (Plates 180 ff.) It was at a comparatively late stage that they assimilated the models that the Italians, French and Dutch had sent over to them or had themselves engraved on English soil. But then many active calligraphers and engravers formed the well-known cursive "round text hand" or "round current hand" on the basis of the French *bastarde* — a reflection of British objectivity and technical prowess. English merchants carried this script out into the world. But the more brilliantly the professional script engravers incised their sober strokes into the copperplate, the more meticulously the superfine hairlines contrasted with the main strokes, the more the hard and sharply pointed steel pen replaced the soft goose quill, the more clumsily the pedantic schoolmaster in the subsequent period of universal education killed all individual impulses in writing, the more speedily did the old, cheerful "penmanship" perish in the course of the nineteenth century.

It is from England that, in the last few decades, the first attempts have come to reawaken the lost joys of beautiful, personal handwriting. The Germans have made successful efforts in other directions. These serious undertakings lie outside the scope of this book. But we would like to hope that the varied stimulus offered by the old calligraphers, as gathered together in the present work, will perhaps point present-day patrons and lovers of artistic calligraphy along freer paths in tune with the times.

ALPHABETICAL LIST OF CALLIGRAPHERS

MASTERPIECES OF CALLIGRAPHY

Die grobe düppel Fractur

Wir Karl der fünfft von Gottes gnaden Rö-
mischer Kayser zu allen Zeiten merer Des
Reichs 2c Inn Germanien beider Sicilie
Hierusalem Hungern Dalmatien Croa-
tien 2c König Ertzhertzog Zu Osterreich
Hertzog zu Burgundi Graue zu Habspurg

Wir Ferdinand von Gottes gnade
Romischer Zu Hungern vnd Be
hem Kunig Infant Inn Hispa
nien Ertzhertzog Zu Osterreich
Hertzog zu Burgundi Graue zu

Niemandt erkennt den Vatter Dann nun der sun Und denen es der Sun offenbart

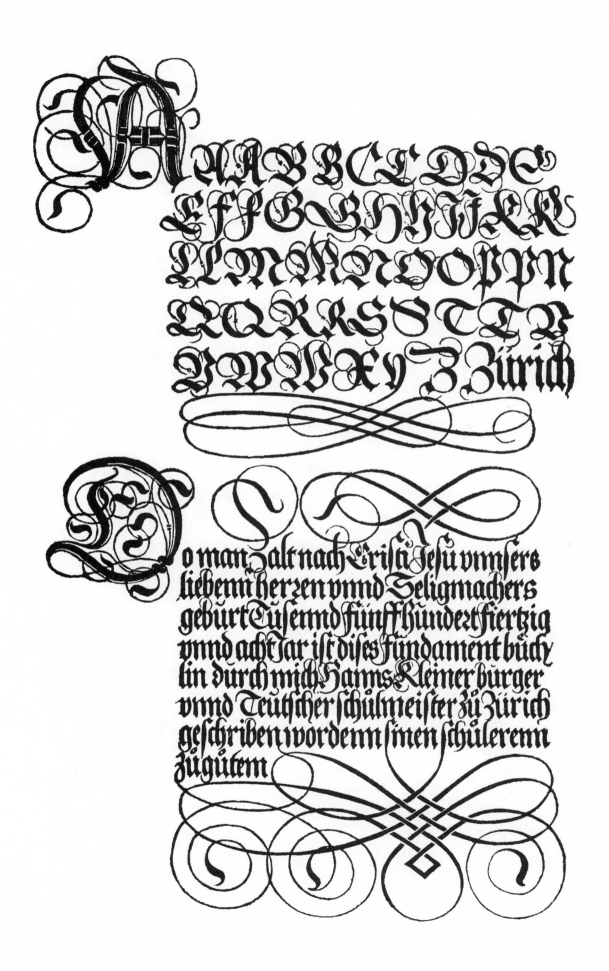

ABCDEFGHIKLMNOPQRSTVWXYZ Zürich

Do man zalt nach Cristi Jesu unsers
liebenn herzen unnd Seligmachers
gebürt Tusennd fünffhundert fiertzig
unnd acht Jar ist dises fundament büch
lin durch mich Hanns Kleiner burger
unnd Teütscher schülmeister zü Zürich
geschriben wordenn sinen schüleremm
zü gütem

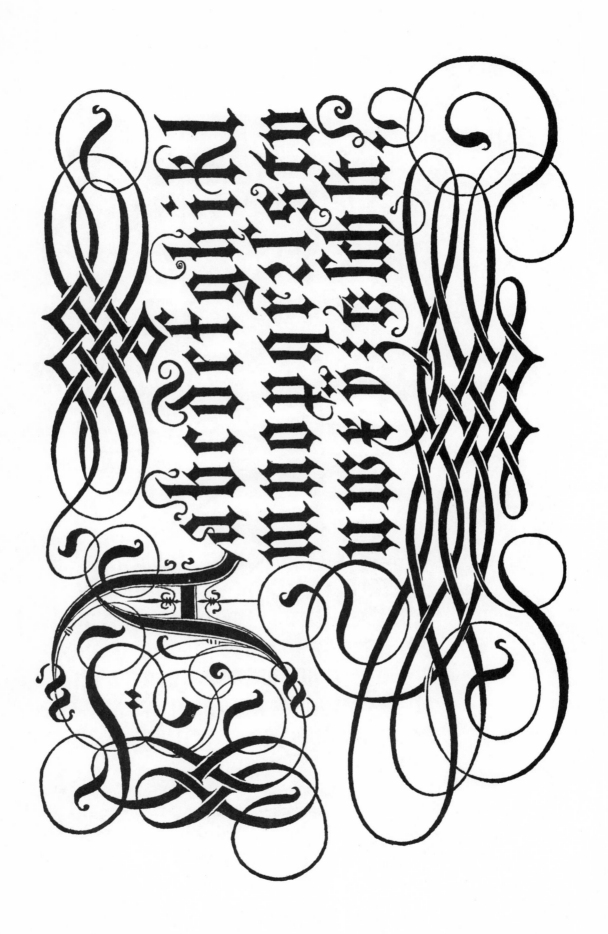

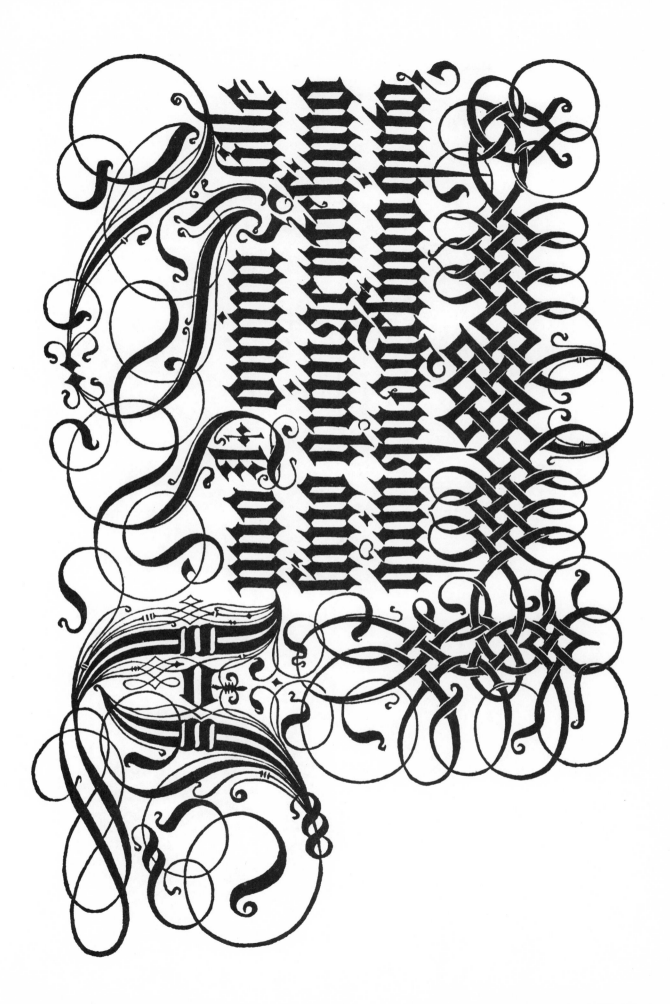

EIN NEUW FUNDAMENTBUCH

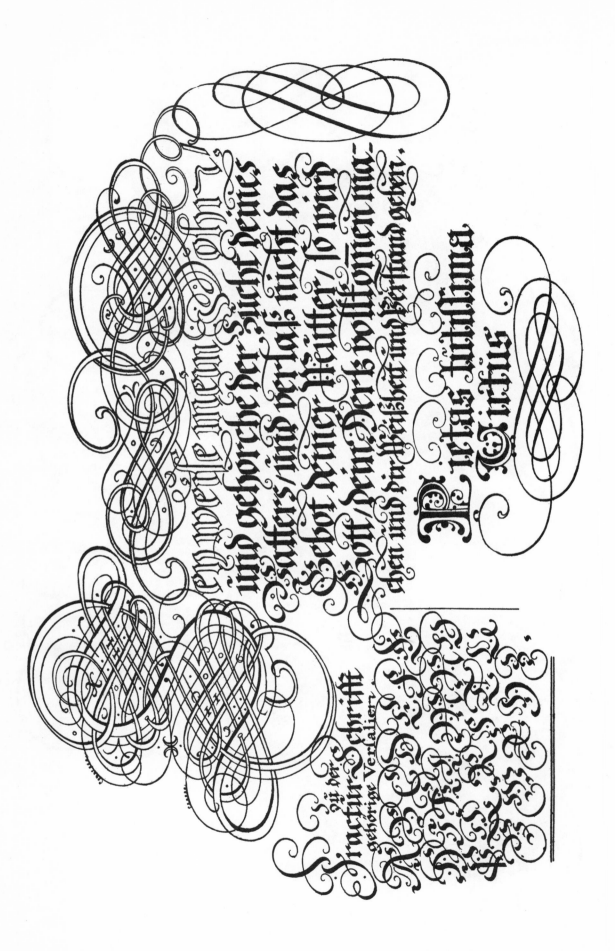

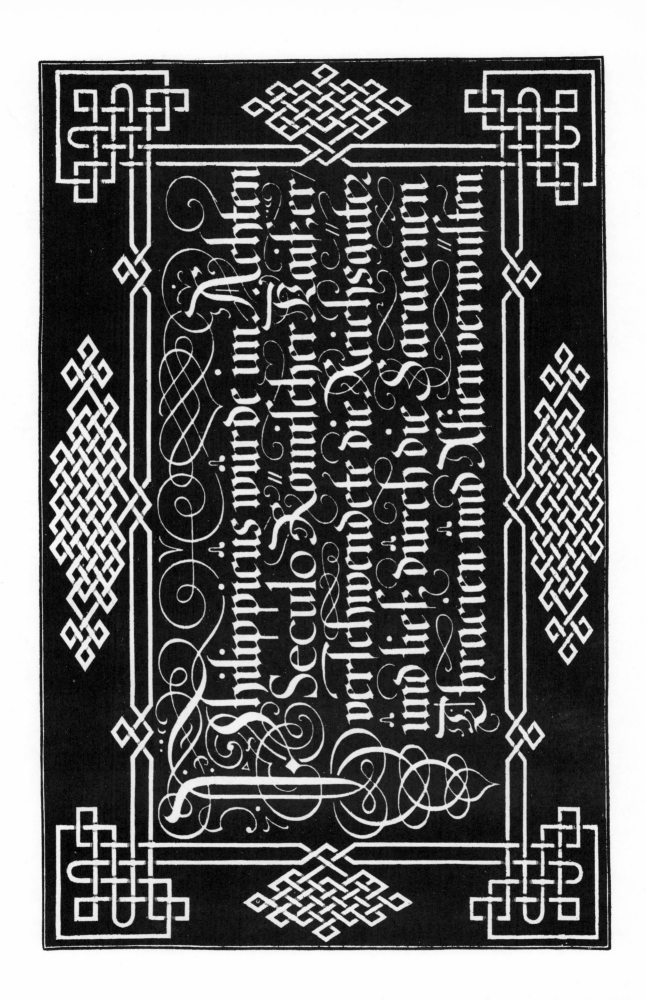

7. BAURENFEIND, NÜRNBERG 1716 WIEDER-HERSTELLUNG DER SCHREIB-KUNST

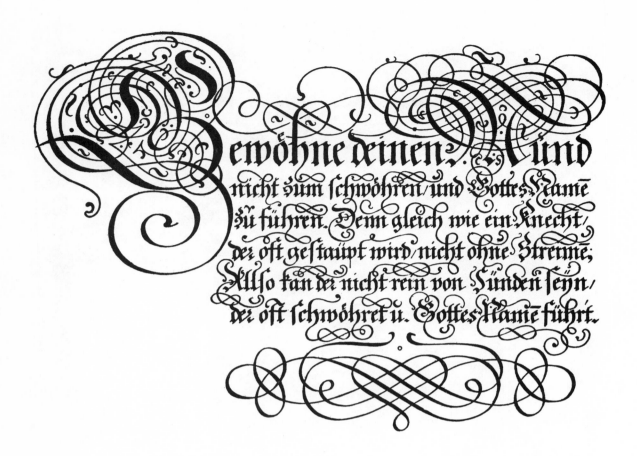

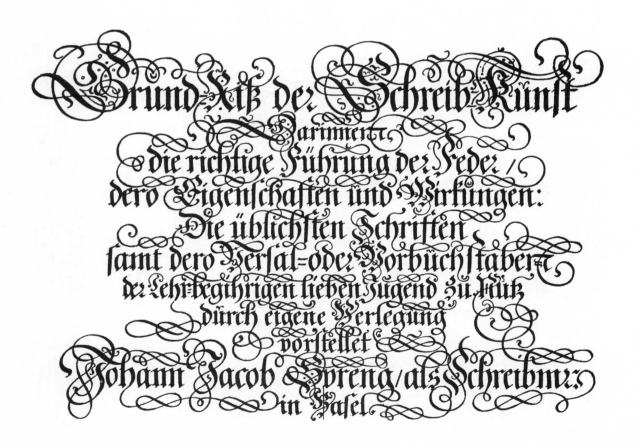

GRUND-RISS DER SCHREIB-KUNST

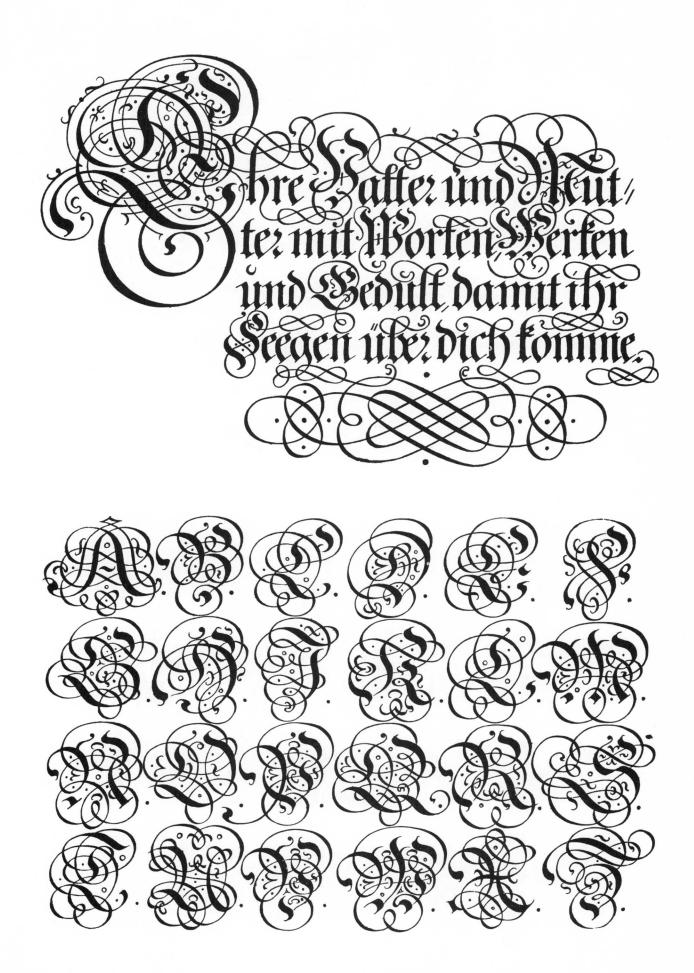

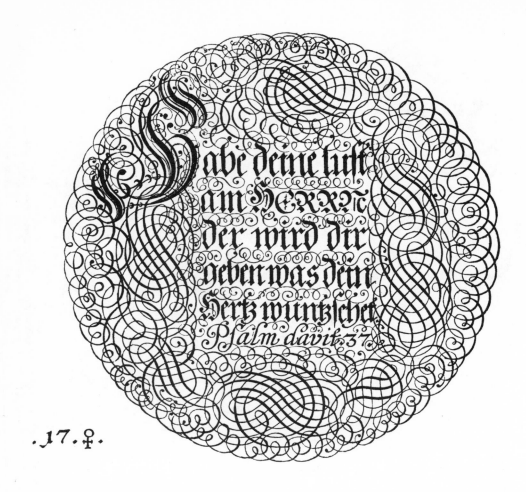

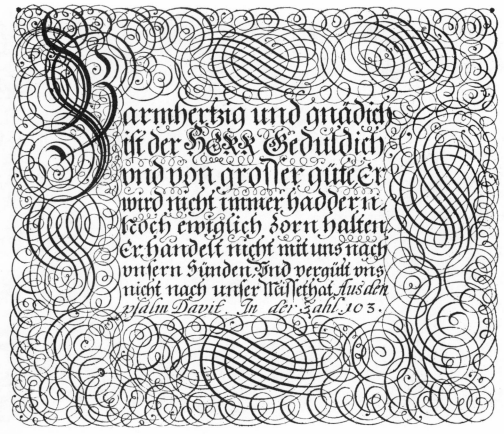

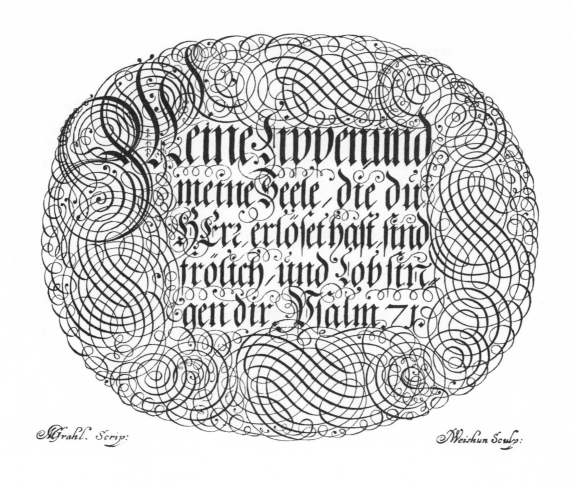

Meine Lippen und
meine Seele, die du
HErr erlöset hast, sind
frölich und Lobsin-
gen dir. Psalm 71

Grahl. Scrip: Weishun Sculp:

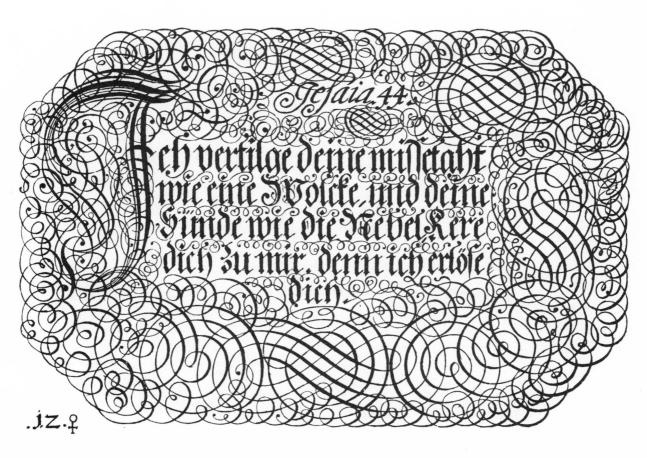

Jesaia 44.

Ich vertilge deine missetaht
wie eine Wolcke, und deine
Sünde wie die Nebel. Kere
dich zu mir, denn ich erlöse
dich

.I.Z.♀

Confitemini domino quoniam bonus. quoniam in seculum misericordia eius Dicat nunc Israel quoniam bonus, quoniam in seculum misericordia eius Dicat nunc domus Aaro quoniam in seculum misericordia eius Dicat nunc qui timet dominum, quoniam in seculum misericordia eius. De tribulatione inuocaui dominum, et exaudiuit me in latitudine dominus. Dominus mihi adiutor, et ego despiciam inimicos meos. Dominus mihi adiutor non timebo quid faciat mihi homo. Bonum est confidere in domino, quam confidere in homine. Bonum est sperare in domino, quam sperare in principibus.

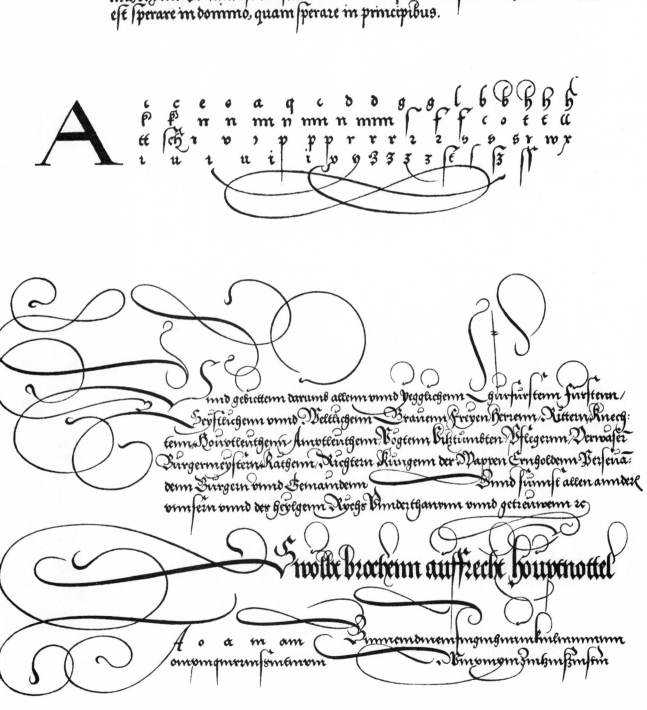

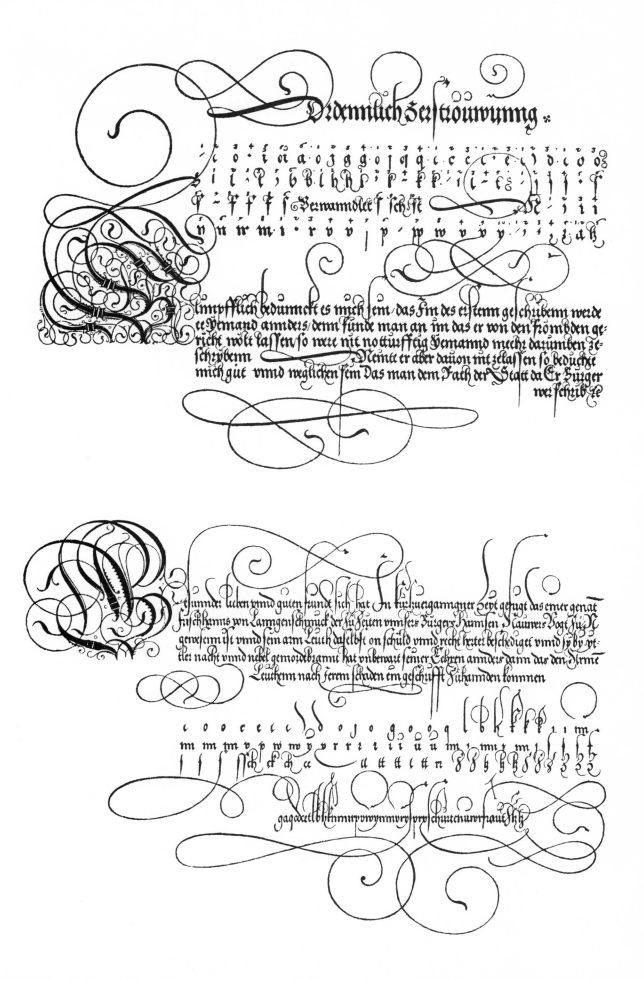

Die kleine duppell Fractur

Dem Allerdurchleuchtigsten Grossmechtigsten Fürsten vnnd herrn herrn Karolen dem Funfften Romischen Kayser zu allen zeiten mehrer des Reichs Jm Germanien Hispanien beider Sicilien Hierusalem Hungern Dalmatien Croatien der Canarischenn vnnd Jndianischen Jnseln vnnd Terre Firme des Oceanischen Meers re Konige. Erzherzogen zu Osterreich Herzogen zu Burgundi zu Lotringen zu Brabat. re. Grauen zu Habspurg zu Flanndern zu Tyrol re. Lanndgrauen Jm Cesas Pfatz grauen zu Hennigaw zu Hollandt zu Seelandt re. Marggrauen zu Burgaw zu Oristani zu Gotiam vnnd des heiligen Romischen Reichs Fürsten zu Swaben re. Vnnserm

a a b c c d e ff g h i i k l m n o o p q r s t v x y z

A A B B C C D D E F F G G H J J K K L L M M N N O O P P Q R S S T T V V W Z X H Z Z S S

Die duppel Fractur vff gelegte arth gestellet.

Dem Allerdurchleuchtigsten Grosmechtigsten Fürsten vnnd herren herrn Ferdinanden Romischen Zu allen heiten Mercern des reichs. Auch zu Hunngern vnnd Behenn Konige Jnfanten in Hispanien Erzherzogen zu Osterreich Herzogenn zu Burgundi Braband Schlesien Stewermarck Kerntenn re. Marggrauenn zu Merhern Grauen zu Habsburg Flandern vnnd Tyroll re. Vnnserm allergnedigsten Herrn

A A B C C D E E F F G G H J J K K L L M M N N O O P P R Q R R S T T C W W V X X D Z S Z re.

A a b b c d e ff g h i k l m n o p q r s s t o w ü x y z

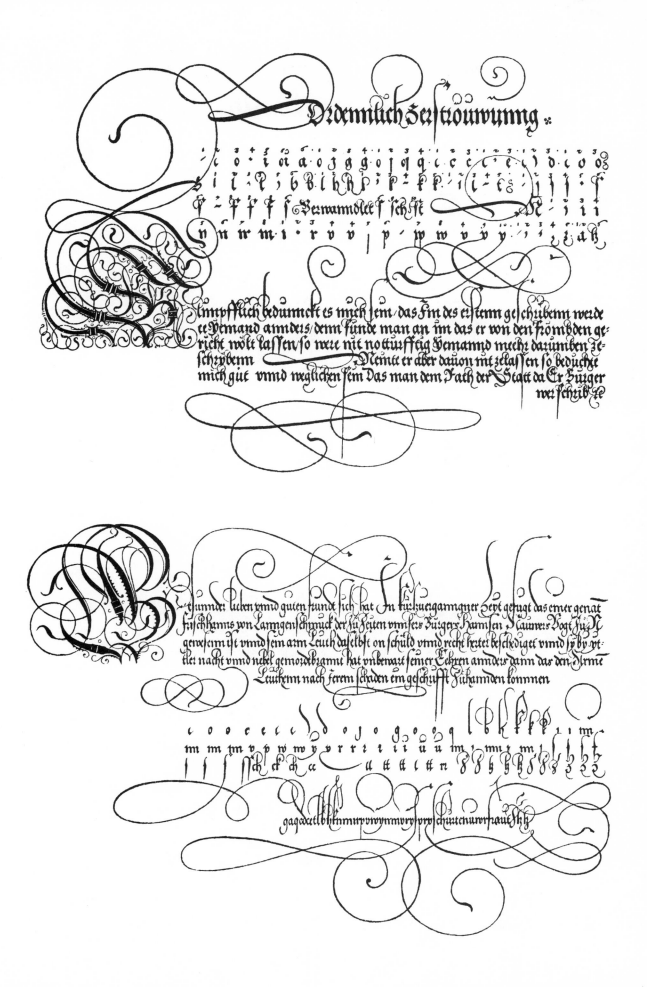

Die kleine duppell Fractur?

Dem Allerdurchleuchtigsten Grossmechtigsten Fürsten vnnd herren herrn Karolen dem Fünfften Römischen Kayser zu allen zeiten mehrer des Reichs Im Germanien Hispanien beider Sicilien Hierusalem Hungern Dalmatien Croatien der Canarischenn vnnd Indianischen Inseln vnnd Terre Firme des Oceanischen Meers ꝛc Könige Ertzherhogen zu Osterreich Hertzogen zu Burgundi zu Lotringen zu Brabant ꝛc Grauen zu Habspurg zu Flanndern zu Tyrol ꝛc Lanndgrauen Im Cesas Pfaltz grauen zu Hennigaw zu Hollandt zu Seelandt ꝛc Marggrauen zu Burgaw zu Oristam zu Gotiam vnnd des heiligen Romischen Reichs Fürsten zu Swaben ꝛc Vnserm

Aaabccds e ff gghi kkelm n oo p q r s t vxyz

AABBECDD EEFFGGHHJJKKLL
MMNNOOPPQQRRSSTUVWW
XYYZB

Die duppel Fractur vff gelezte arth gestellet.

Dem Allerdurchleuchtigsten Grosmechtigsten Fürsten vnnd herren herrn Ferdinanden Römischen Zu allen zeiten Meern des Reichs. Auch zu Hungern vnnd Behemn Konnge Infanten in Hispanien Ertzherhogen zu Osterreich Hertzogenn zu Burgundi Braband Schlesien Steyermarck Kerndtenn ꝛc Marggrauenn zu Merhern Grauen zu Habsburg Flandern vnnd Tyroll ꝛc Vnserm allergnedigsten Herrnn

AABBCCDDEEFFGGHHJJKKLLMMNN
OOPPQQRRSSTTWWVXYYZ BB

Aaabbcdefffghik lmnopqrsstvwüzz

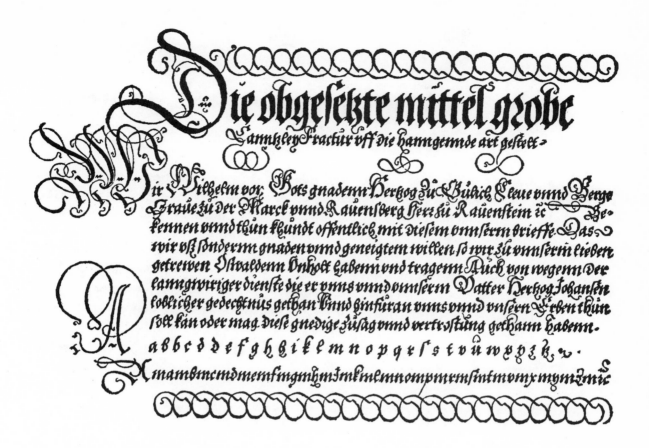

Die obgeſetzte mittel grobe

Cantzley Fractur vff die hanngennde art geſtelt

Wir Wilhelm vor Gots gnadenn Hertzog zů Gülich Cleue vnnd Berge
Graue zu der Marck vnnd Rauensberg herr zů Rauenſtein rc He-
kennen vnnd thun kũndt offentlich mit dieſem vnnſerm brieffe Das
wir vß ſonderm gnaden vnnd geneigtem willen ſo wir zu vnnſerm lieben
getrewen Oſtwaldenn Vnhoff haben vnd tragenn Auch von wegenn der
lanngwiriger dienſte die er vns vnnd vnnſerm Vatter Hertzog Johanſen
loblicher gedechtnus gethan vnnd hinfuran vns vnnd vnſern Erben thun
ſoll kan oder mag dieſe gnedige zůſag vnnd vertrostung gethann habenn

a b c d d e f g h i k l m n o p q r ſ s t v ů w x y z k rc

A mamb mc md me mf mg mh mi mk ml mn nomp mr mſ mt mv mx my mz rc

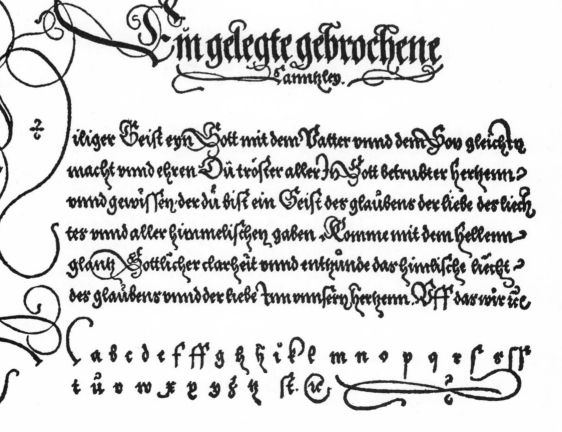

Ein gelegte gebrochene

Cantzley

Hiliger Geiſt eyn Gott mit dem Vatter vnnd dem Son gleicher
macht vnnd ehren Du troſter aller In Gott betrubter hertzenn
vnnd gewiſſen der du biſt ein Geiſt der glaubens der liebe der liech-
ter vnnd aller hiinmeliſchen gaben Komme mit dem hellenn
glantz Gottlicher clarheit vnnd entzunde dar hiinliſche liecht
des glaubens vnnd der liebe inn vnnſern hertzenn Vff das wir rc

a b c d e f ff g h i k l m n o p q r ſ ſſ
t v ů w x y z k rc

Em andere gelegte Cantzley

Curent sambt dem Alphabeth darzu gehorig

Erwirdigster Churfürst Genedigster herre. ⁊ Nach meiner vnertheniger gantzwilliger dienst erbietung wissen ewer Churfürstliche G. sich noch sonder zweiffle wol zuerinneren das Ich derselben verruckter Zeit zum offtermalen Im vnertthenigkeyt entdeckt vnnd zuerkennen geben wie das Ich vor schwer weil vnd anligender noth vnnd eusserster armüt willem meiner blutsverwanndten deney zur Heidenn etliche pfeunde versatz Welche Ich bißhero vnermogenheit halben nit hab wider vmb loesenn kunnen. ⁊ Mit vnnthertheniger bit dieweil solche pfeunde volgennds an Doctor Johannsen seligen der tochter zur Heidenn auch seligem man ererbeths vnnd anerstorbenn vnnd Ire also leichtlich vnnd mit titulo oueroso aukomen sind dar. E. G. ꝛc

a b c d e f f g g h i k l m n o p q r s s ss s t u v w x y z z
L man bur vnd men sing vnr Hu in Jnk lul nu nn om pa que vns Sut uer rmy un zu. st k v

Die rund gelegte gebroche

ne Cantzley schrifft.

Fürsichtigen Ersamen vnnd Weysen grosgünstige liebe herrenn ⁊ Nach meiner enrredroßsenen gantzwilligenn dienste erbietung geb L. W. Ich dienstlicher weynung zuerkennen. Wie das ich Bürger zu Leiptzig Im land zu Meyssen warhafftig Herman Braun genant mir Jn dar der mynderen halb vortzigg Jm der Frannckfurter Herbstmesser fünfftzig Engelischer tucher vmb zwolff hundert guldenn abgekaufft vnnd mir die bezalung oder zwey Jar darnach daselbst zu Frannckfurt Jnn einer vnertzeilter summen zuthun vermyge seiner eygener besiegelter vnnd mir zugestelter handtschrifft gelobet vnnd versprochen ꝛc

A a b c d e f g g i k l m n o p q r s t e u w x y z z. ꝛc
L man bur vnd men sing vnr Jnn Jnk lul nu nn om pa que vns sut vnr rmy un zu Jn.

Noch ein andere Lurrent

gelegt gebogen oder gewunden der negsten Zugegeun.

Edler vund wolgeborner Grave &c. Mein gantz vunterthenige vund gehorsame dienste sindt ewern gnaden allzeit mit allem vleis zuvor. Gnediger herr. E. g. weist sich noch ohne zweiffel zuerinnern Wie das sie mir vor etzlichen Jaren vngefahrlich die genedige vertrostung gethain haben das sie mich so baldig zu zu meinem vorstentlichem Jaren komen vund zu dienen geschickt sein wurde mit einem negst erledigstem dienst denn Ich vorsehen kündte bedenncken wolten. Die weil ich dann vor mir das ewer &c. vor etlichem tagen ein schreiber abgangen. Bate dann vermitlich das E. G. einen anderen an seine stadt annemen werde. Vund dieweil mich dann vom Jugent Inn der kunst des schreibens dermasse

a a b c d e f f g g h i k e l m n o p q r ſ s t v u w y z z tſ ſt.

maubter und mein fugen hiku leu kuno np pu quur nſut uuv vom uſn zu

∞∞∞∞∞∞∞∞∞∞∞∞∞∞∞∞

Ein andere rund geleg

te lauffennde Hanndt.

Ein gantz willige vnuerdrossene dienste allzeit zuvor Ernvester vund from mer grossgünstiger lieber Juncker Nachdem ewer E. mich zu einem Anwalte vund Procurator verordnet vund gesatzt hat, die Appellation sache zwischen ewer Ewer E. vund denen von der Lippe am Keyserlichen Camergericht anhen gig einzumachen vund auszuführen. Vund wie dann miteinander abgeredt vund beschlossen, was er mir zu der fering vund volnfüring dieser sachen gethun solt. So hab ich demnach gegenwertigem meinen diener Johann senn vn Reinarg zu ewer E. abgefertigt das solt dann euch zuerkantsamgeun

A a b c d e f f g g h i k l l m n o p q r ſ s t v u w y z. ∞

Ei maubter und mein fugen hiu denkkn leu nno np pu gur nſut uuvmo mgu yzn zu

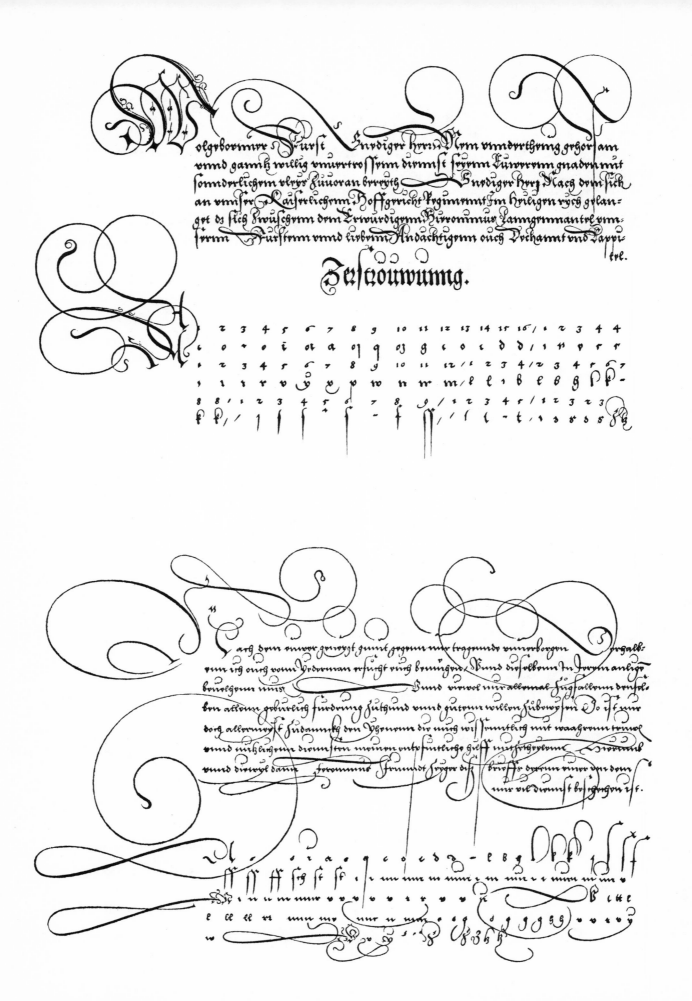

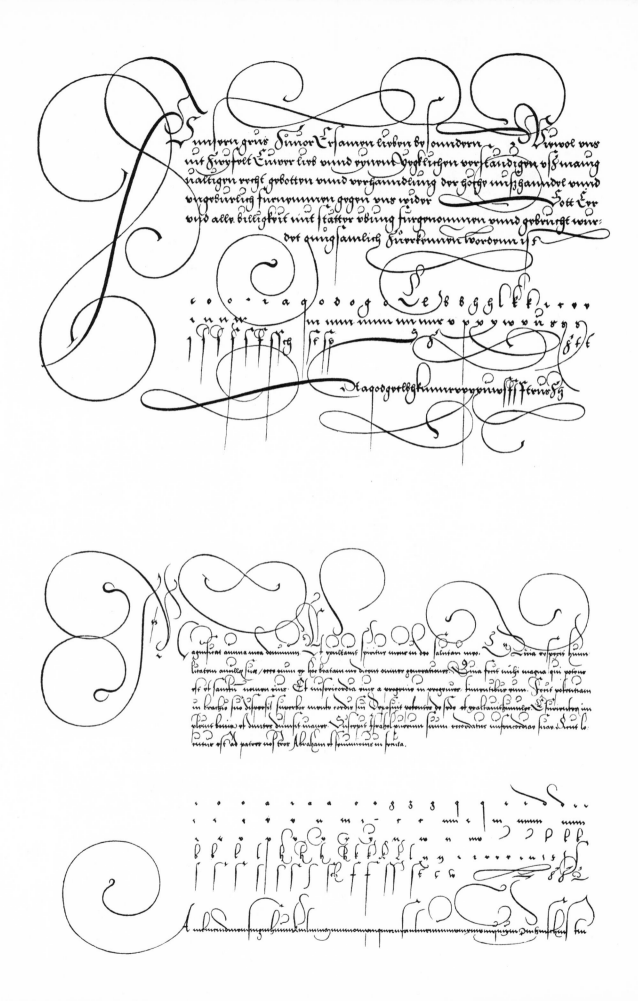

1. Belacste grundschrift. ——— Lit E

Als man gesinnet, eine gewisse grundschrifft zuschreiben,
so müssen alle buchstaben, nach desselben grundes
eigenschafft, recht und deutlich gemacht werden,
dann, von allen grundschrifften ist dieses zumerken:
daß sie keine vermischung der grundbuchstaben leide.

2. Stesende Grundschrift.

Bey allen Grundschrifften, beruhet der eigentliche grund
rechter unterscheidunge, auff dem kurzen grundstrich und
seiner abrichtung, daneben auch auf den mittel und
langbuchstaben, und dero veränderung, wobey zumerken:
daß alle kurze und lange striche müssen gleichweitig steh.

3. Geschobene grundschrift.

anziehen oder brechen der buchstaben, durch den ober
und unterbruch, muß sich ebenermaßen richten nach
dem fundament des kleinen grundstrichs, damit
die gebrochenen buchstaben auch mögen nach art
des grundstrichs, gelegt stehend od geschoben könne.

4. Gewelbte grundschrift.

eine Gewelbte schrifft ist die, deren kurzer grund,
strich über sich, wie ein gewölbe gebogen, und hat
sich nach dem gehobenen grunde, Wobey fer-
ner zumerken, daß in den schrifften des krummen
grundstrichs, müssen kurze mittel buchstaben sein.

5. Gebogene Grundschrift.

Fünff grundschrifften sein vorneulichen, und ist
diese letzte gebogen, die artet sich nach dem geleg-
ten grunde, wie das der kleine grundstrich etwas
rund unterwerts gebogen, und ist sehr fertig,
wan dabey werden die laufbuchstaben gebraucht.

Braunschweig anno 1665. den 24 Martij Vorgeschrie.

Die Buchstaben der Grundschrifften **Lit. c.**

1

Gelegte Art.

N. 3.

mit Geschoben.

N. 4.

Stehende Art.

N. 5.

Geschobene Art.

N. 6.

Gewundene Art.

N. 7.

Gewelbte Art.

N. 8.

Lauff Buchstaben.

N. 9.

Braunsweig a⁰ 1665. 3. Januarij.

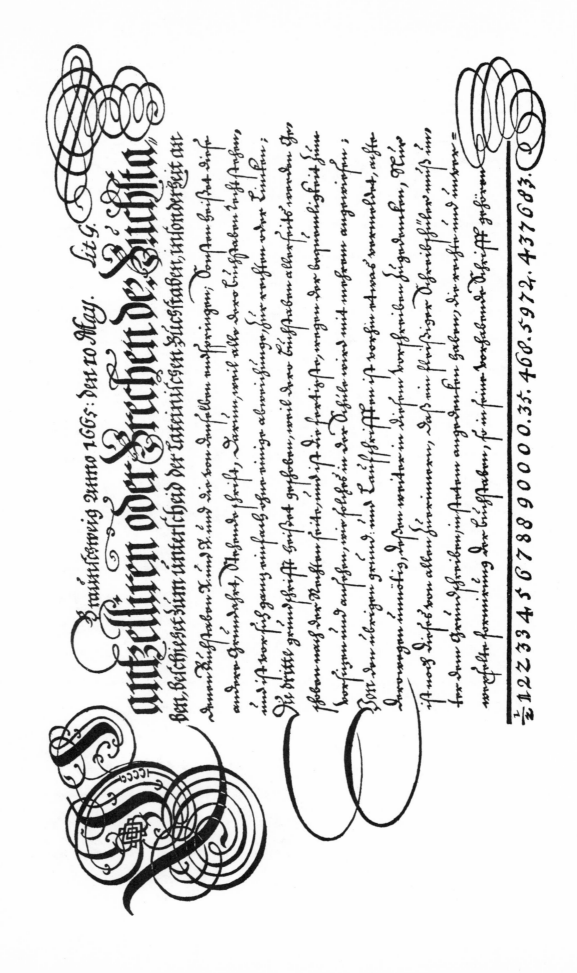

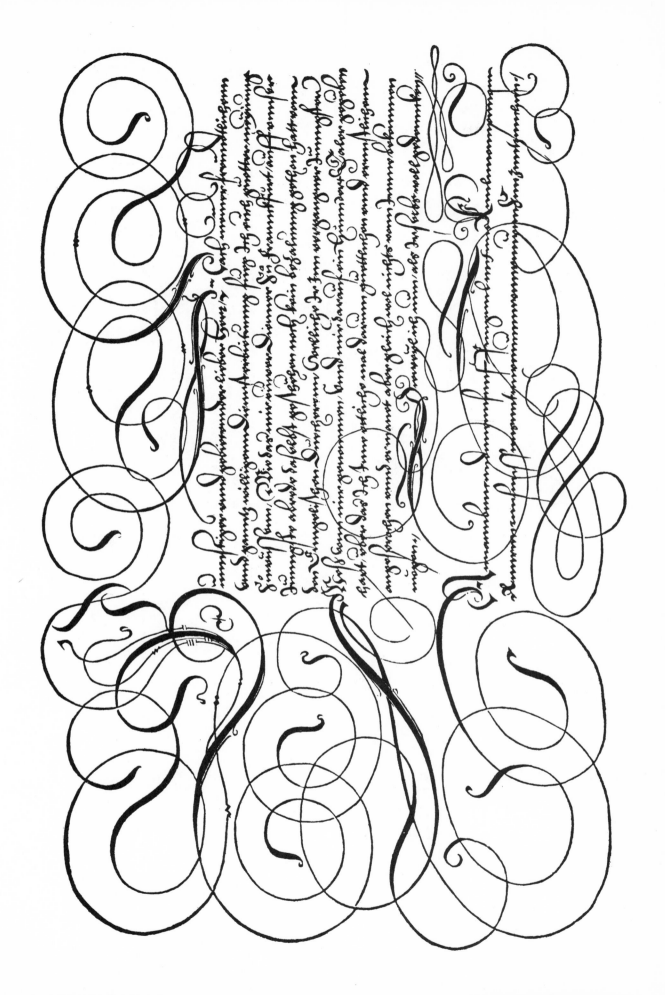

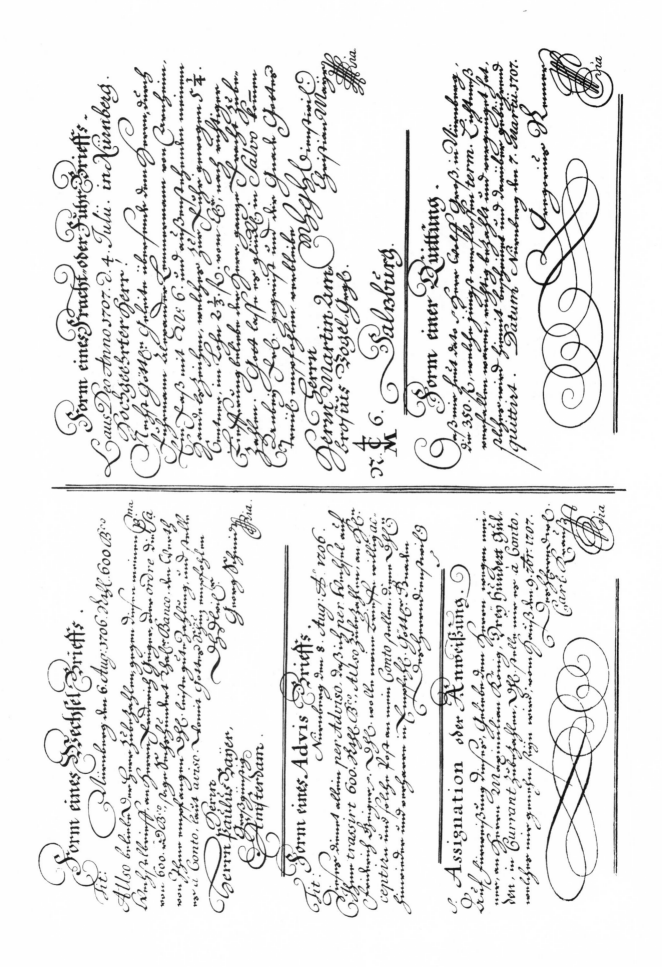

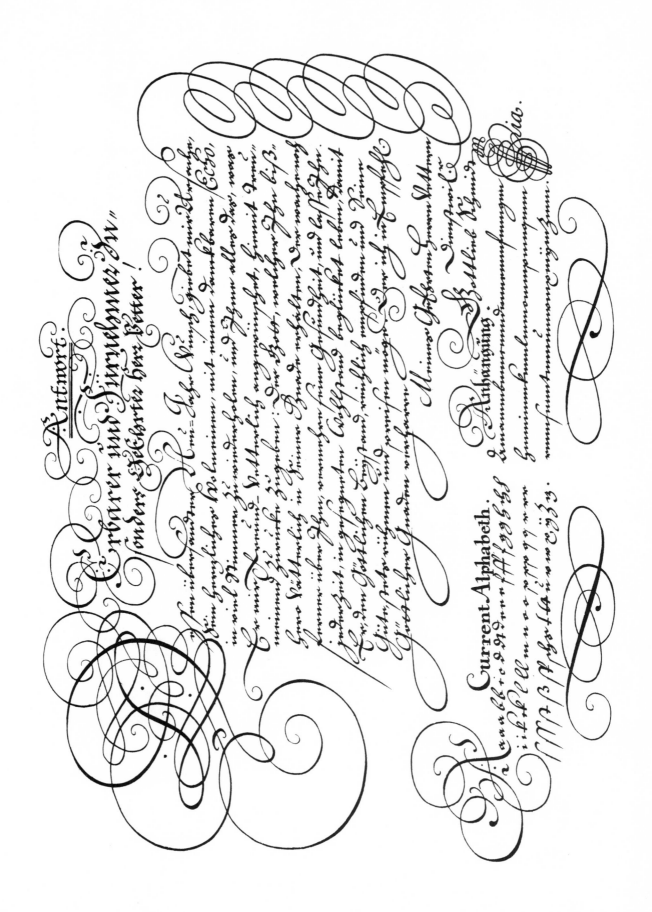

Brabendische Fractur

Here op di betrouwe ic laet mi nemmeimer te scanden werden. helpt mi daer af met diner gerechtich. ... Teiget dine ooren tot mi haestelick. verlost mi. Syt mi een stercken steen ende een huys tot een Casteel. dat ghi mi helpet Want ghi syt minen steen ende myn Casteel: ende om diner namen willen wilt ghi mi leyden ende vueren ... Ghi willet mi vt dem nette trecken dat sy mi gestelt hebben. want ghi syt min stercke. In dinen handen beuelen ic minen Geest ghi hebt mi verlost Here. ghi getrouwe God.

Ein Brabendisch oder Niderlenndisch Schriftlein

Allen den ghenen die diese bræn solen sien oft hooren lesen Burgermeisteren Scepenen ende Raide van der stadt van Antwerpen Salum doen te wetent. Dat opten dachs van huyden vor ons comen Jr Godenart van der Hagen boeckvercoopere. Ende hest wettelick mechtich gemaet en In zyne stede gestelt. maecte wettelick mechtich en stelde In zyne stede met desem brieue Meesteren Godenarde Hettorp burgere tot Coelne. Omme van zyn tweegen ende In den naeme van hem Alle zyne schulden resten ende gebreecken welckerhande die wesen moghen abwe tot wat

a b c d e f f g g h i k l m n o p q r st w x y z
A B C D E F G H I I K L L
M N O P Q R S T V W X Y Z

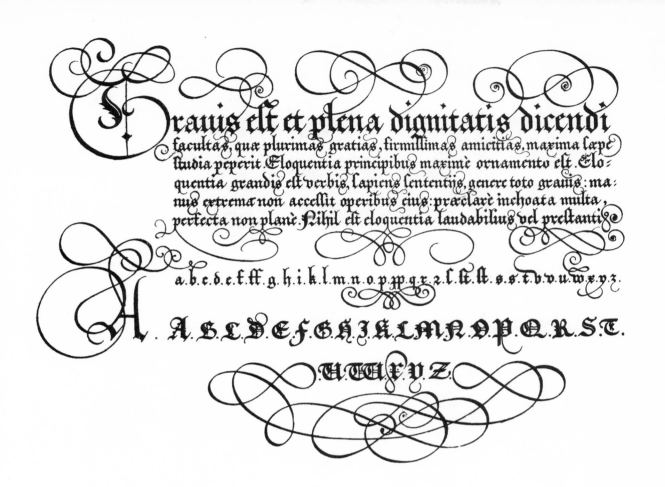

Grauis est et plena dignitatis dicendi
facultas, quæ plurimas gratias, firmissimas amicitias, maxima sæpe
studia peperit. Eloquentia principibus maximè ornamento est. Elo-
quentia grandis est verbis, sapiens sententijs, genere toto grauis: ma-
nus extrema non accessit operibus eius: præclarè inchoata multa,
perfecta non planè. Nihil est eloquentia laudabilius vel prestanti.

a.b.c.d.e.f.ff.g.h.i.k.l.m.n.o.p.pp.q.r.z.s.ss.st.st.s.s.t.b.v.u.w.x.y.z.

A. A.B.C.D.E.F.G.H.I.K.L.M.N.O.P.Q.R.S.T.

U.T.W.X.Y.Z.

XVIII.

Lob Vnnd danck sagen Wir dir Herr Gott himmelischer Vat
ter vmb deine theüre gaaben die du vns abermalen so mültigelichemm
bescheret hast vnnd bitten dich gib vmns die selbigen deine heilige gaa-
ben mit waser danckbarkeyt vnnd aller Zucht zunuessen daduech Wir
deinen Nammen heiligenn vnnd grozmachen ———— Amen.

Aa.a.b.c.d.d.e.f.ff.g.g.h.i.k.l.m.n.o.o.p.pp.q.z.r.s.s.t.u.v.x.ij.z.

27 a. PERRET, ANTWERPEN 1571
27 b. HOUTHUSIUS, AACHEN 1591

EXIMIAE PERITIAE ALPHABETUM
EXEMPLARIA SCRIPTURAE

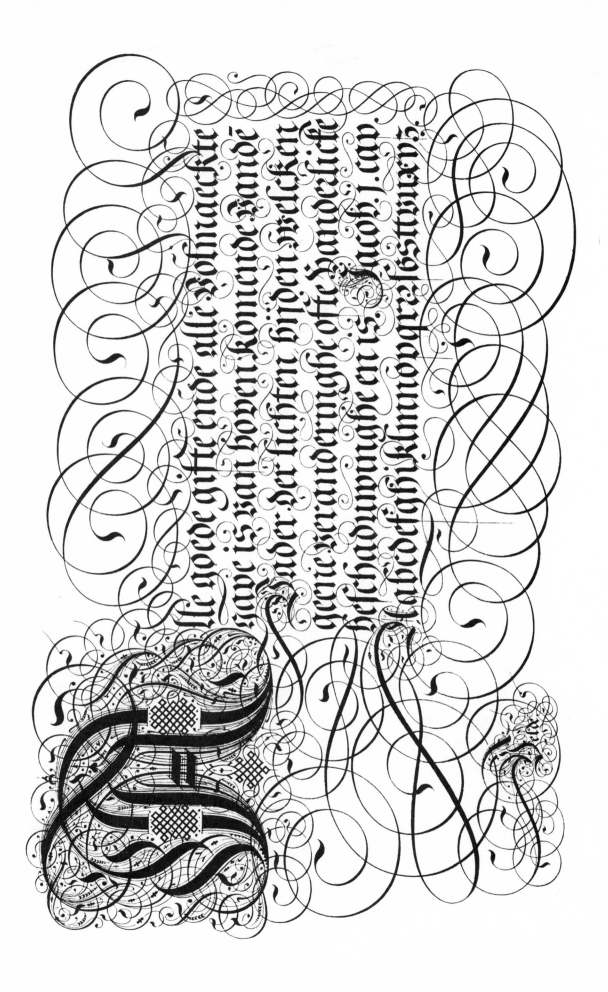

28. VAN DEN VELDE, ROTTERDAM 1605

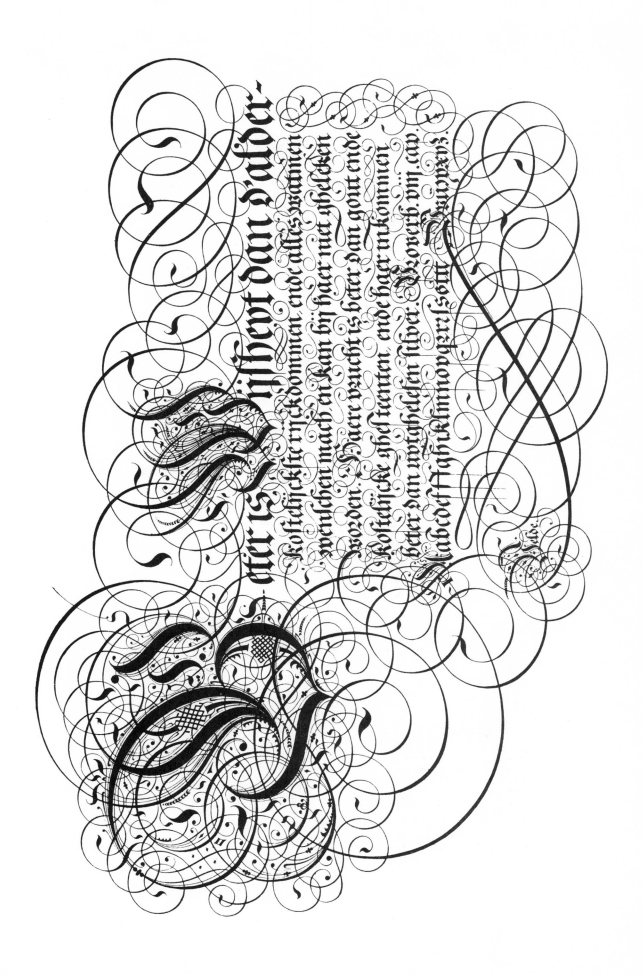

29. VAN DEN VELDE, ROTTERDAM 1605

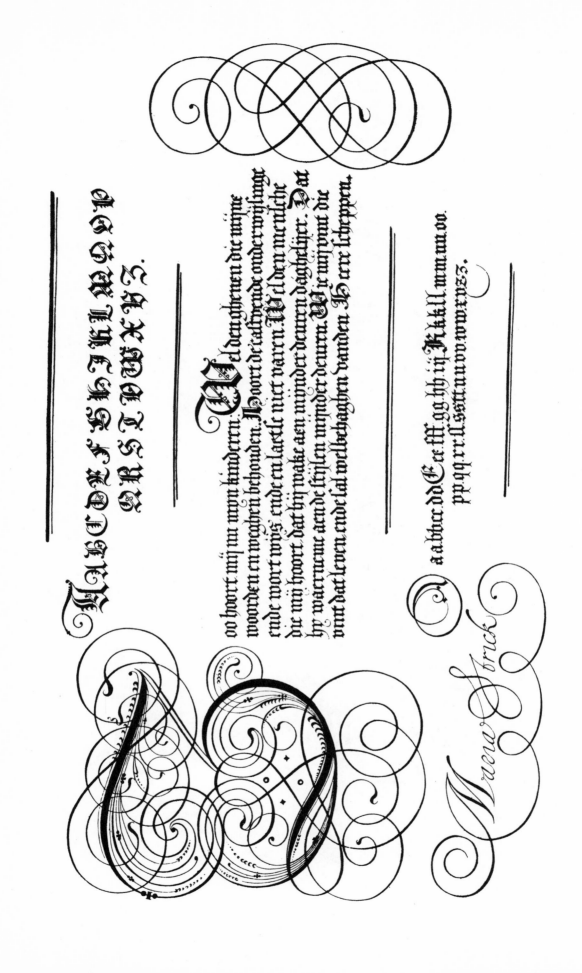

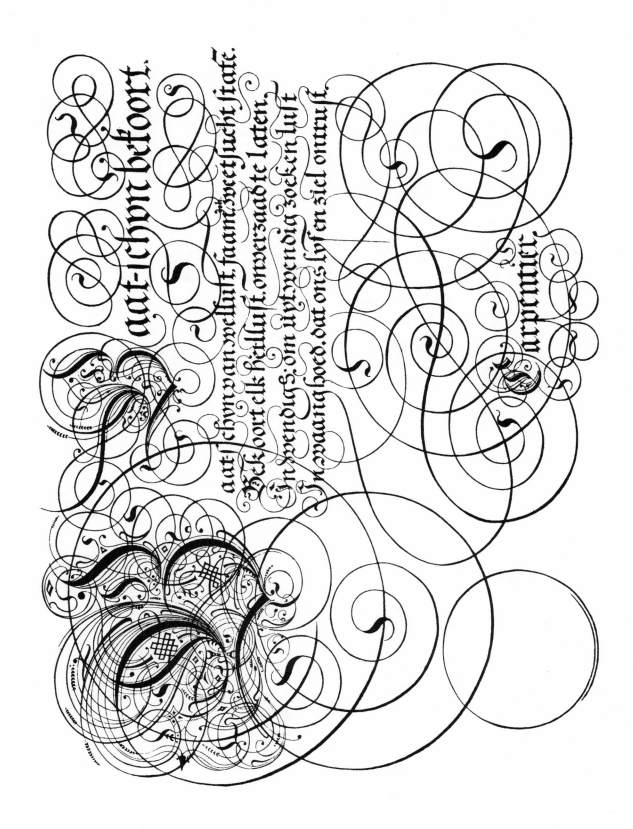

31. CARPENTIER, HAERLEM 1620

ALPHABETUM

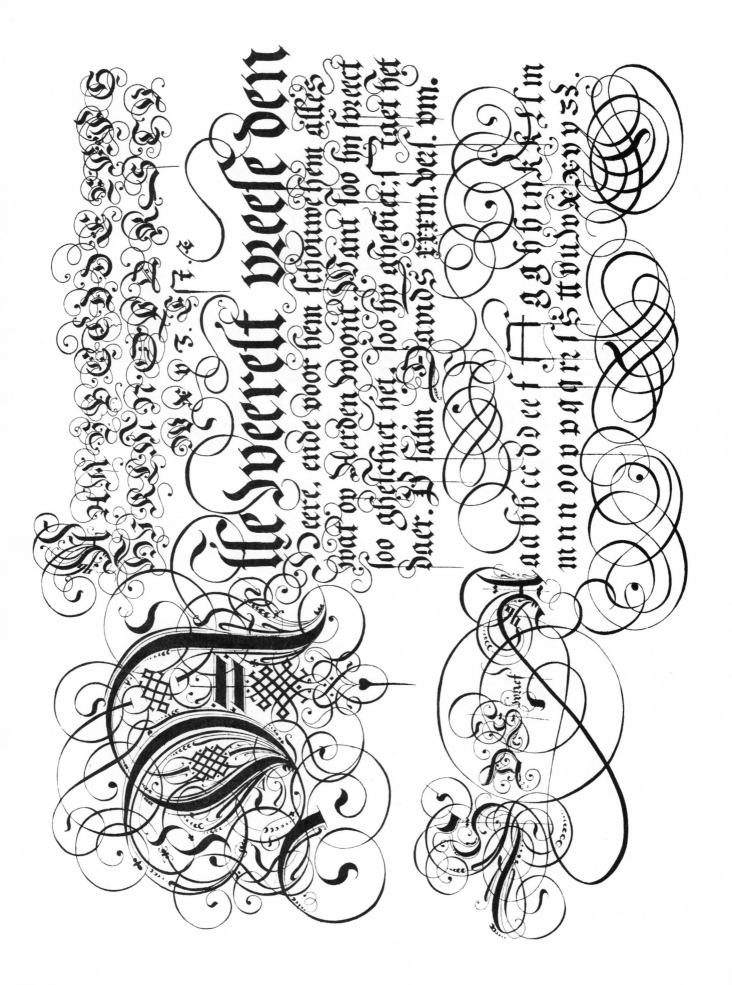

PROEFSTUCK VAN DE SCHRYFKONSTE

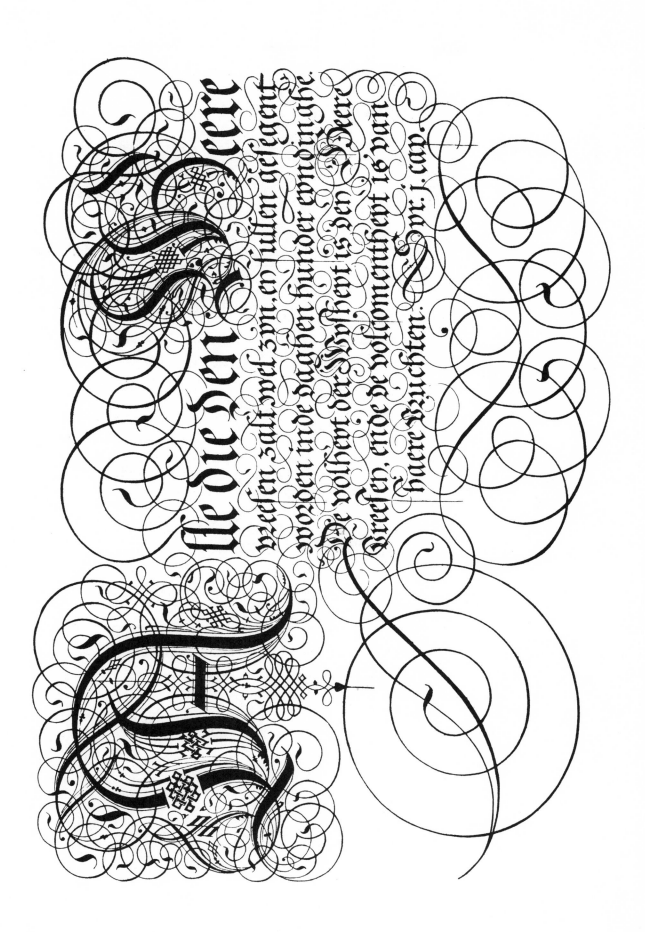

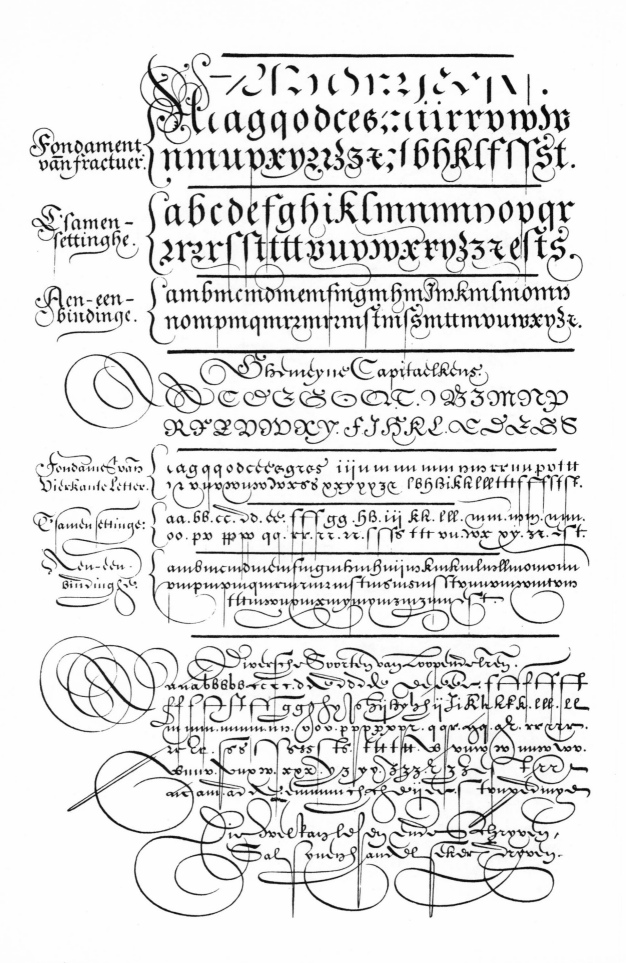

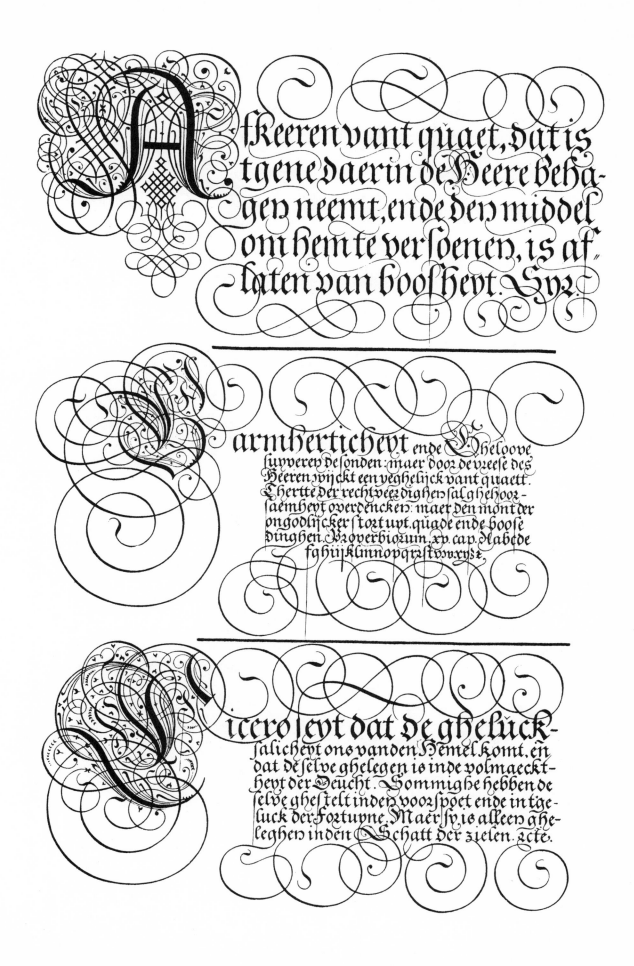

Afkeeren vant quaet, dat is tgene daerin de Heere behagen neemt, ende den middel om hem te versoenen, is af laten van boosheyt. Syr.

Barmherticheyt ende Gheloove suyveren de sonden: maer door de vreese des Heeren wijckt een yeghelijck vant quaett. Thertte der rechtveerdighen sal gehoorsaemheyt overdencken: maer den mont der ongodlijcker stort uyt quade ende boose dinghen. Proverbiorum. xv. cap. Aabcde fghijklmnopqrstvvwxyz.

Ciceroseyt dat de ghelucksalicheyt ons vanden Hemel komt, en dat de selve ghelegen is inde volmaecktheyt der Deucht. Sommighe hebben de selve ghestelt inden voorspoet ende int geluck der Fortuyne. Maer sy is alleen ghelegen inden Schatt der zielen. &c.

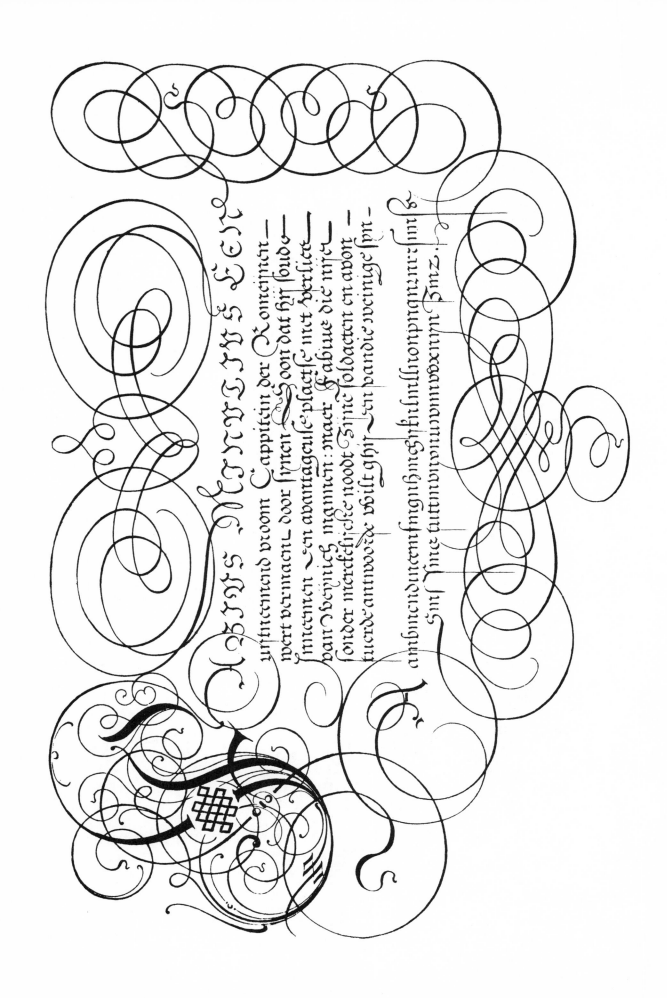

EXEMPLAREN VAN GHESCHRIFTEN

37. BOISSENS, AMSTERDAM CA. 1616 EXEMPLAREN VAN GHESCHRIFTEN

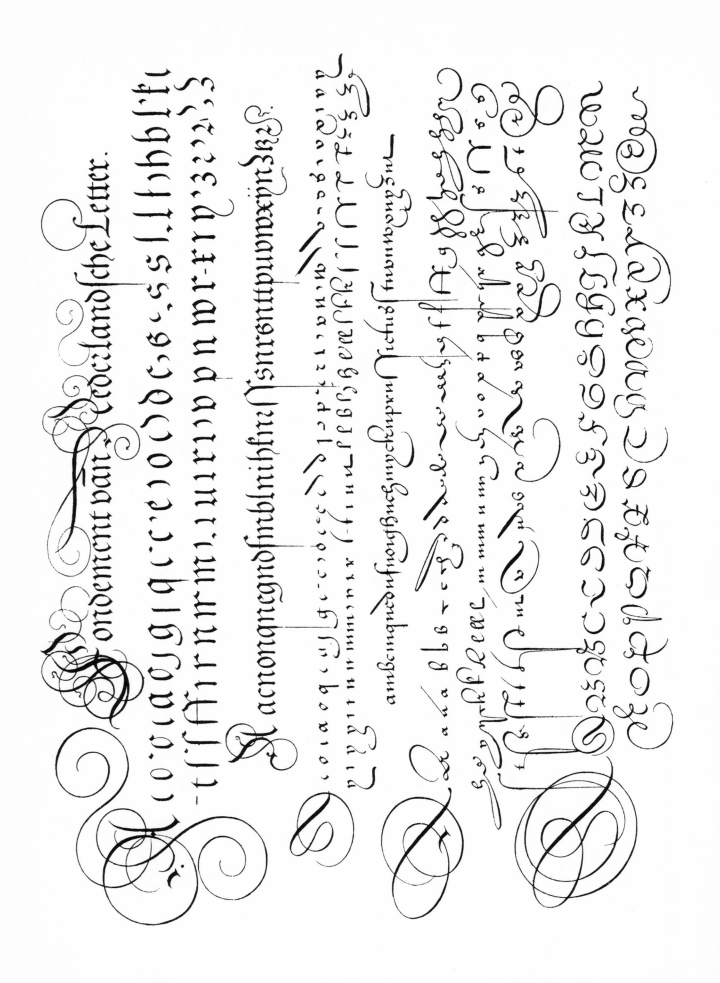

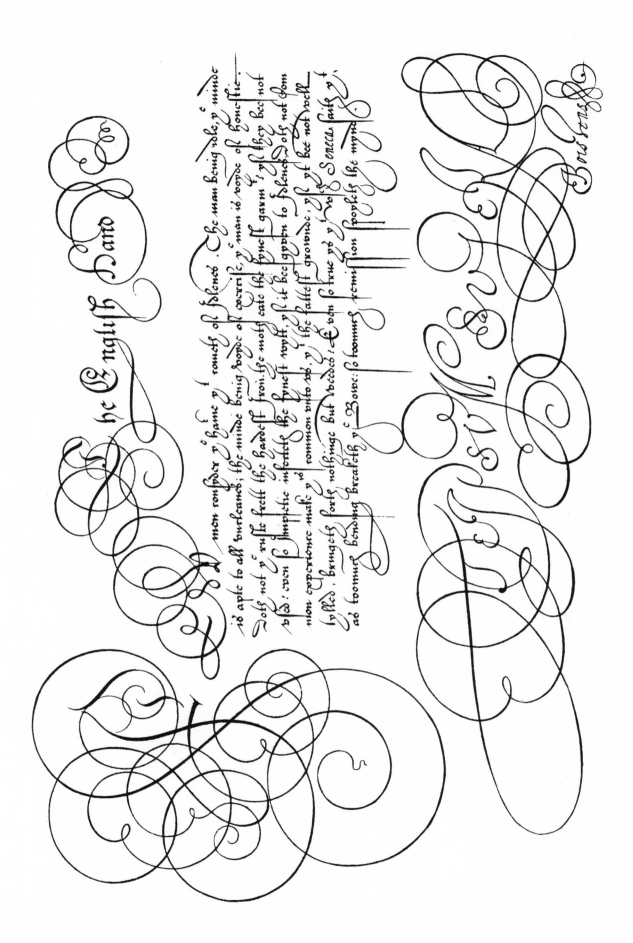

PROMTUARIUM SCRIPTURARUM

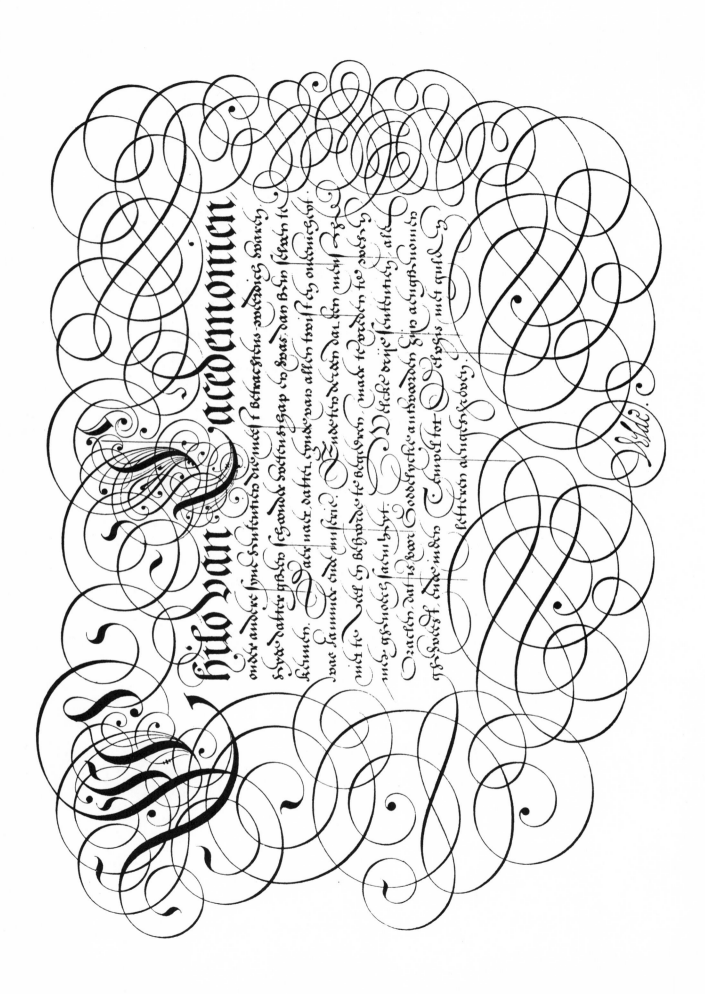

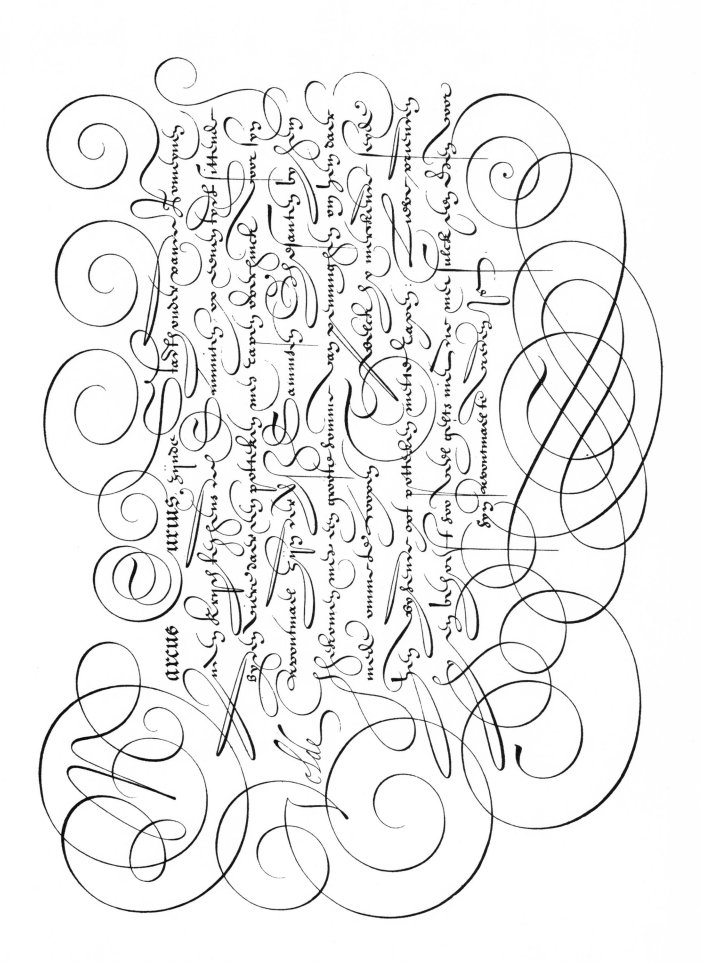

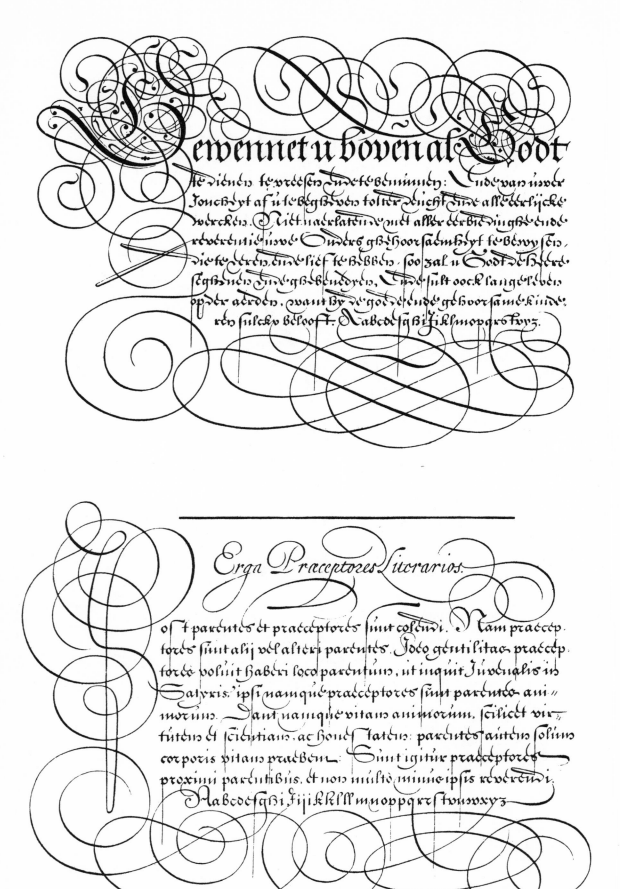

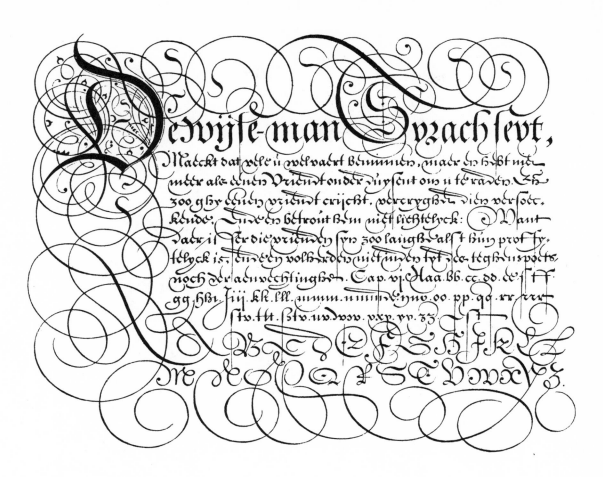

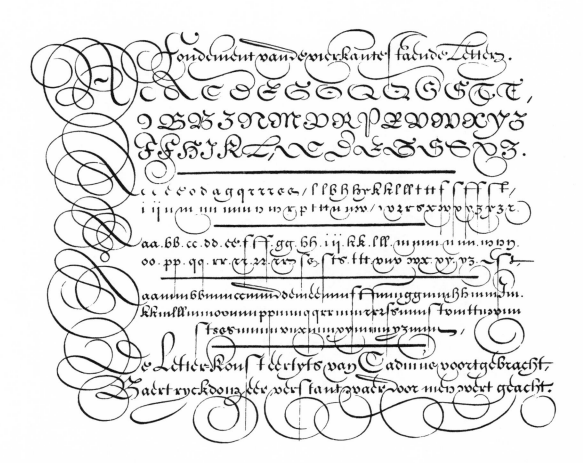

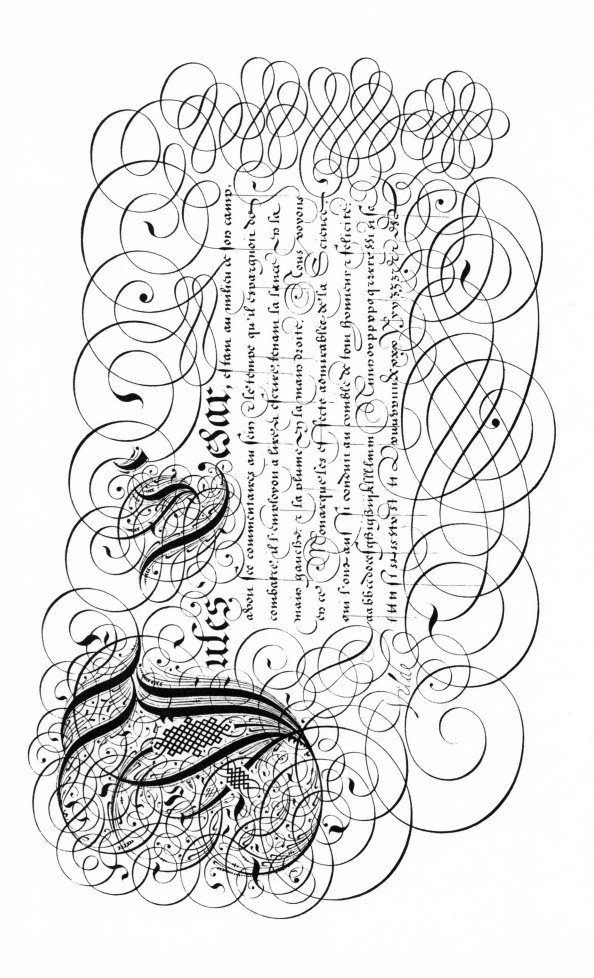

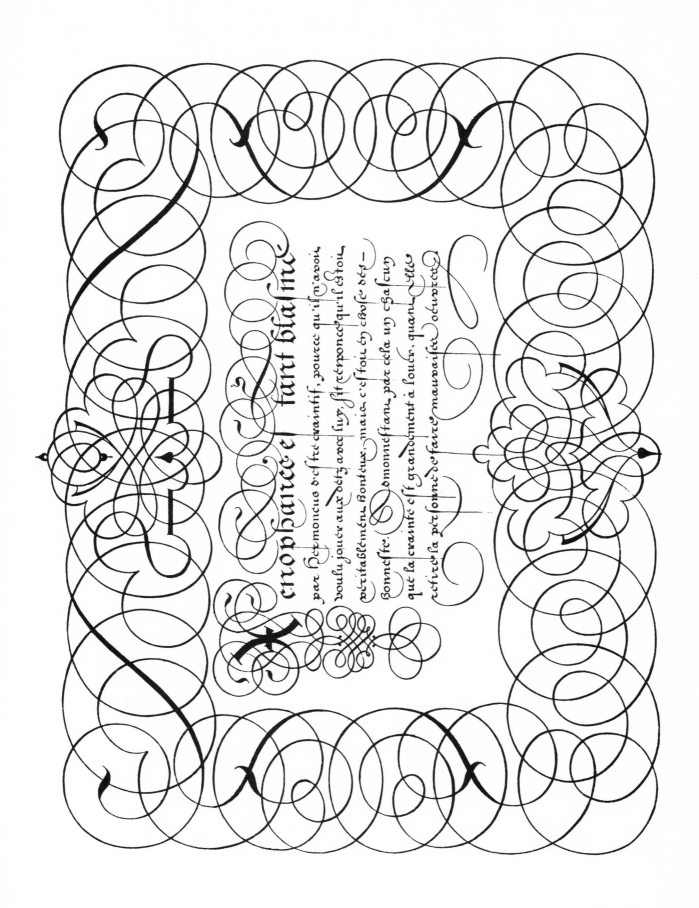

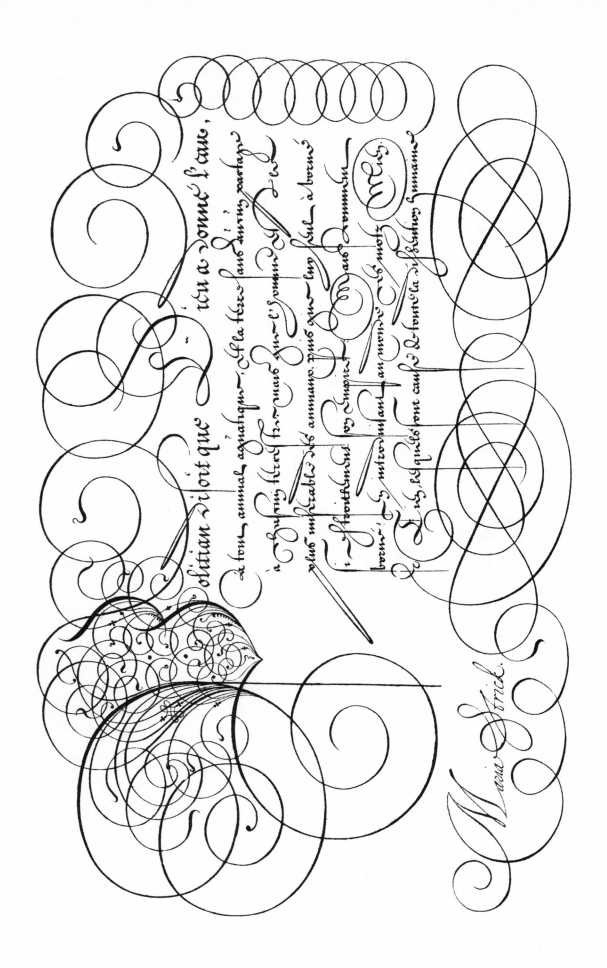

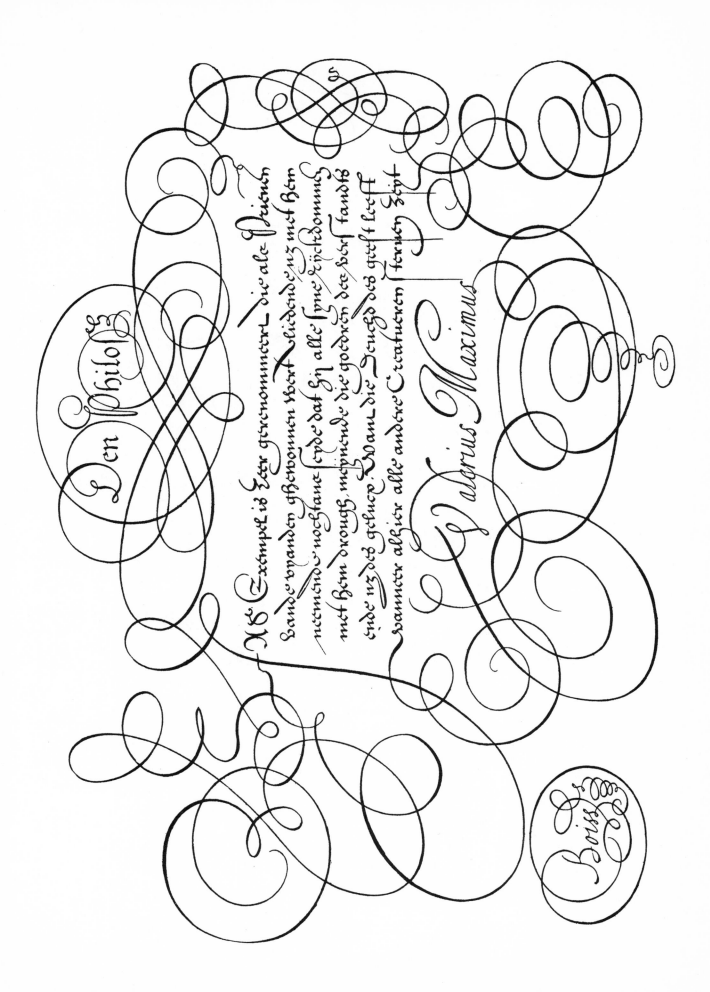

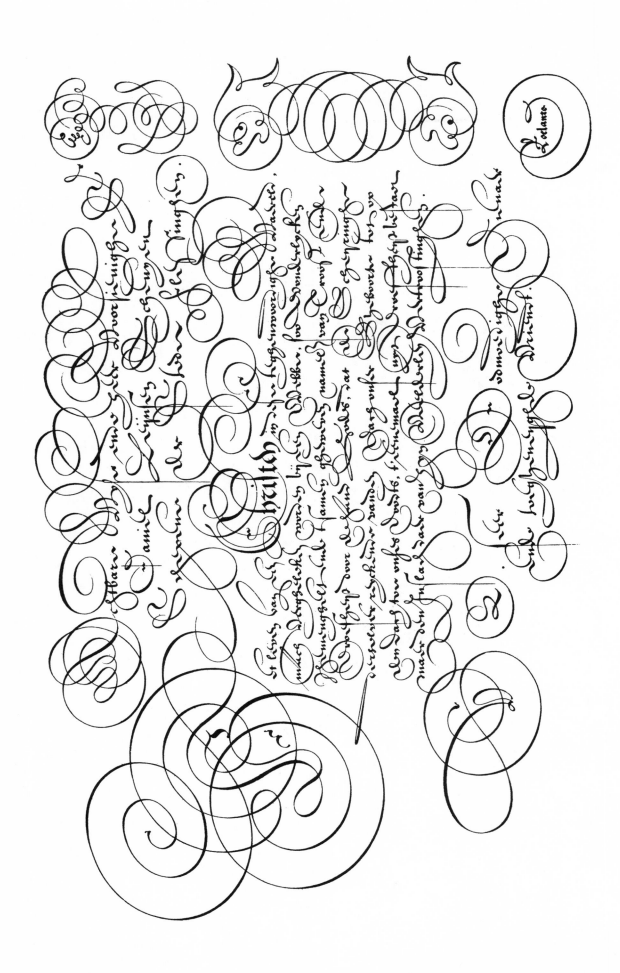

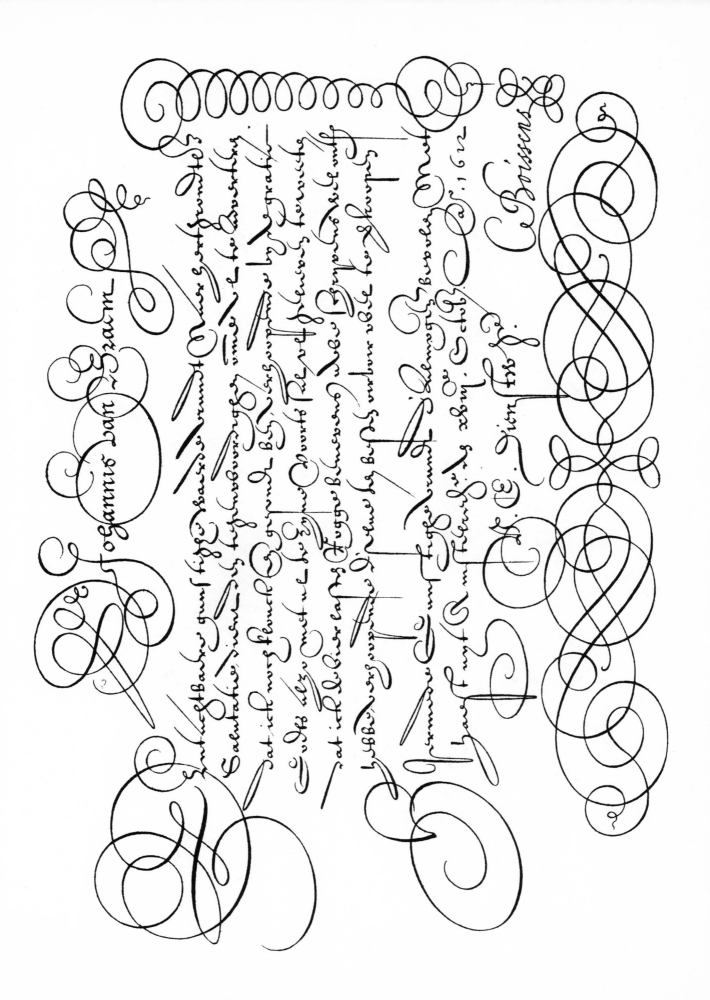

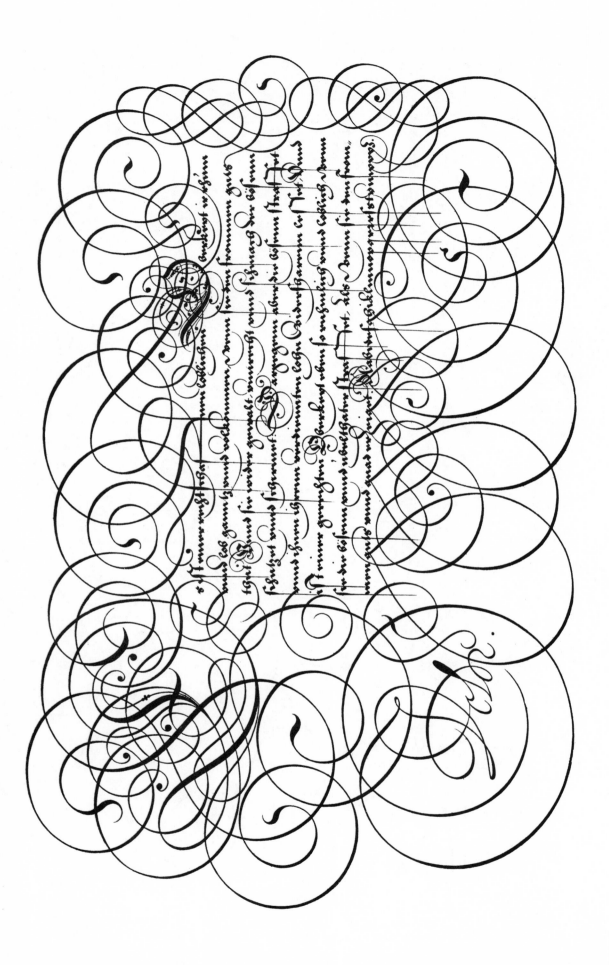

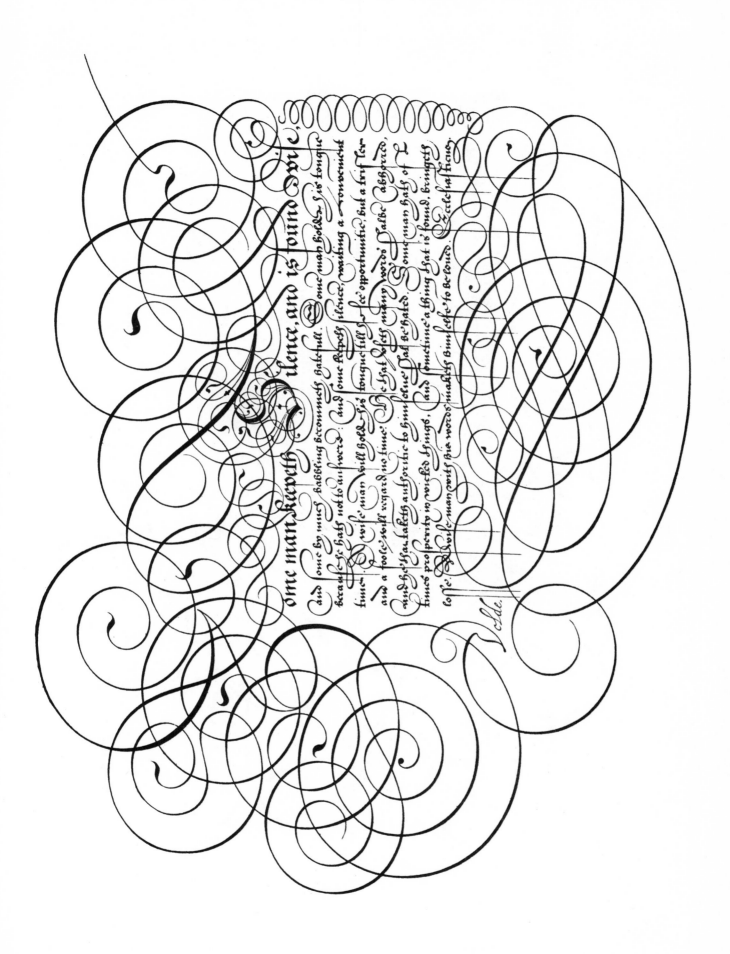

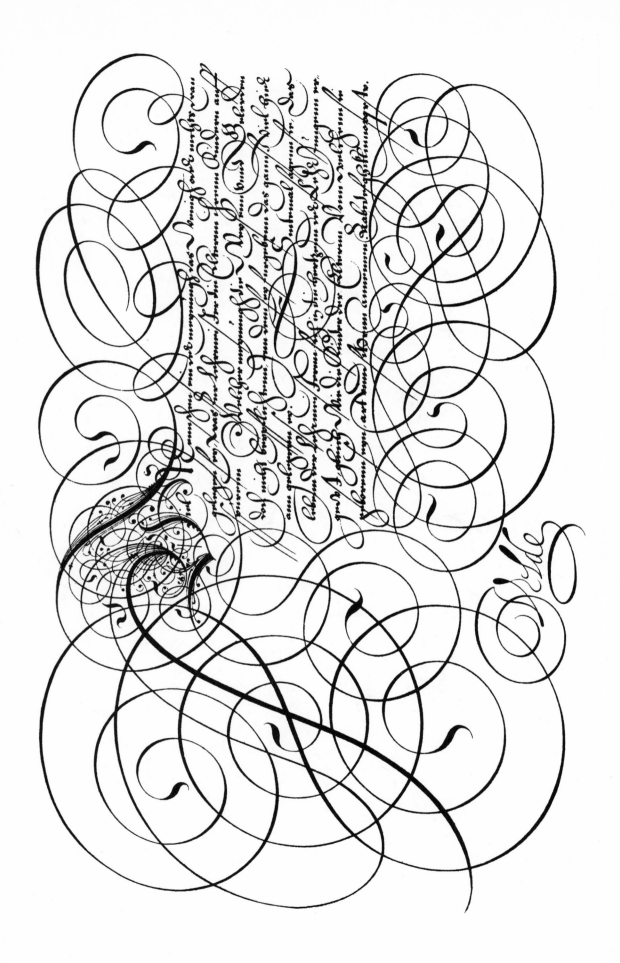

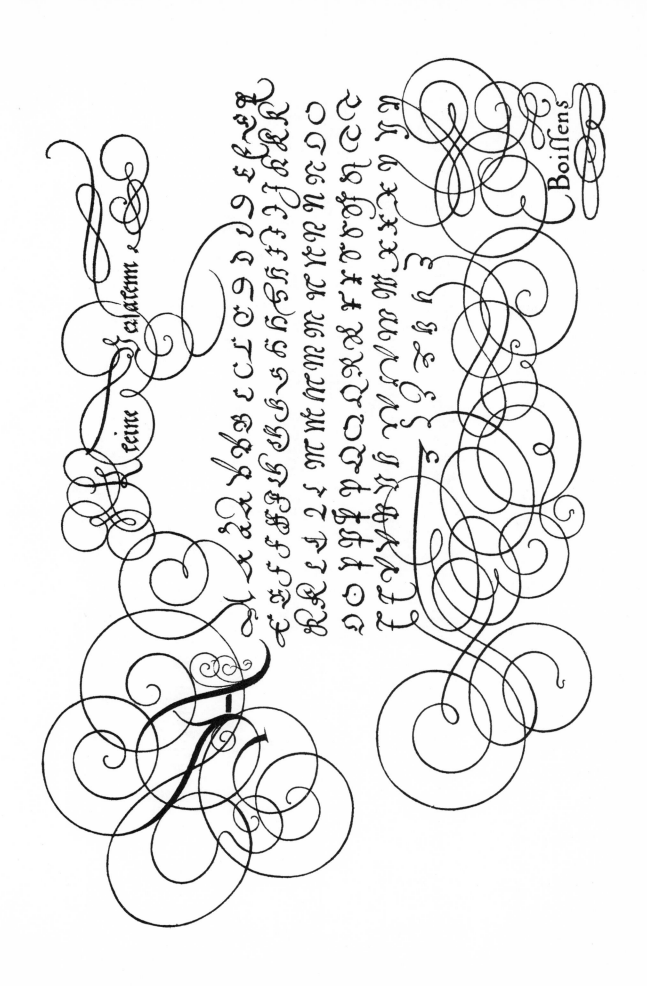

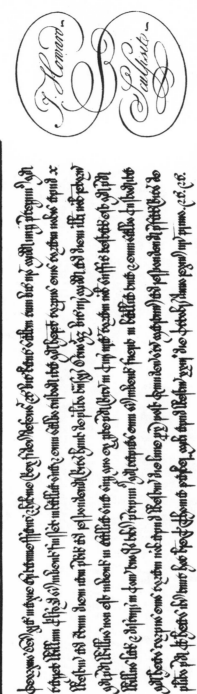
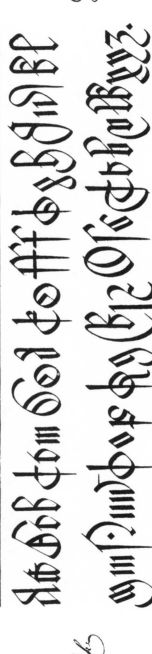

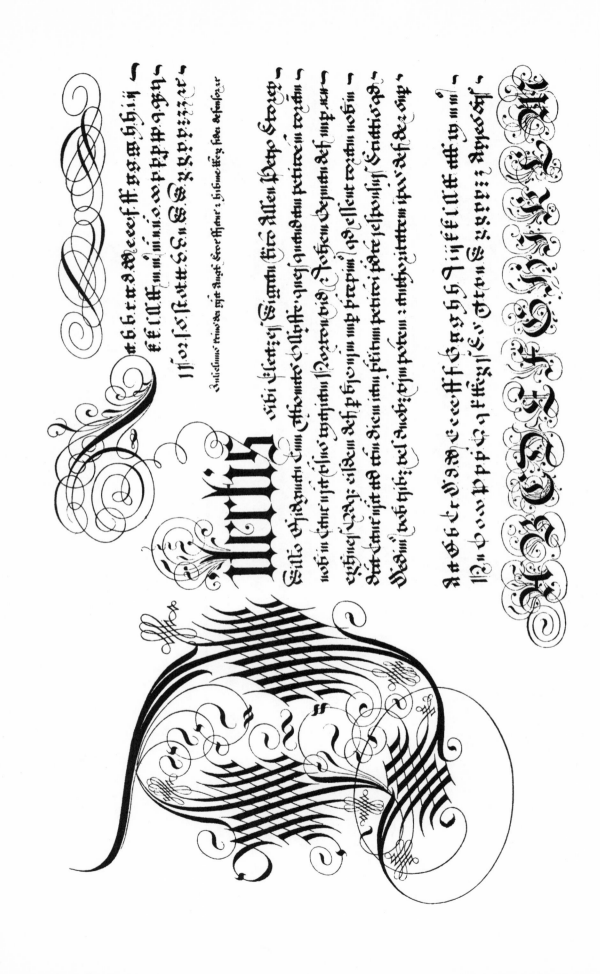

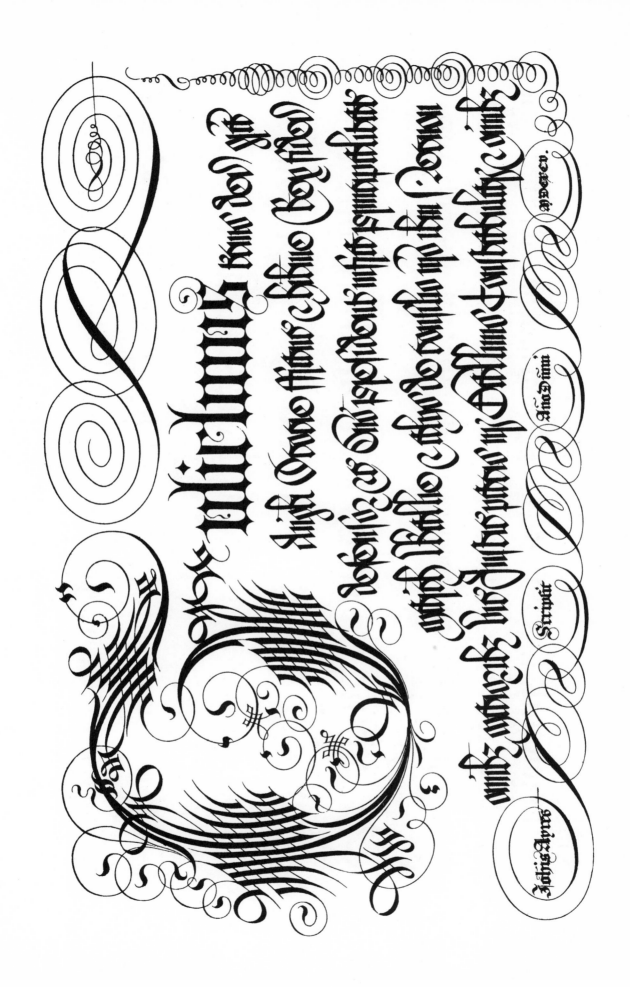

A TUTOR TO PENMANSHIP

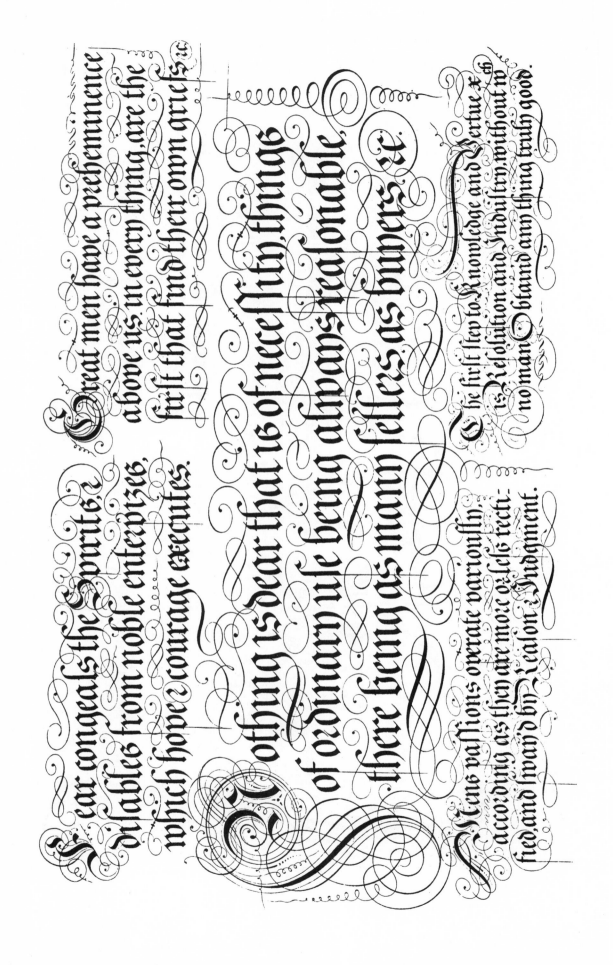

58. SHELLEY, LONDON 1714 THE SECOND PART OF NATURAL WRITING

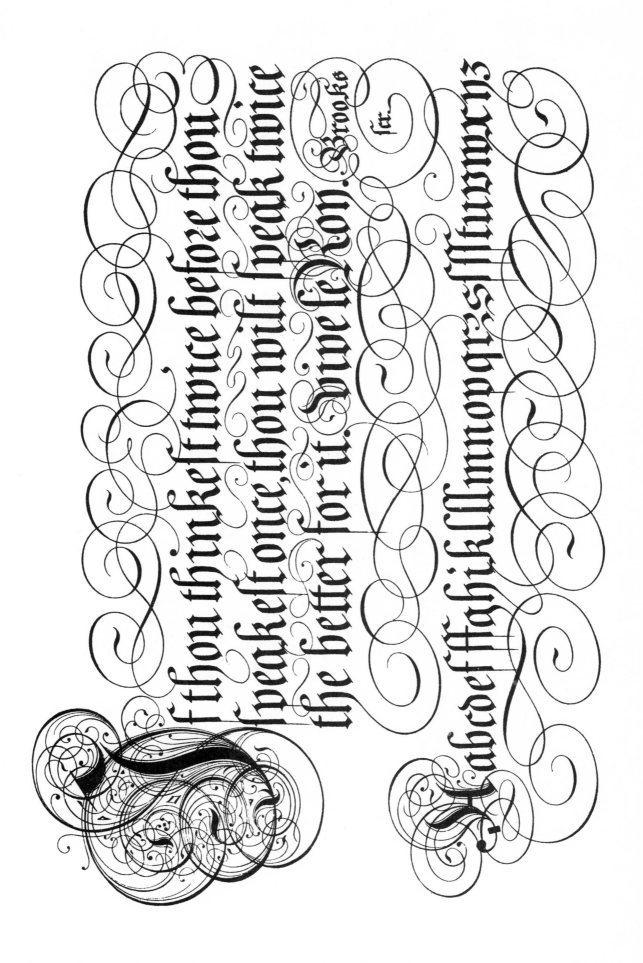

If thou thinkest twice before thou
speakest once, thou wilt speak twice
the better for it. Give Reason.

Brooks
fec.

abcdeffghikllmnopqrsstuuwxyz

A DELIGHTFUL RECREATION

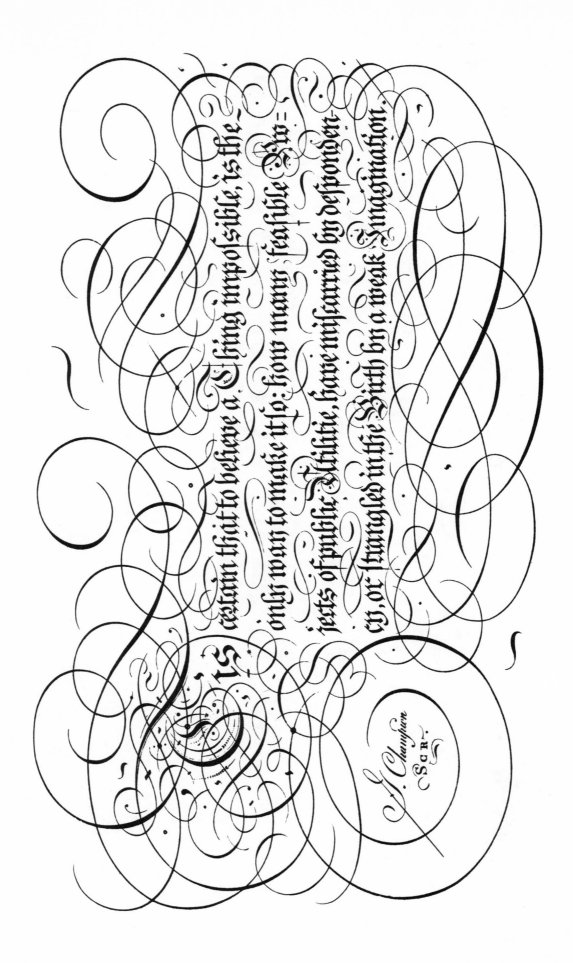

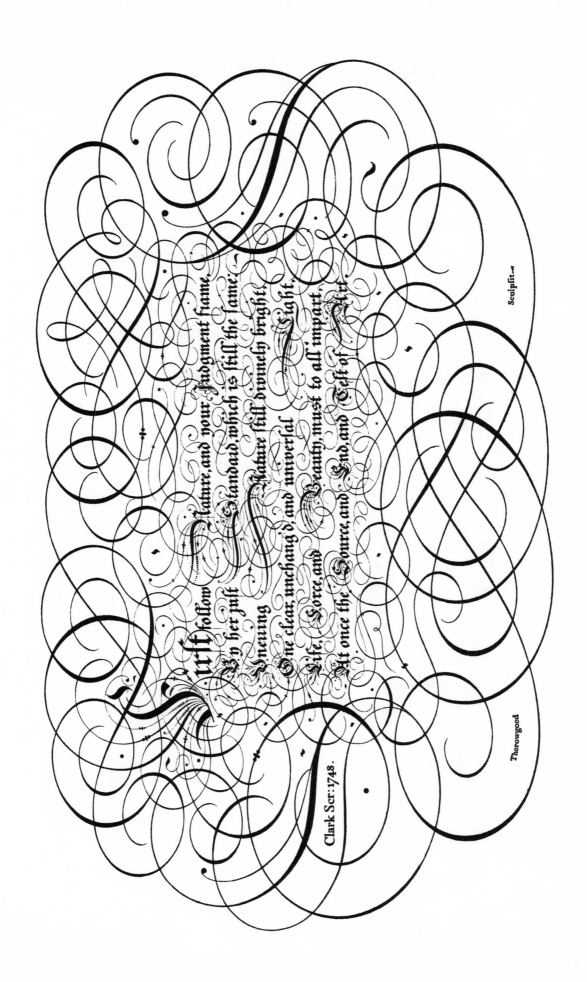

First follow Nature, and your Judgment frame.
By her just Standard, which is still the same:
Unerring Nature still divinely bright,
One clear, unchang'd, and universal Light,
Life, Force, and Beauty, must to all impart,
At once the Source, and End, and Test of Art

Clark Scr: 1748.

Sculpsit

Thorowgood

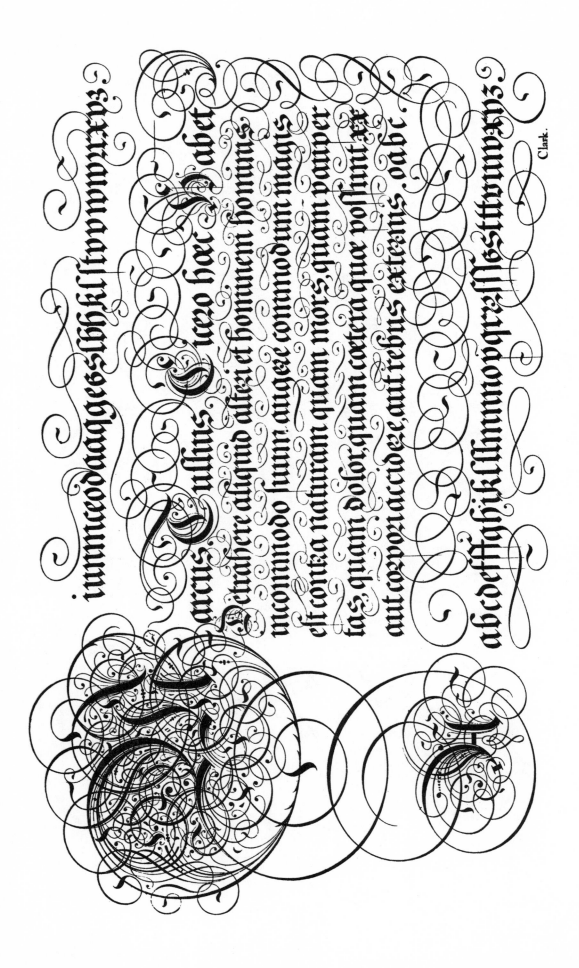

WRITING IMPROV'D

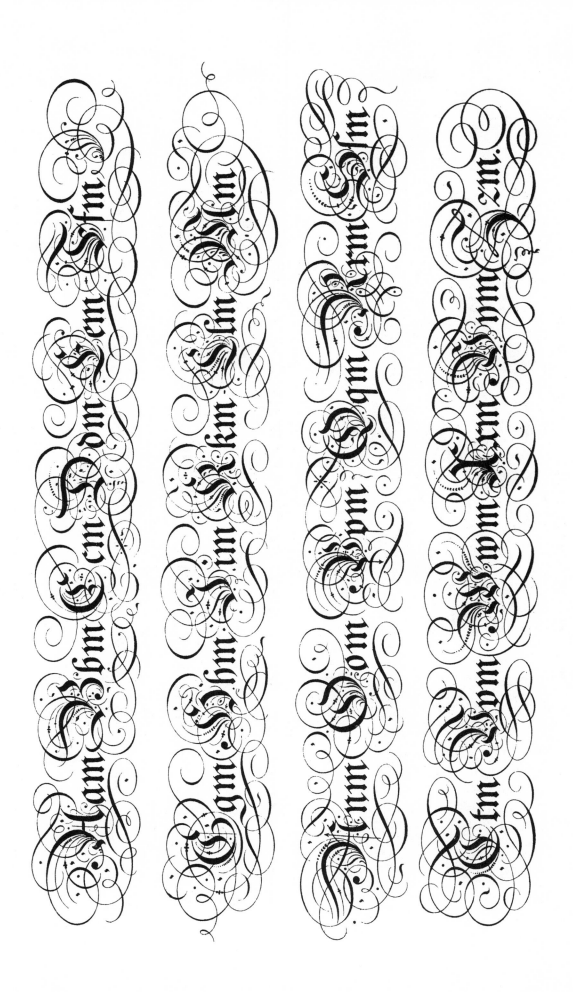

63. RICHARD CLARK, LONDON 1758

THE SECOND PART OF

An Essay in Writing.

Exemplified in the several Hands, and Forms of Business;

With a grand piece of German Text, and

A new sett of Running Hand Capitals, & Examples, &c.

WRITTEN

By the late eminent Mr. John Bland.

And carefully Copied from his admired Remains, found in the Collections of the Curious.

A. HOWARD

London, SCULPSIT.

Printed for & sold by Robert Sayer in Fleetstreet, and Carrington Bowles in St Paul's Ch: Yard

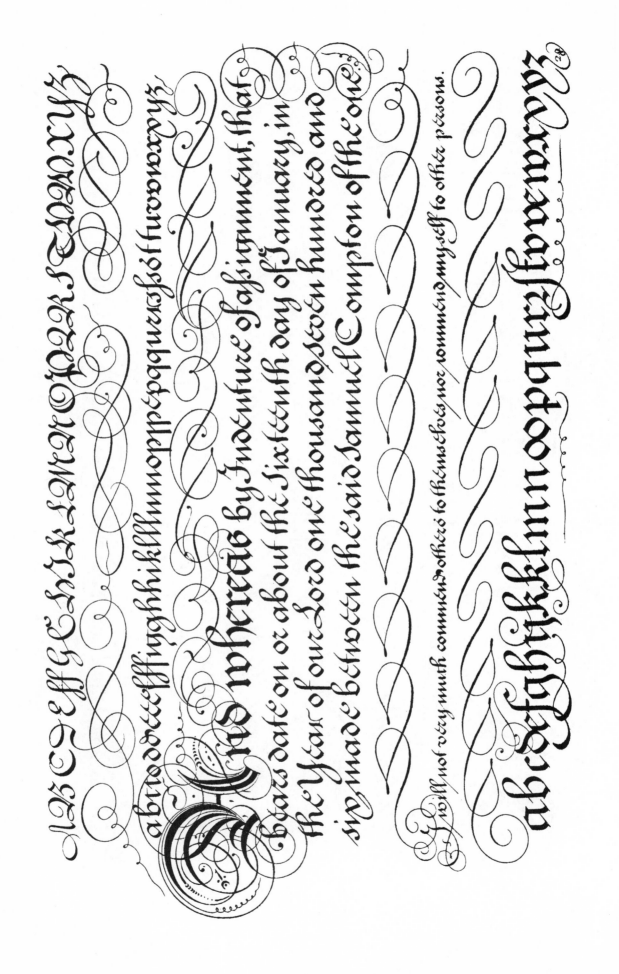

66. SHELLEY, LONDON 1709

NATURAL WRITING

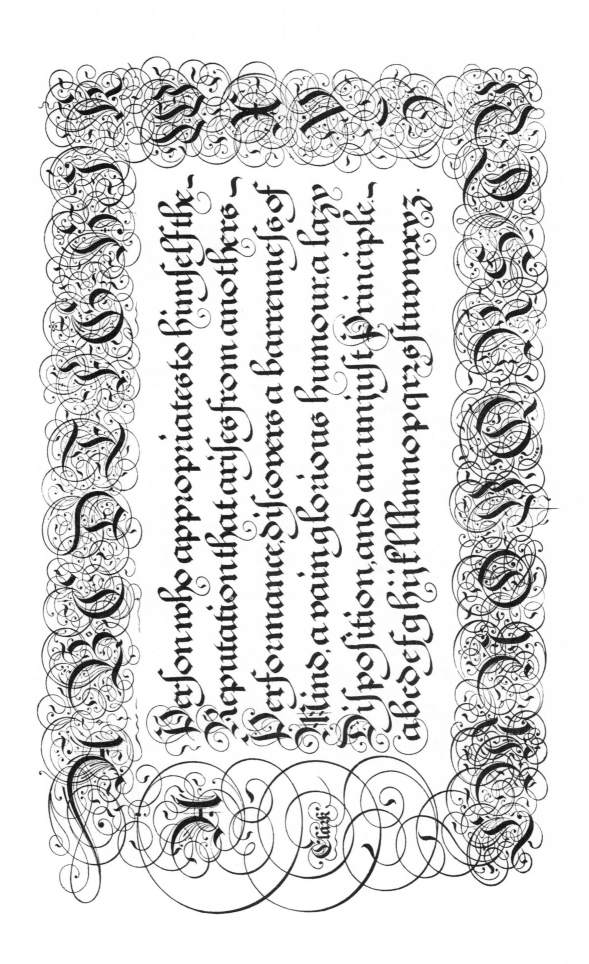

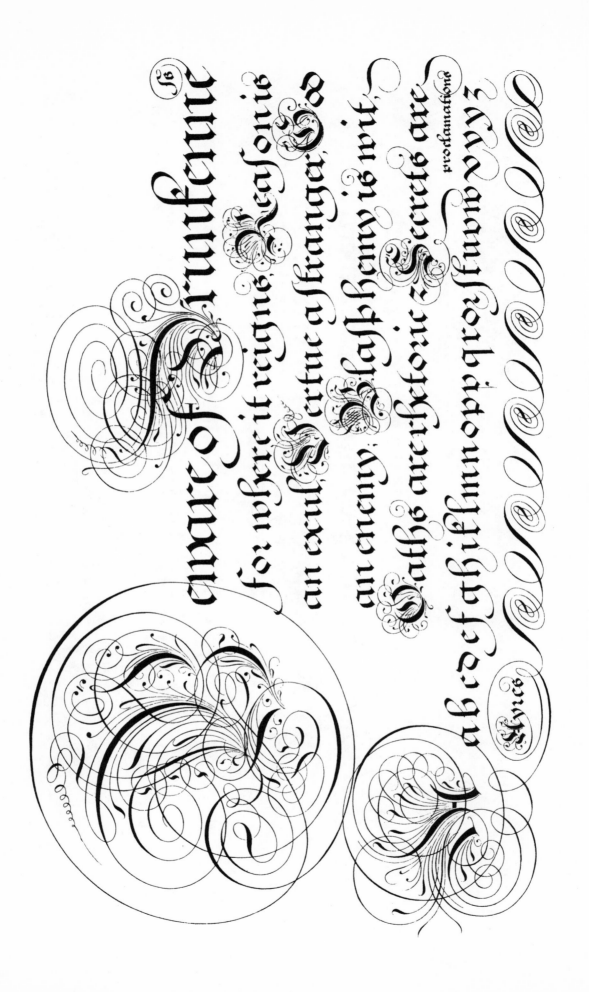

A TUTOR TO PENMANSHIP

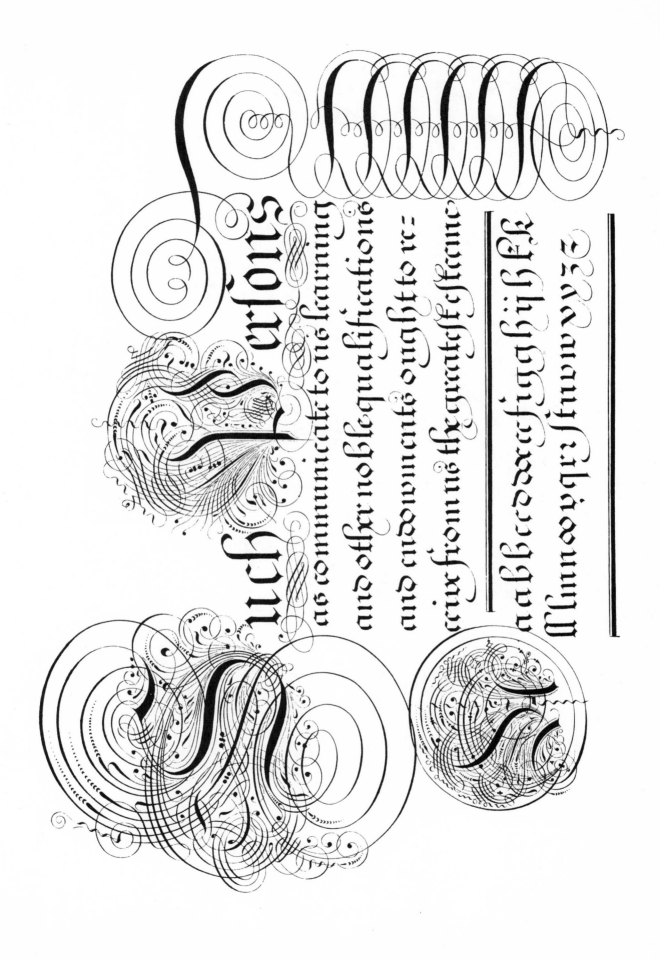

THE ACCOMPLISH'D CLERK

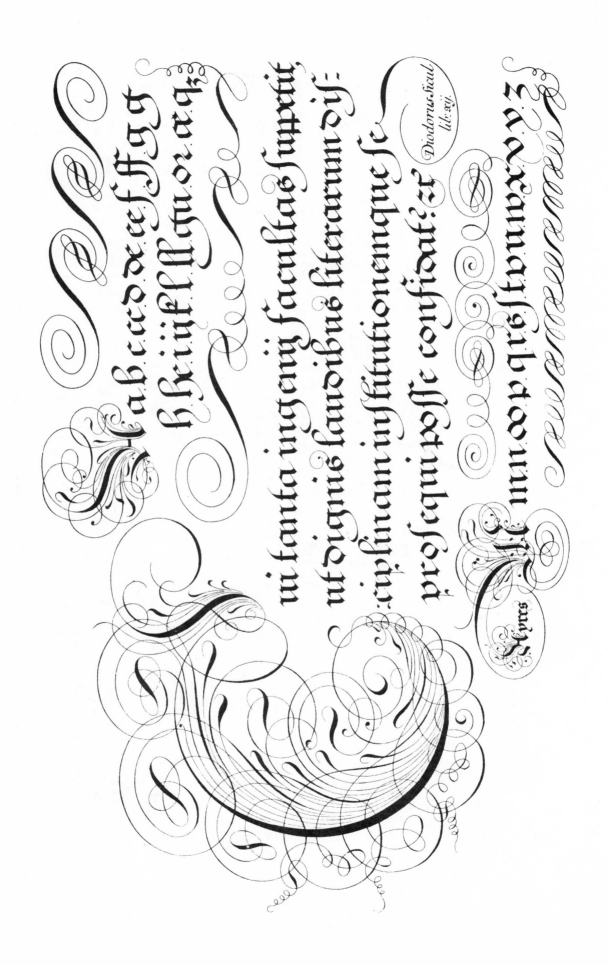

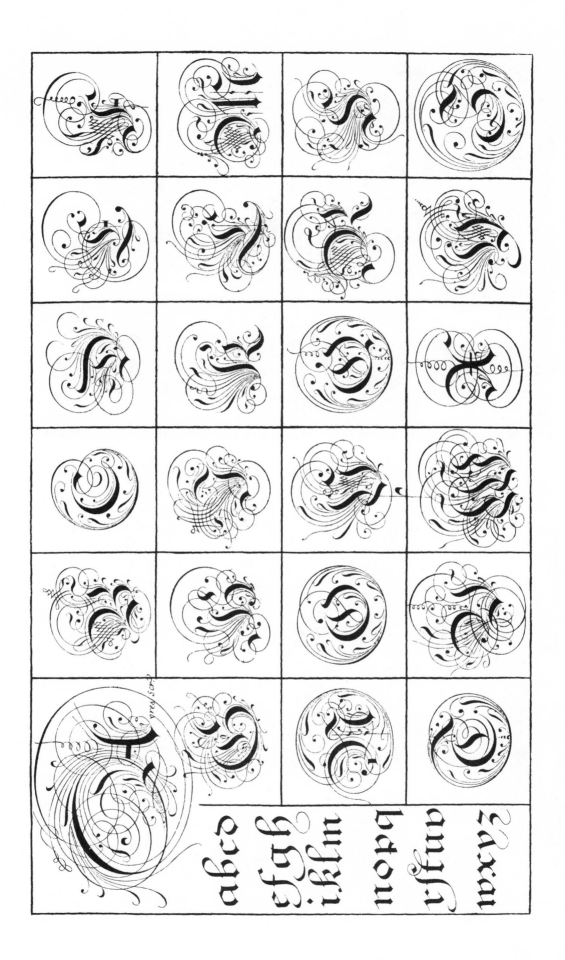

THE ACCOMPLISH'D CLERK

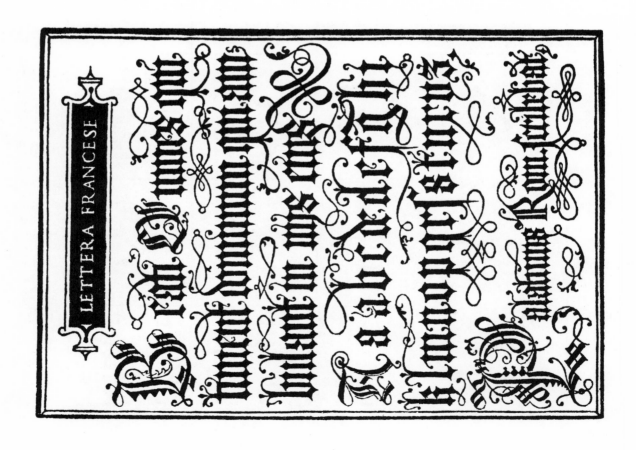

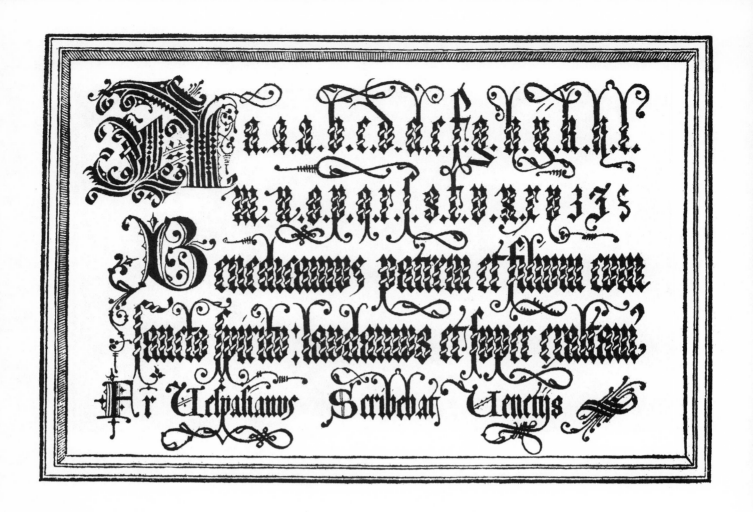

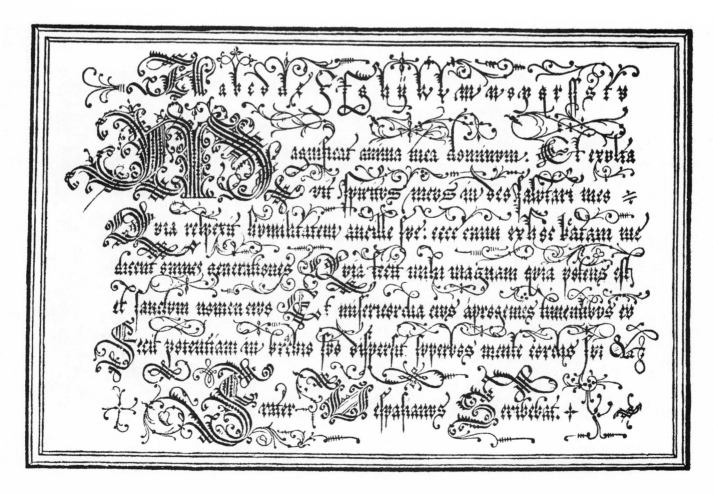

OPERA, NELLA QUALE S'INSEGNA A SCRIVERE

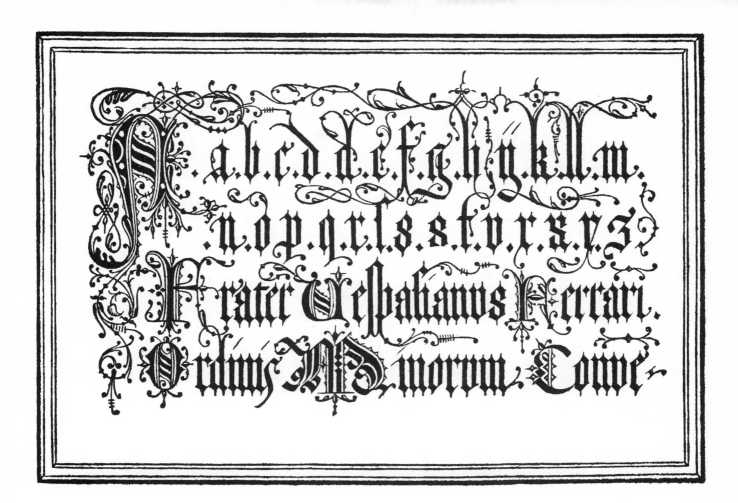

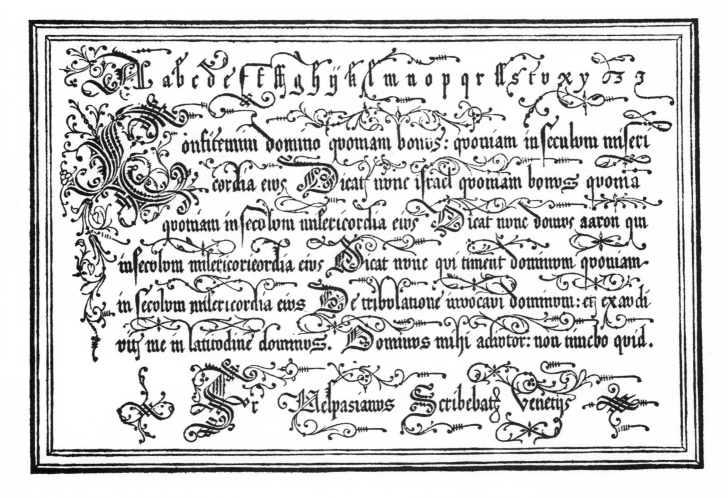

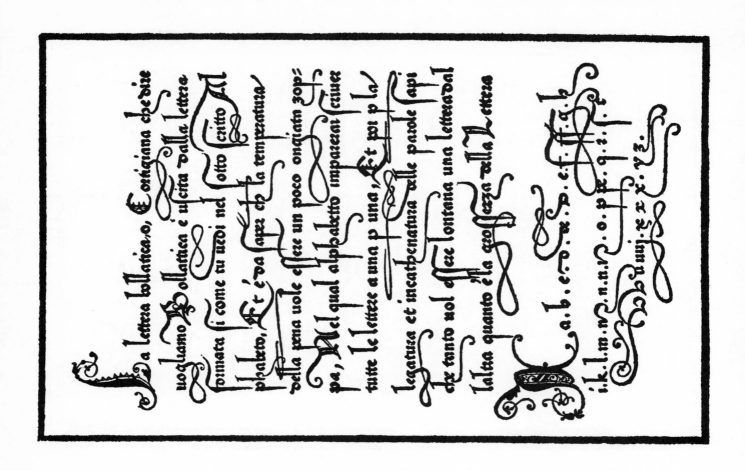

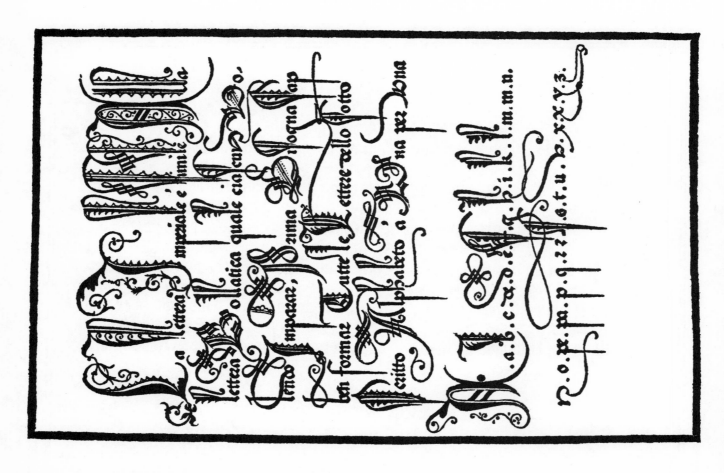

LIBRO, NEL QUAL S'INSEGNA A SCRIVERE

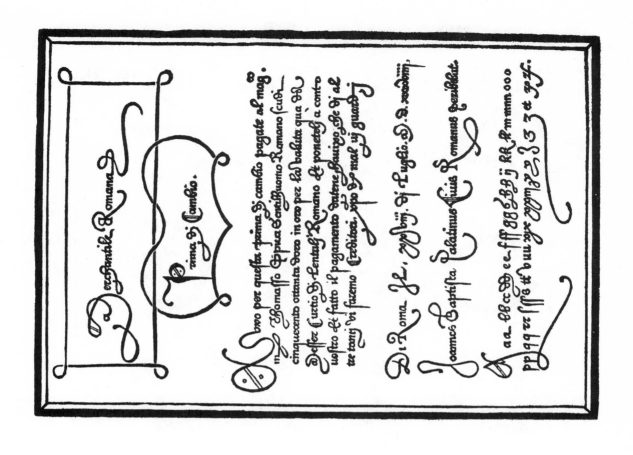

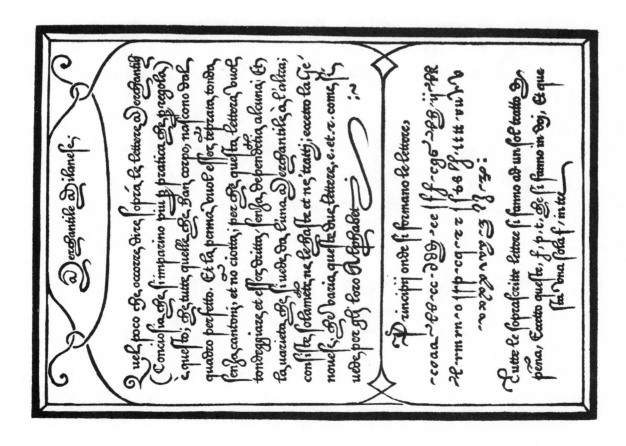

abcdefg

hiklmno

pqrzſstu

vyz.9.ꝣꝭ.

Aſſez demande

qui bien ſert

Lettre Caxxe.

Au commencement que lon commencoit a escrire, lon escrivoit
aux cendres avec le doigt. apres aux escorces d'arbres, aveques cousteaux.
puis sur pierres aveques du fer, sur fuielles de laurice avec pinceaulx,
sur parchemin aveques cannes, maintenant sur papier aveques plumes

a.b.c.d.e.f.g.h.i.k.l.m.n.o.p.q.r.s.z.f.t.u.x.y.z.

LE ESCRIPTVRE
francoyse currant.

En verite en verite. Je vous dy: Se vous ne mangez la chair du fils de l'homme...

Nsi dominus e/
dificauerit do/
mum: in uanum la
bozauerut qui edifi
cant eam . Crescius.

Aaabcddefggh
hiykklmmnnoo
ppqqzrrfsttuv
xxyyzʒʒʒʒʒ.
ddd. Crescius scrib.

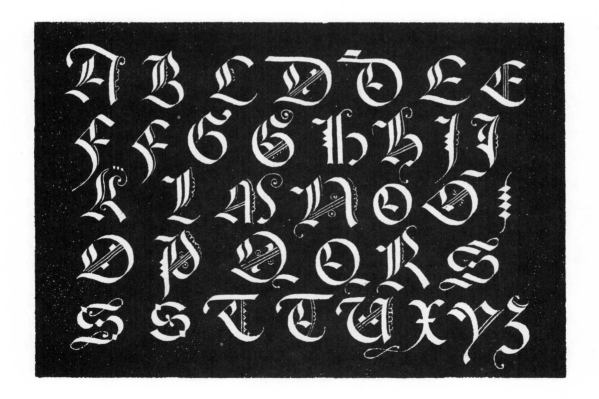

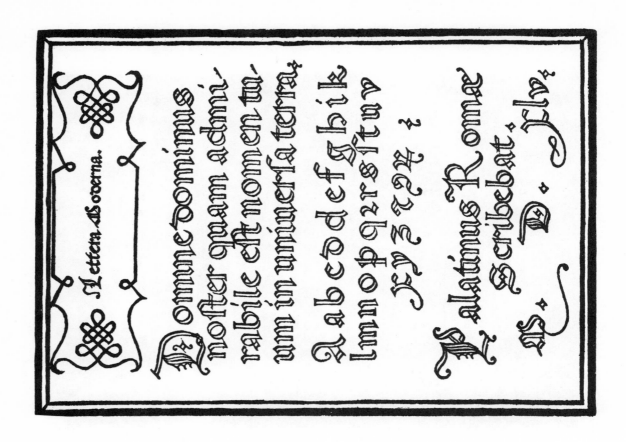

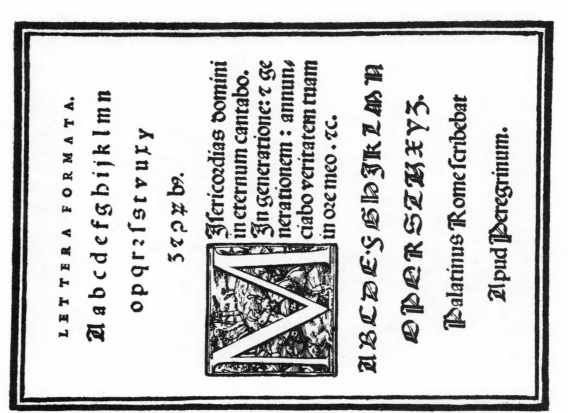

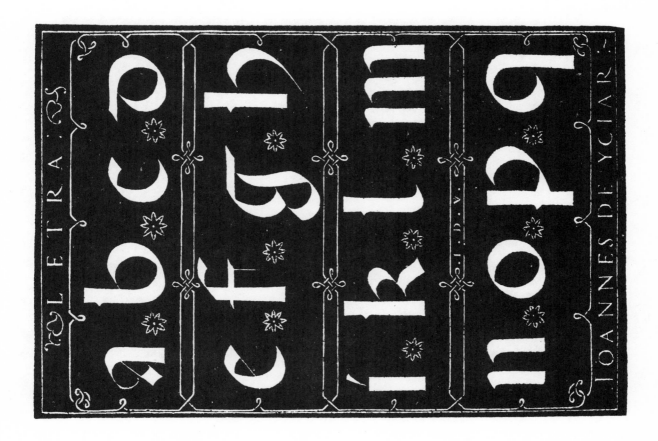

87. YCIAR, ÇARAGOÇA 1548 RECOPILACION SUBTILISSIMA

88. CRESCI, ROMA 1560 IL PERFETTO SCRITTORE

PReparans montes in uir;
tute tua, accinctus poten;
tia, qui conturbas profundũ
maris, sonum fluctuum eius.

Crescius scrib:

Aaabbccddeeffgghh
hhiikllmmnnooppq
qrrſſssttuuvvxxyyz
z & & : æ æ ſſ ſſ ff gg gg gg
ſp ſp ſt ſt ę ę æ ffl œ œ tt &.
Crescius Scribebat.

II .

AD NOBILES ET MAGNIFICOS CONSVLES, ET SENATVM POPVLVMQ. LIBERÆ IMPERII VRBIS ET REGIÆ SEDIS AQVISGRANI .

Exemplaria hæc scripturæ, quæ priuato meorum vsui expoliueram, agere inductus sum, vt in pub-
licum euulgarem. quò, non ad me solum, si quis in ijs fructus, sed ad alios quamplurimos redun -
daret. Et hanc opellam meam, visum est dedicare vobis, Viri Prudentissimi. Ad id audendum,
humanitas vestra me impulit: quam in nos exteros æquè ac ciues vestros propensissimam ,
cottidie experimur. Tum & decorum postulabat, vt nata in hac Vrbe, & per otium elaborata ;
iure Senatoribus inscriberem eiusdem Vrbis. Laborem meum haud ostento. & idem alijs antè
tentatum scio, imò perfectum : sed hîc, si pluria dari adfirmem, quâ à scripturæ elegantiâ, quâ
ab imitationis facilitate, non hactenus visa publicè; magis verè dicam quàm arroganter. Habete
igitur à me hoc munus, Viri eximij, tenue quidem, fateor, sed cui precium non à se, spero, faci-
etis; magis ab animo meo: quem reuera Dignitatis vestræ obseruantissimum sine dolo profiteor.
Valete .

Jacobus Houthusius

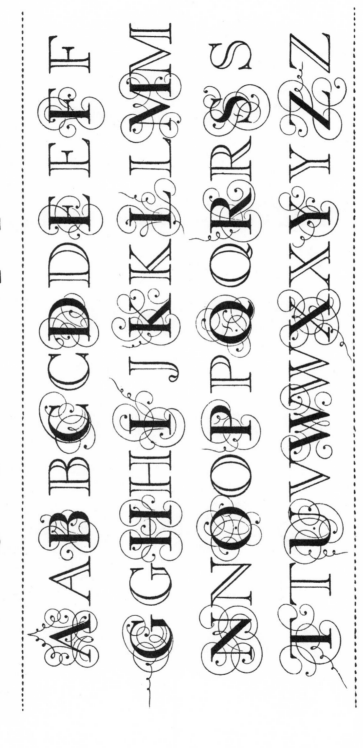

ABCDEFGHIJKLM

abcdefghijklmnop

ABCDEFGHIJKLMN
OPQRSTUVWXYZÆ.
qrfstuvwxyzæœ&

French Cannon

Shelley Scrip.

NOPQRSTUVWXYZ.

NATURAL WRITING

A B C D E F G H I K L M

IVINUM MIRACULUM

certè vt exxxiv. notis & interdum apud aliquas nationes
paucioribus, infinita vocabula mentes diversæ, contraria:
actus omnium hominum & ipsæ cogitationes possint efficacius
& perfectius quam ipsa pictura repræsentari: fiuntque scriptu-
ræ ad perpetuam rei memoriam: conservat enim scriptura
quæ hominis memoria non potest complecti. Petrus Gregorius.

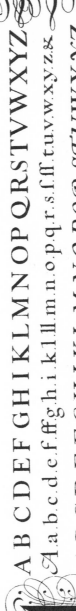

A B C D E F G H I K L M N O P Q R S T V V W X Y Z
A a b c d e f ff g h i k lll m n o p q r s fff t u v w x y z &
A B C D E F G H I K L M N O P Q R S T U W X Y Z
A a b c d e f ff g b i j k k l ll m n o p q r ff fft t u v w x y y z & &.

N O P Q R S T U W X Y Z

aalmente si comprendeno gli intimi precordij delli buomini confabulando seco, dalli cottidiani ragionamenti, dalli loro mouimenti & da altre mille soprauenienti occasioni. Onde gli sapientissimi, & esperimentatissimi Philosophi insegnorono alla posteritade questi documenti, per ilche obligatissimi sempre dobbiamo essere alle memorie loro imitando con ogni nostro studio et diligentia vigilantissimamente, quanto quelli s'affaticorono scriuere, à nostro beneficio, ornamento & perpetua vtilitade, Et cosi fuggiremo ogni nota de ingratitudine gle si attribuisse alli obliuio.

Humanissimo & osseruandissimo. S. mio, Tra tutti gli deuoti serui di V. Rz. S. ig. ma Vespasiano Amphyareo Ferrarese Minoritano Conuentuale, porta scolpita nelli intimi precordij la uostra diuinissima imagine, et con animo tutto pieno di religioso affetto, appende alla clementissima sua cortesia, la presente tabula, non altrimete che sogliano quelli che saluati da marittimi naufragij lieti consagrano voluntarij doni alli honorati altari del gran padre Nettuno. Et con piatoso core pregano il terribil Eolo che con piaceuol aura gli riduchi à lor paterni lidij. Et aquella mj Rac.

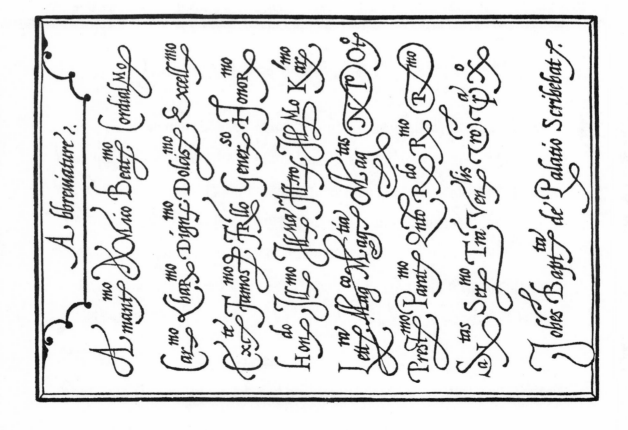

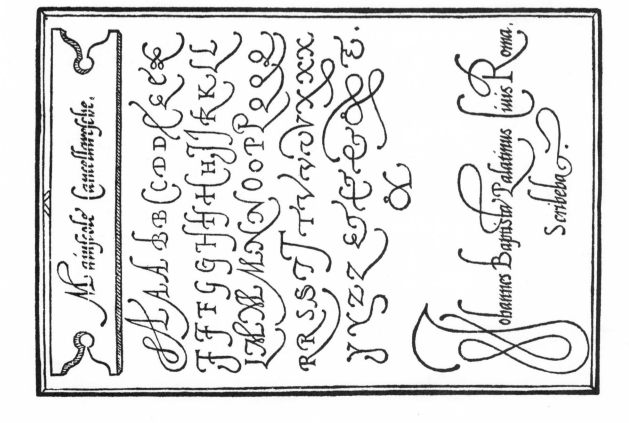

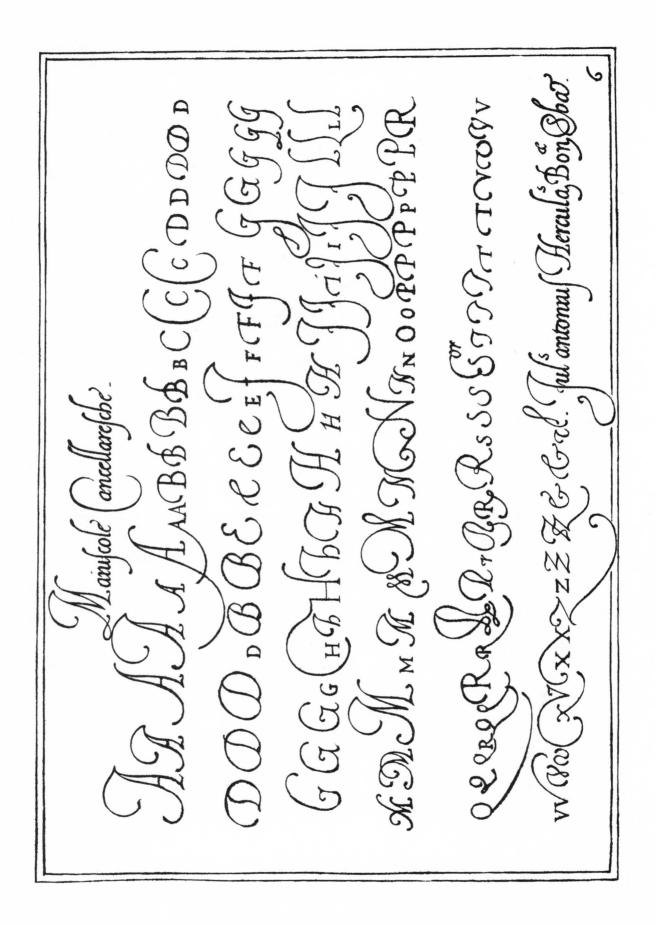

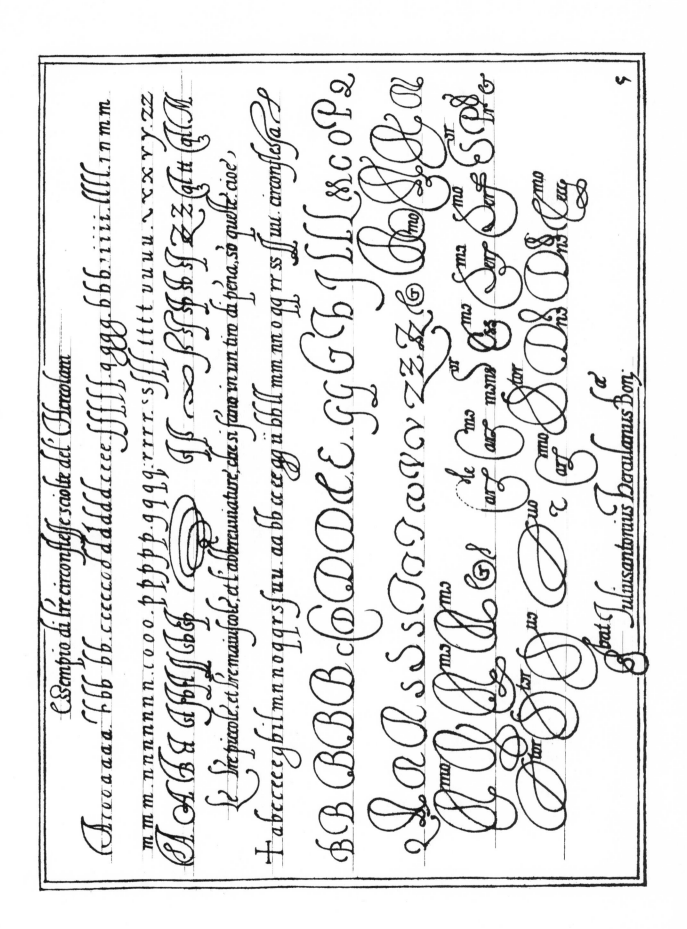

ESSEMPLARE DI LETTERE CANCELLARESCHE

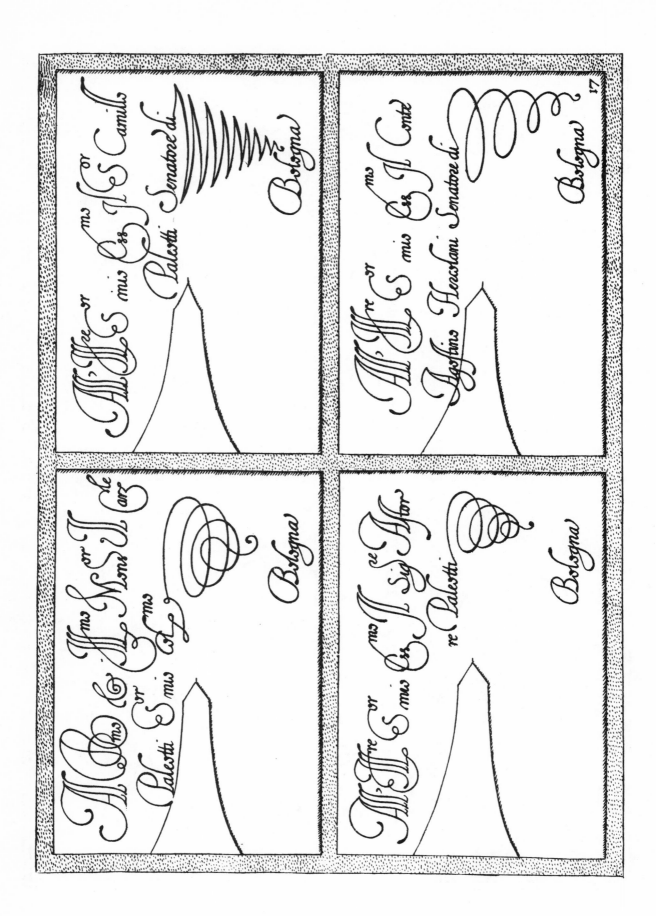

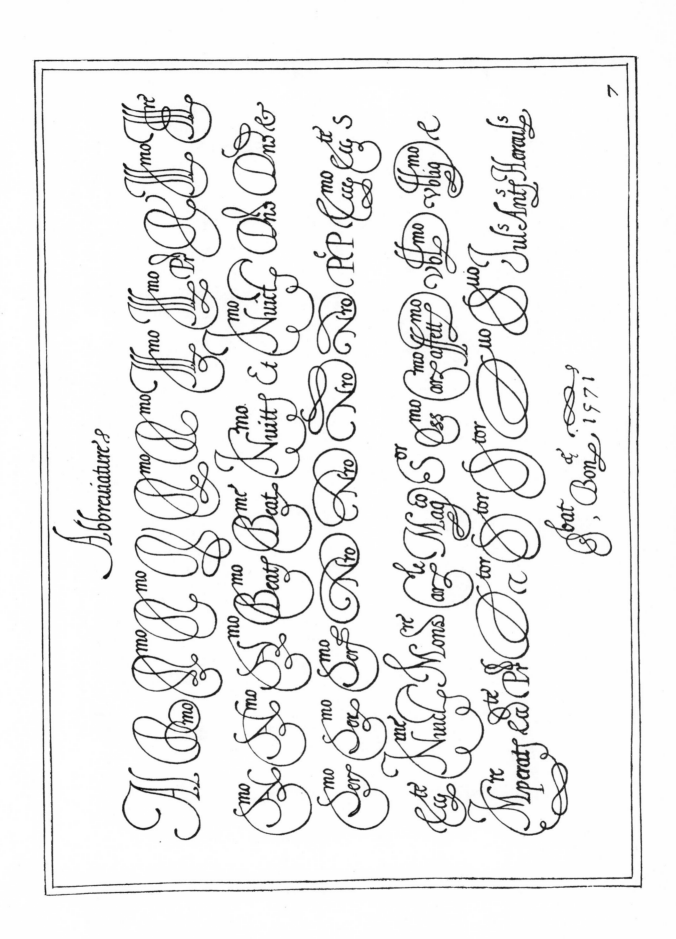

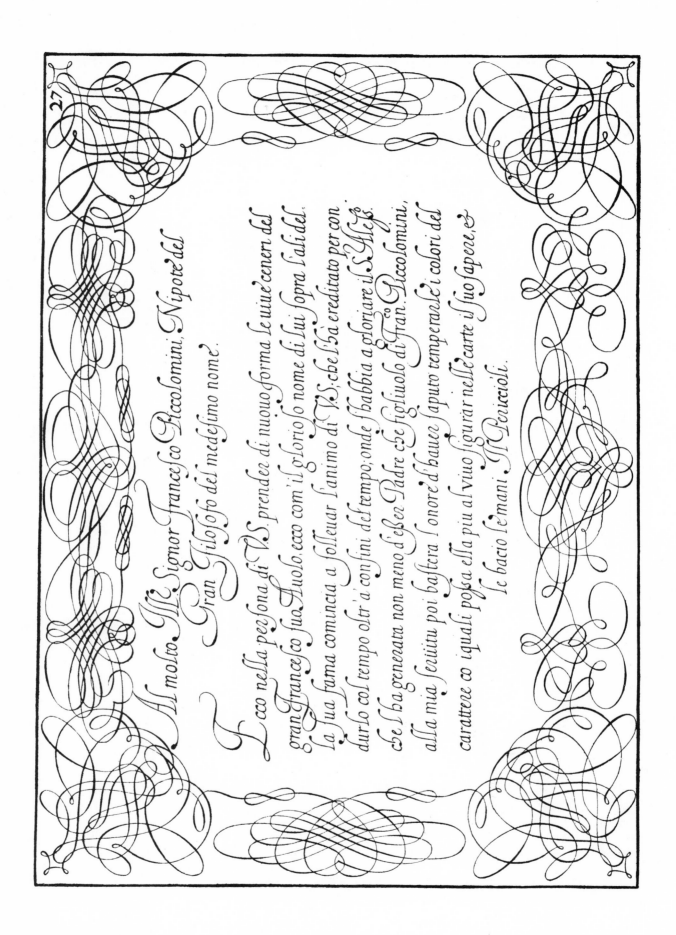

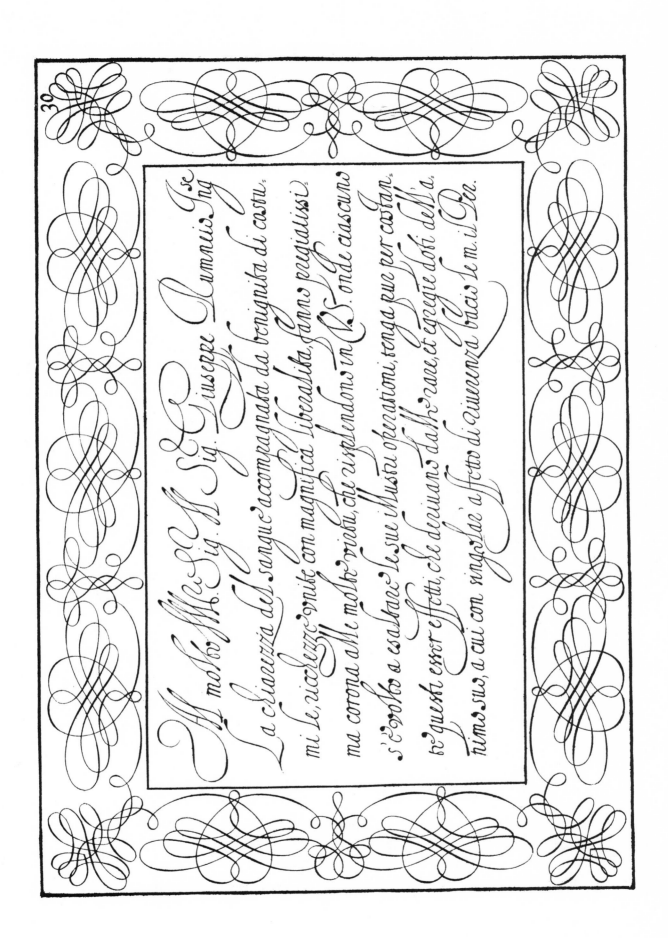

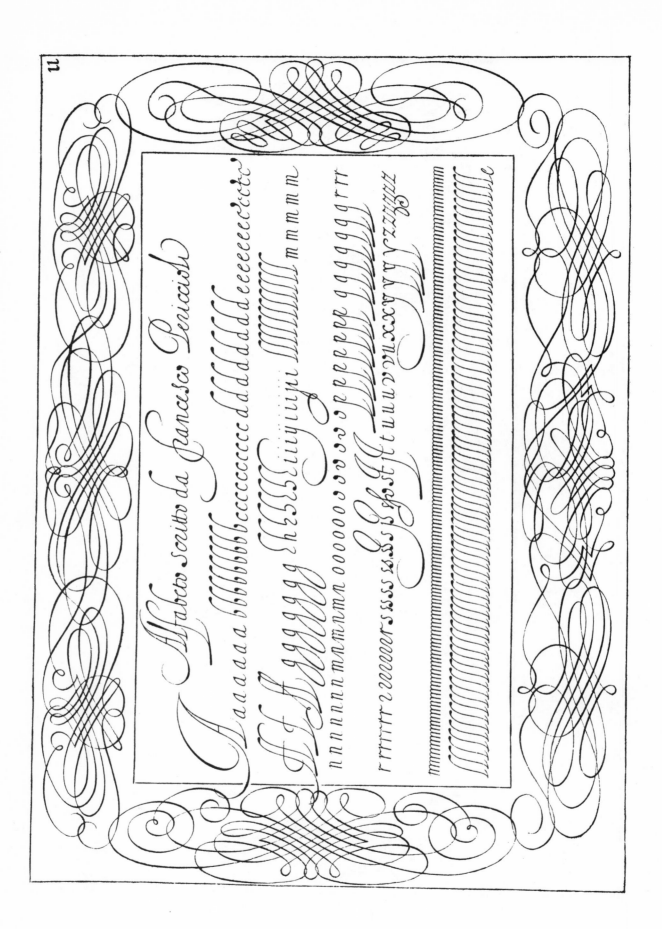

IL TERZO LIBRO DELLE CANCELLARESCHE CORSIVE

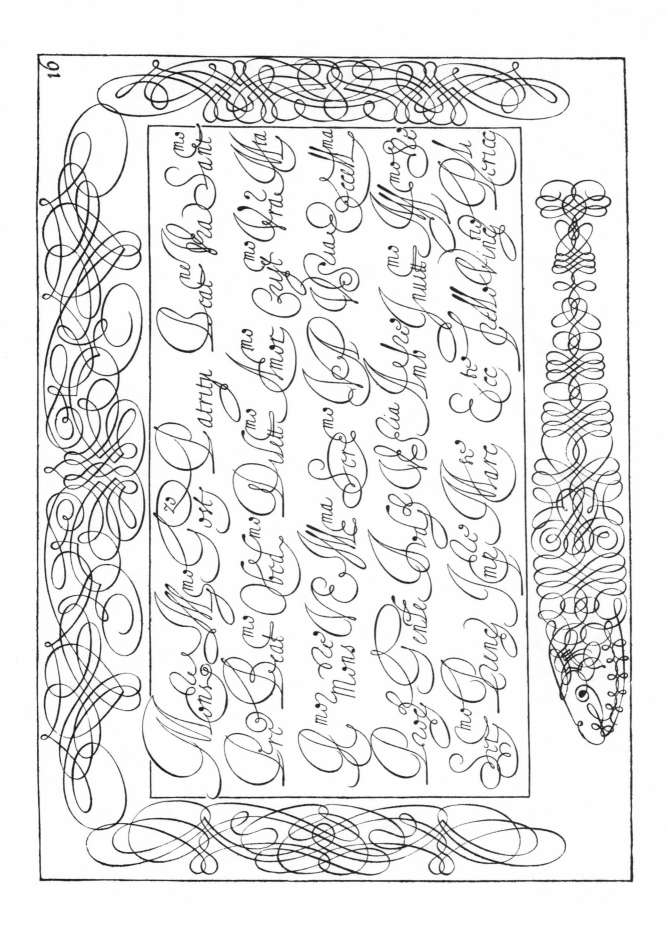

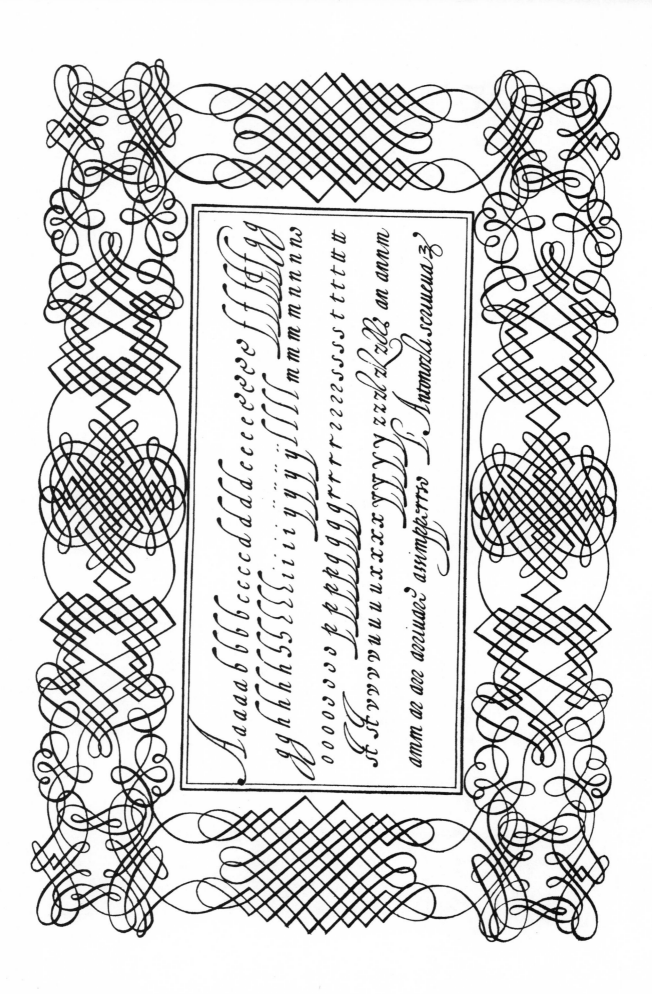

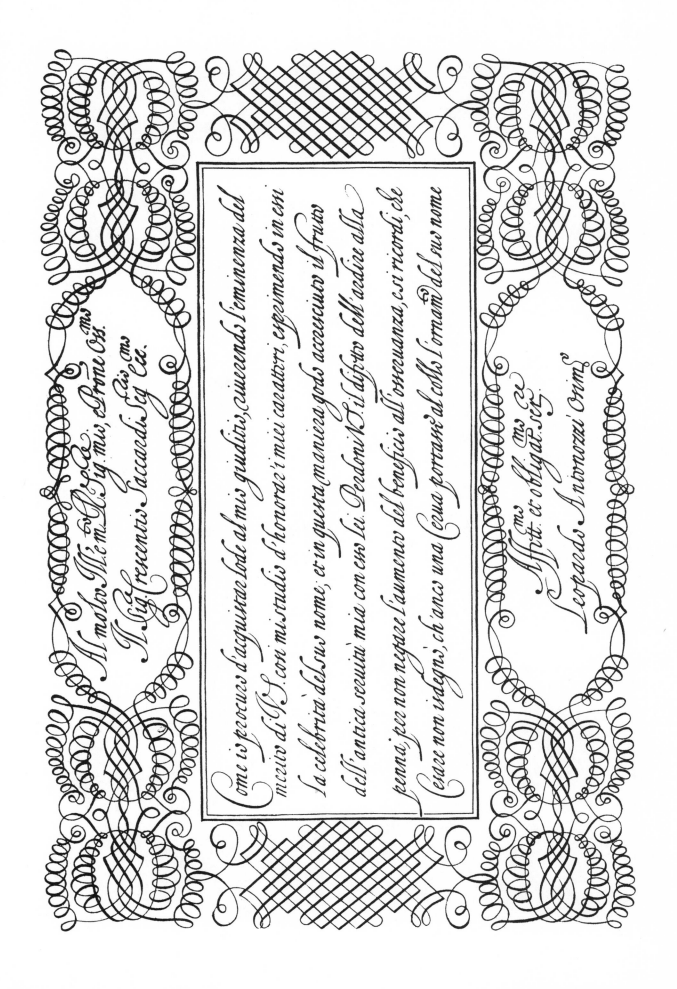

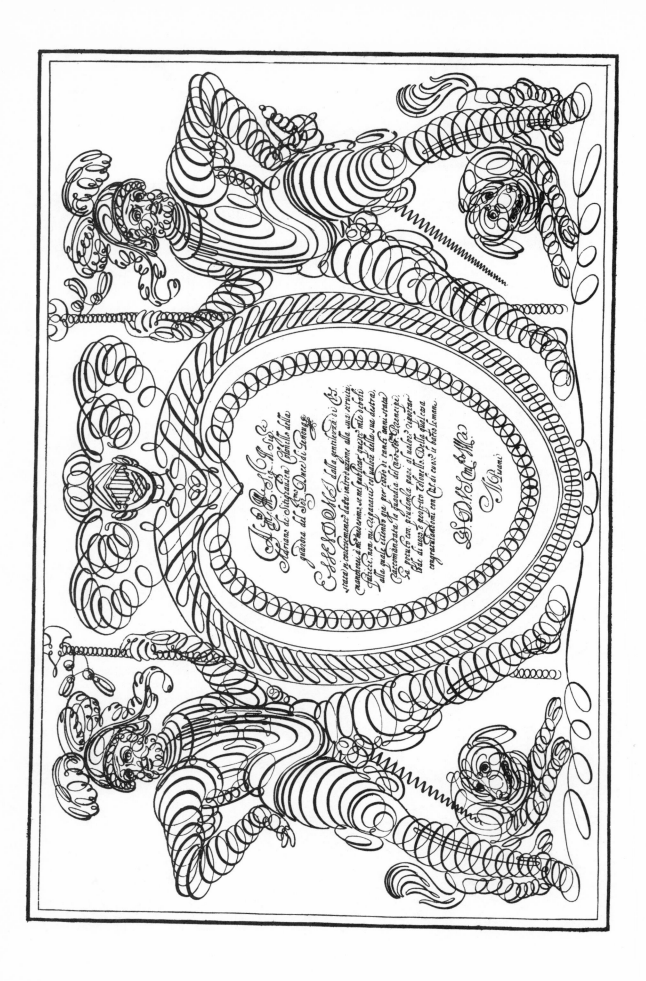

110. PISANI, GENOVA 1640

TRATTEGGIATO DA PENNA

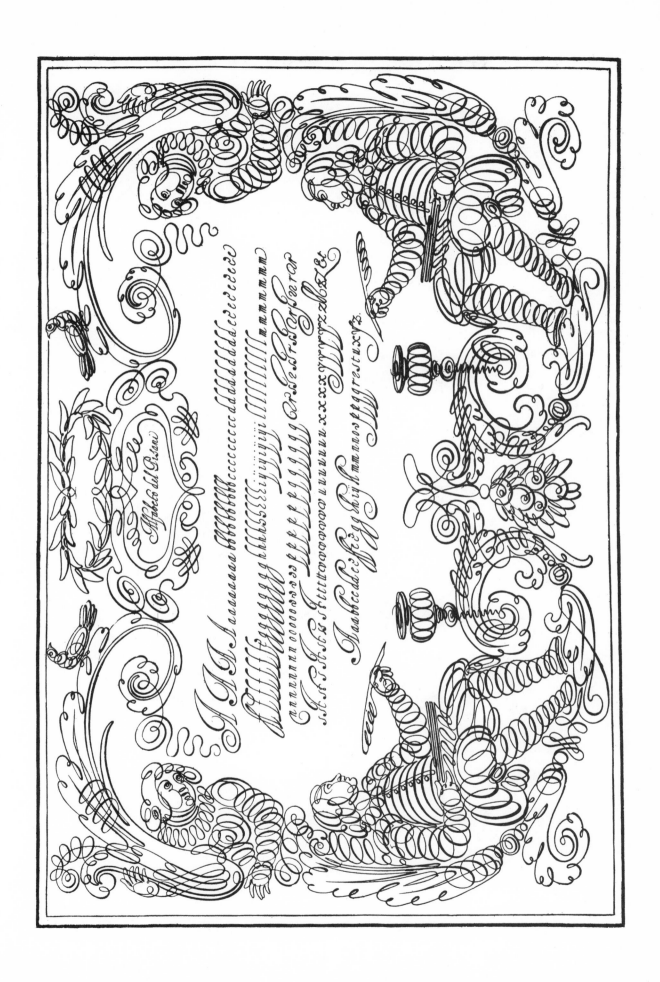

TRATTEGGIATO DA PENNA

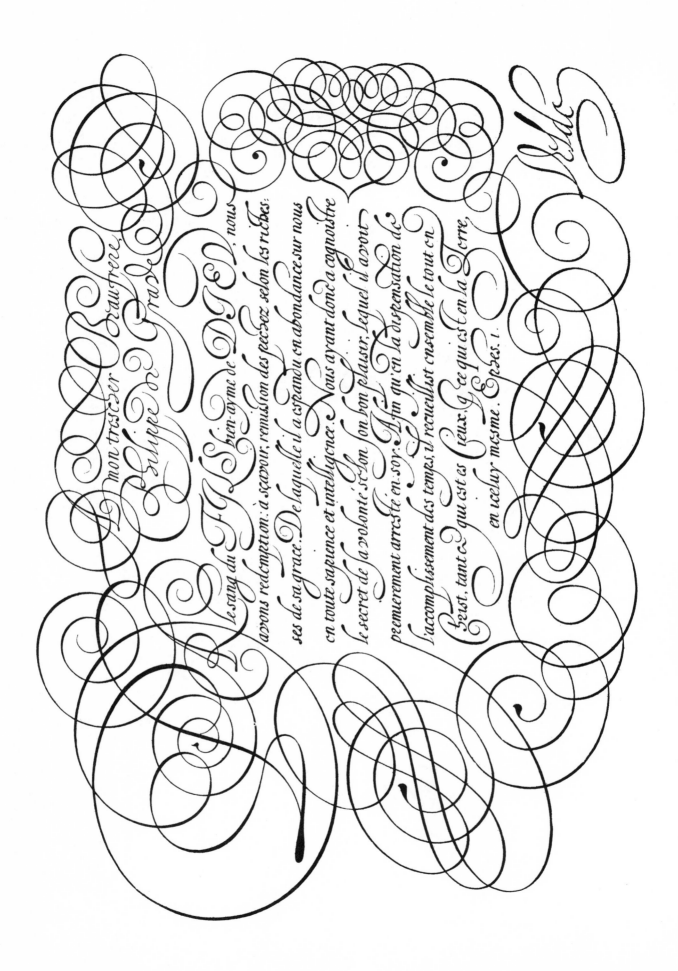

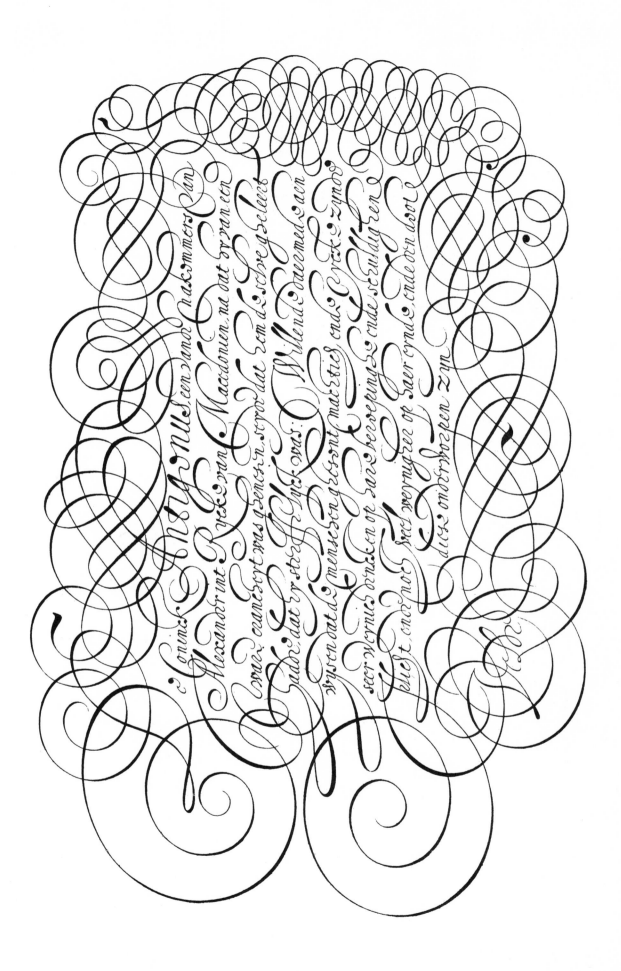

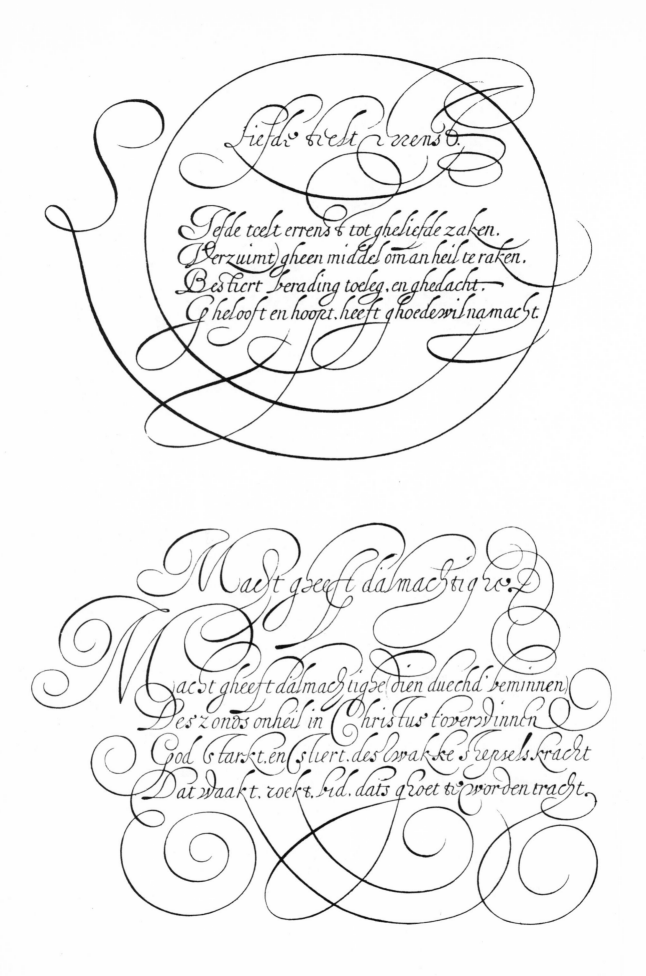

Liefde teelt in mensch.

Liefde teelt errens t tot gheliefde zaken.
(Verzuimt) gheen middel om an heil te raken.
Bestiert berading toeleg, en ghedacht.
Ghelooft en hoopt, heeft ghoedewil na macht.

Macht gheeft d'almachtig &c.

Macht gheeft d'almachtige (dien duechd beminnen)
Des zonds onheil in Christus toverwinnen.
God starkt, en stiert, des bwakke schepsels kracht
Dat waakt, roekt, bid, dats ghoet te worden tracht.

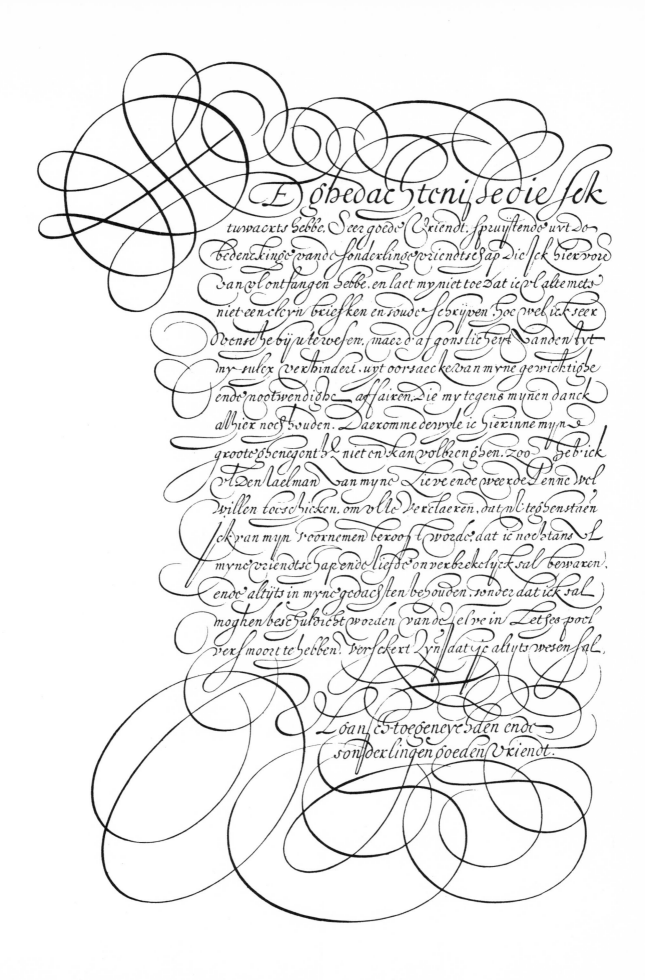

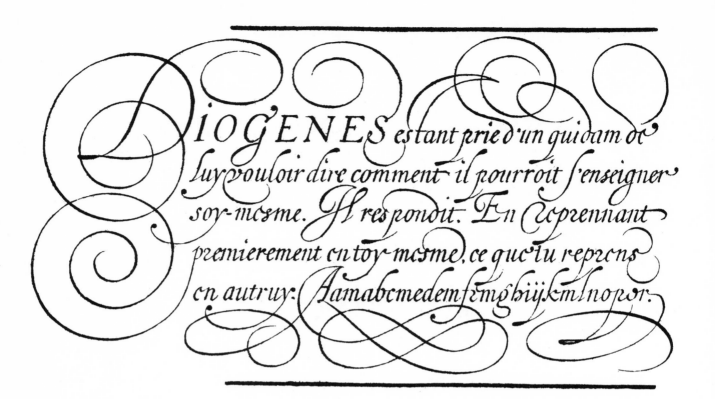

DIOGENES estant prie d'un quidam de luy vouloir dire comment il pourroit s'enseigner soy-mesme. Il respondit. En reprennant premierement en toy-mesme, ce que tu reprens en autruy: Aa ma bc me dem fe mg hii jc ml no por.

Den 20 Maart 1693

Uyt de hand Contant Verkocht aan d'onderstaan'de Navolgende
Wynen den 12. 13 en 14 Coar gelost uyt het Schip de
Abrahams Offerhande Schipr Isaak Abrahamsz
soudende Volgens Connossement 150 Vat aan myn geconsigneert
door sr Cournois tot Bourd om voorzyn reekening te
benificeeren te Weten

aan Arent Santcamp 30 Vat a £ 24 t Vat f 4320:
aan Harmanus Beyering
30 Vat a Lvls 18 t Vat 3240:
f 7560:

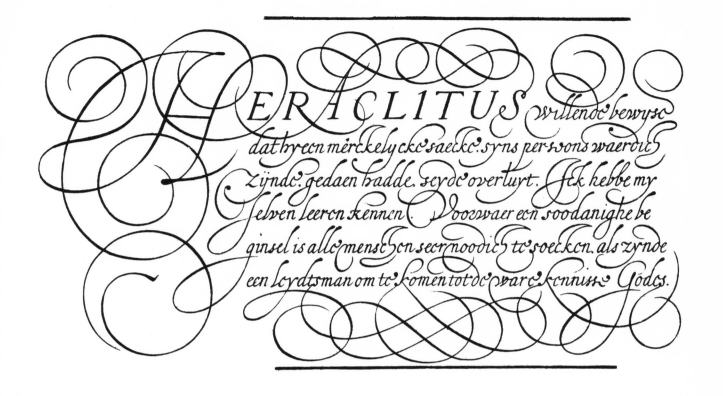

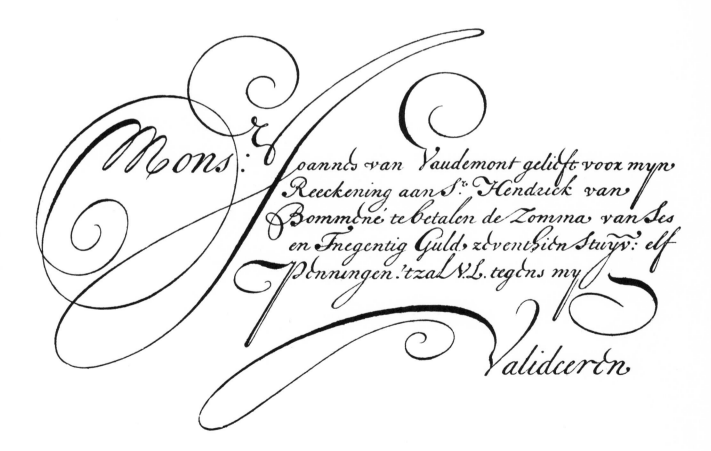

DUYTSCHE EXEMPLAREN

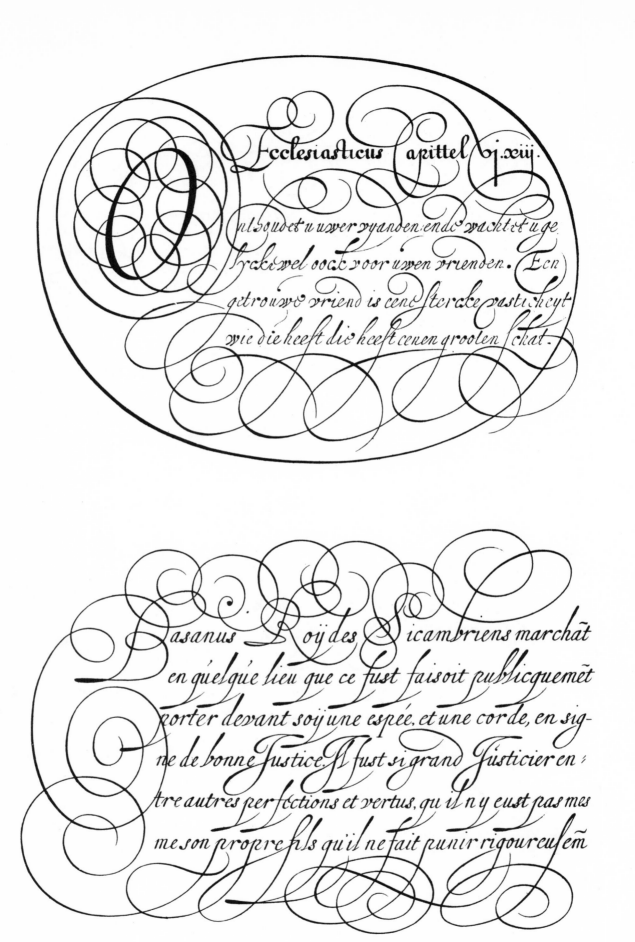

Ecclesiasticus Capittel vj.xciij.

Ontsoudet u uwer vyanden ende wacht et u ge
lijck wel oock voor uwen vrienden. (Een
getrouwe vriend is eene stercke vasticheyt
wie die heeft die heeft eenen grooten schat.

Pasanus Roij des Sicambriens marchãt
en quelque lieu que ce fust faisoit publicquemẽt
porter devant soij une espée, et une corde, en sig-
ne de bonne Iustice. Il fust si grand Iusticier en:
tre autres perfections et vertus, qu'il n'y eust pas mes
me son propre fils qu'il ne fait punir rigoureusẽm

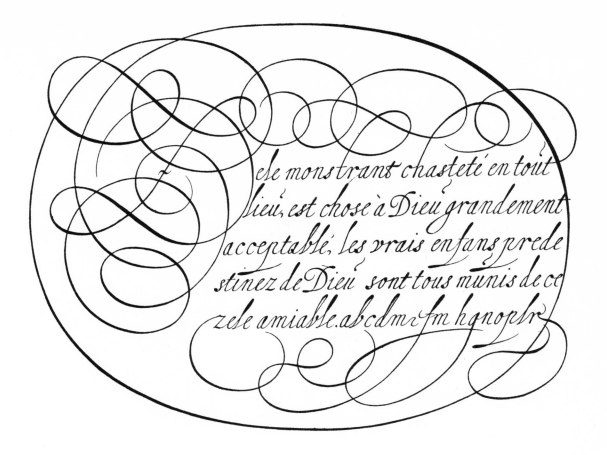

ele monstrant chasteté en toüt
lieu, est chose à Dieu grandement
acceptablé, les vrais enfans prede
stinez de Dieu sont tous munis de ce
zele amiable. ab cd m fm h q no p b r

Exemplaer-boeck Jnhouden
de verschijden geschriften.
Geschreven door Jean de La
Chambre, Françoijsche School
Meester binnen de Stadt van
Haerlem, Anno 1649 .

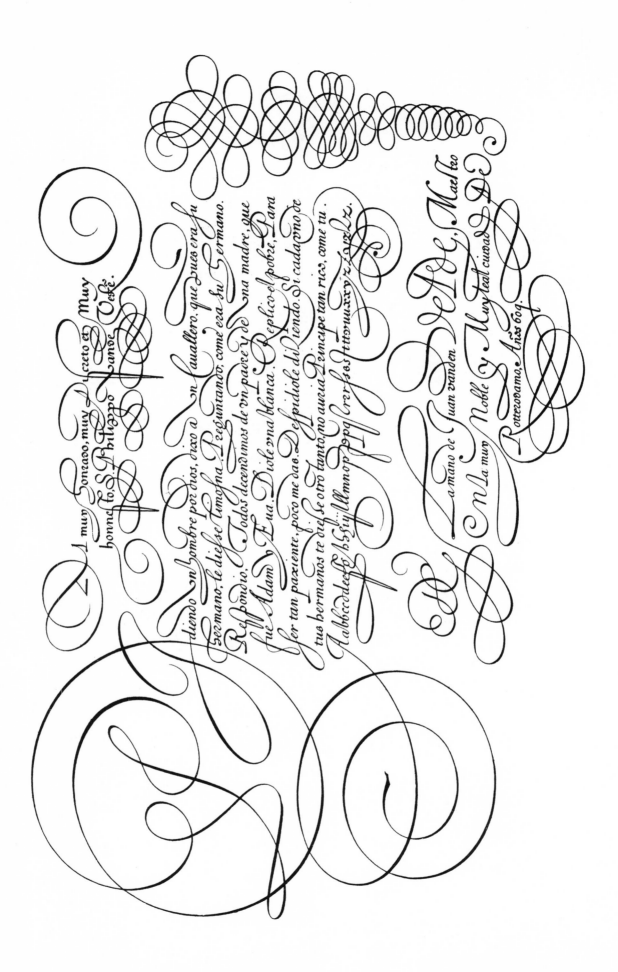

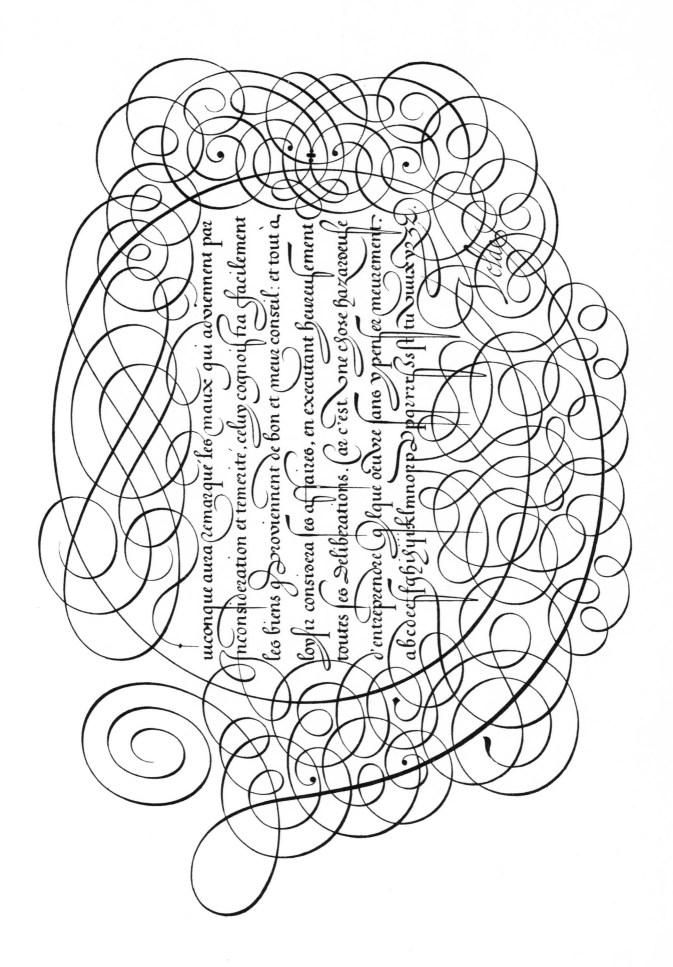

Redondilla llana.

Socrates, aunque otros lo attribuyen a Democrito, viendo que un hombre era tan prodigo, que a qualquiera persona, sin hazer ninguna diferencia, daua su hazienda, dixo: Tu moriras mala muerte, pues que las gracias que son virgines, comunicandolas con qualquiera las ha te rameras. Ennio a semejante proposito dixo

Las buenas obras mal repartidas, ami parecer, son malas

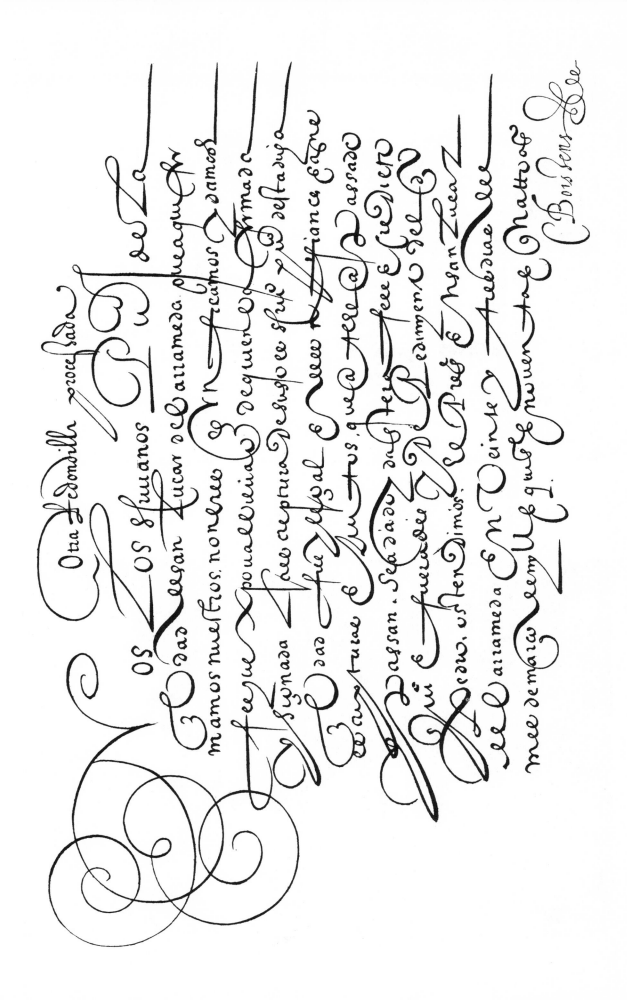

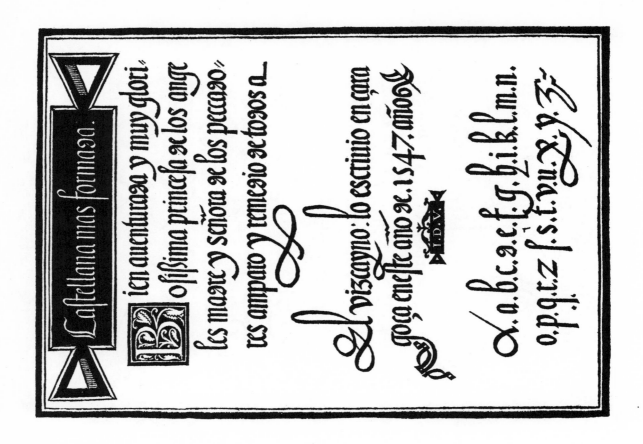

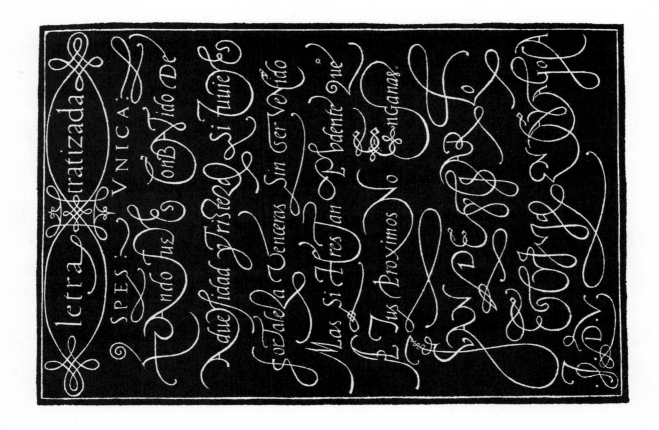

Plate (Rezonçillo):

-:- Rezonçillo:-

En el campo me meti:-
aliviar con mi desseo,
conmigo mismo peleo.
defiendame Dios e mi
Si yo mismo me doy

-:- guerra y:-

A a b c d e f g h i j l l m
n o p q r s t v u x y z z
de Frañ. Lucas. Año 1576

Plate (Bastardo):

-:- Bastardo:-

:O clementissimo y benignissimo
Jesu enseñame, endereçame, ya
yudame señor en todo. O muy
dulcissimo Jesu quando tu visi-
tares mi coraçon alegrarse han-
todas mis entrañas. Tu eres mi-
gloria y alegria de mi coraçon:
tu eres mi esperança y mi refri-
gerio en el dia de mi tribulaçiõ,

-:- y trabajo:-

Frañ. Lucas lo escrevia Año
-:- A. D. I.XXvi.:-

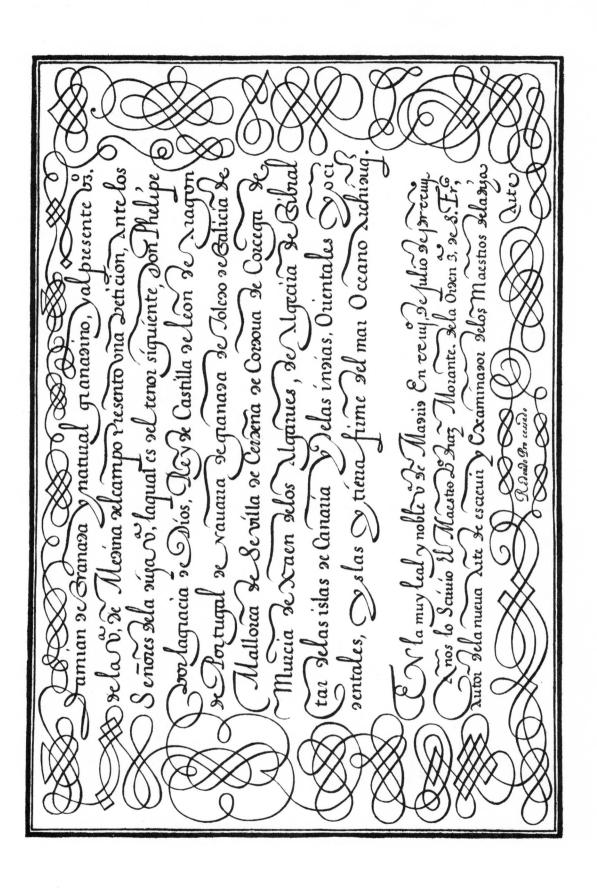

ARTE DE ESCRIVIR

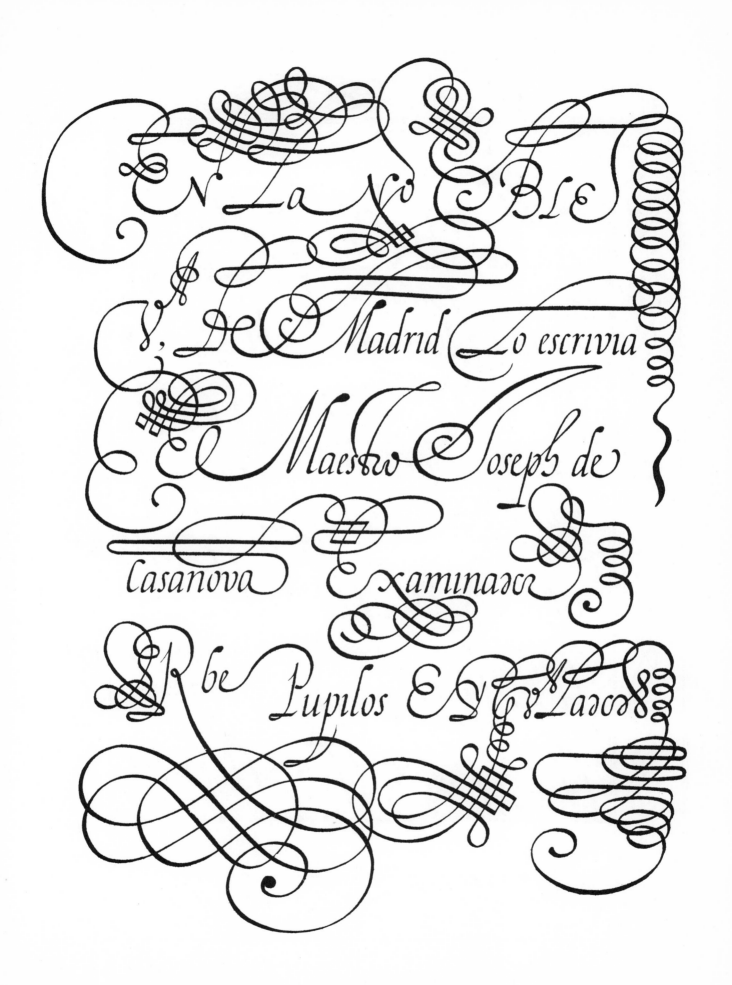

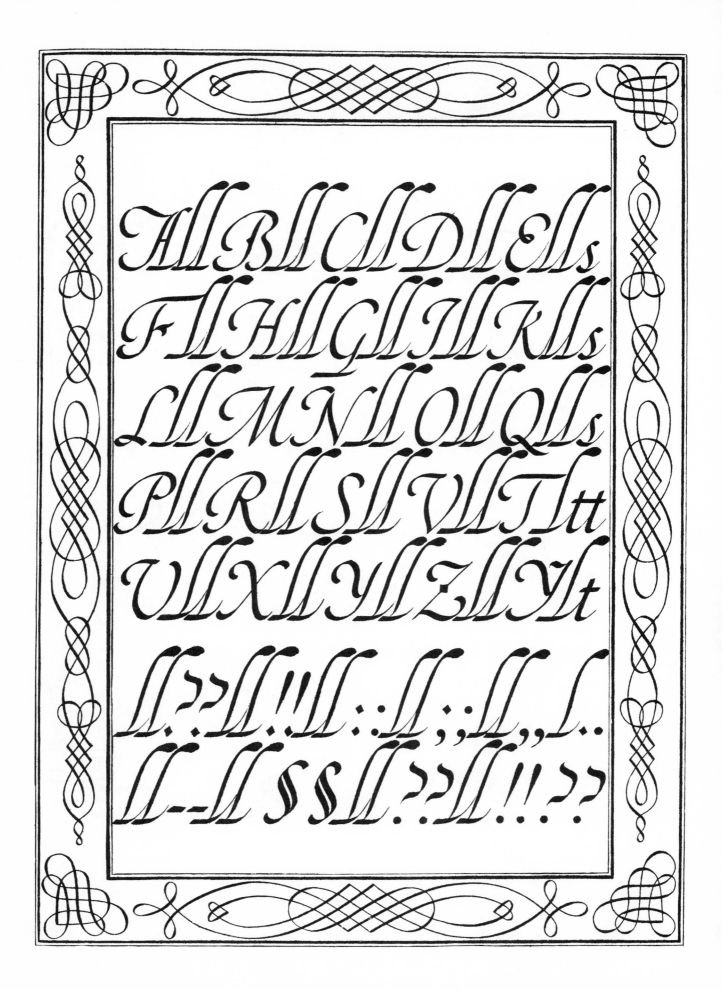

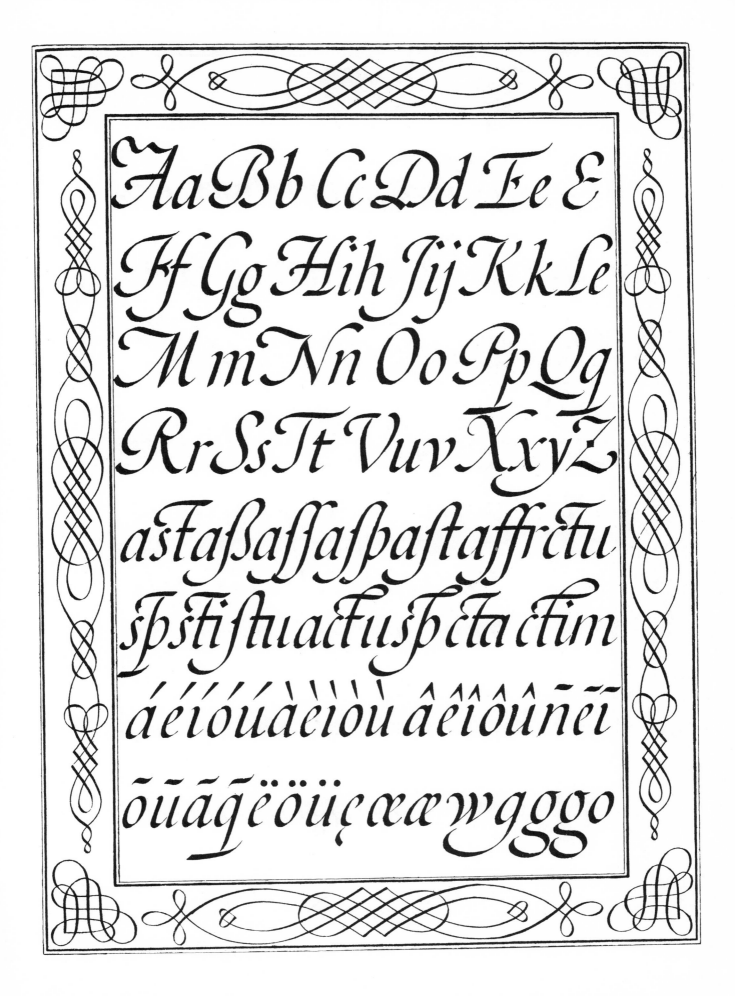

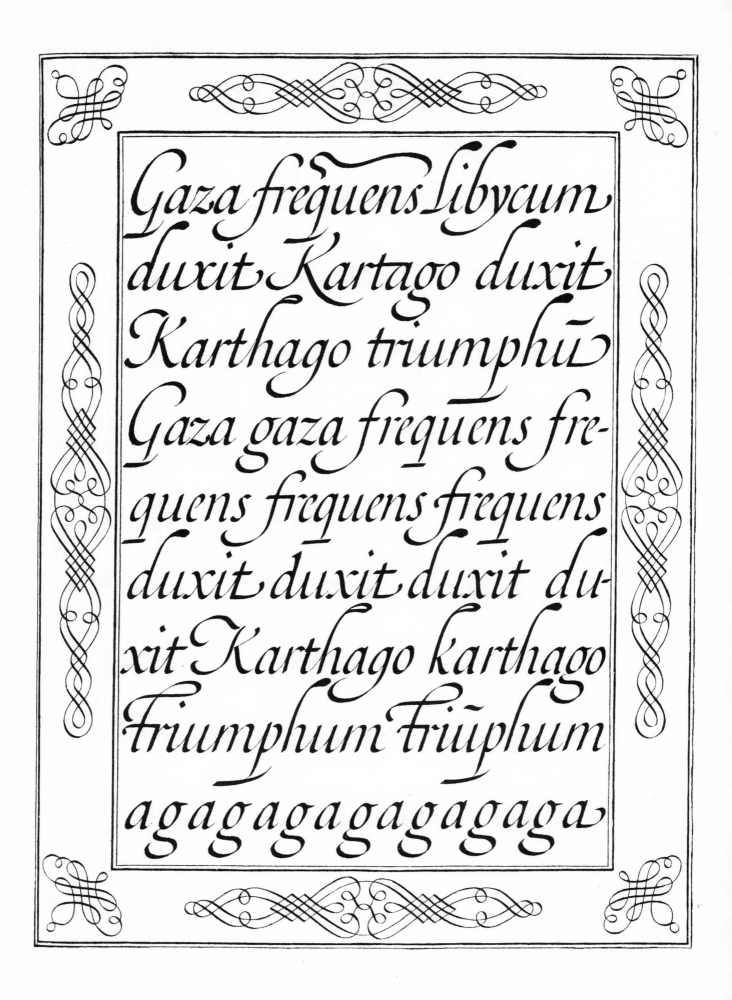

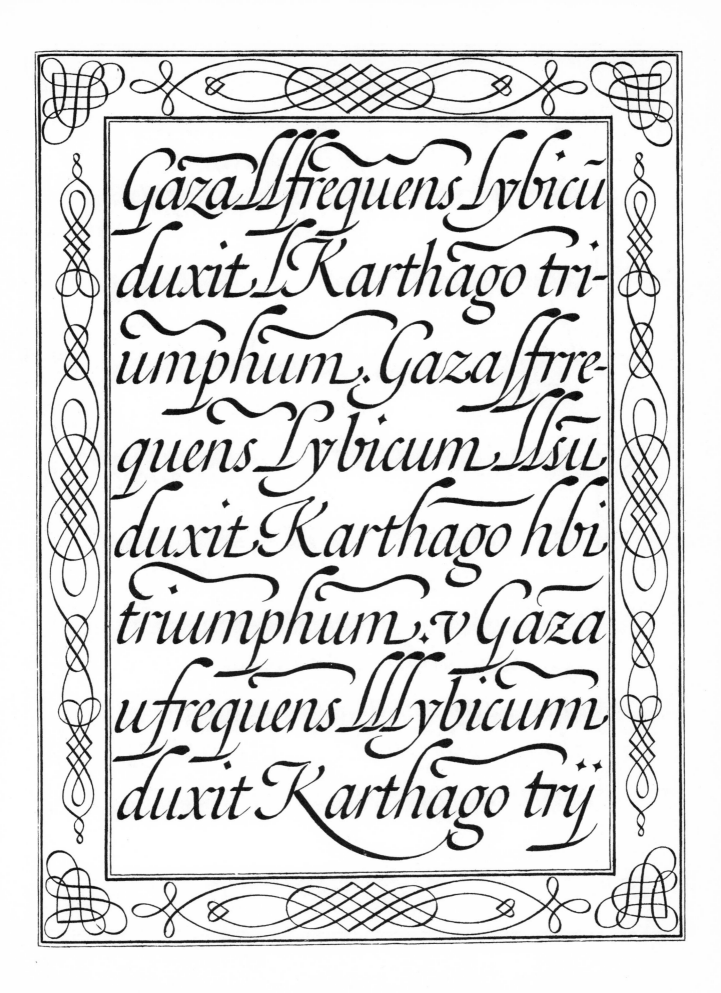

Amffm affm bcffm defnvghijklffm
lnuiof pg rrfsssss tttt vvuxyz m bl

El hijo criado à sus anchuras llenará
de confusion à su madre, y llegará à
ser insolente. Proverbios. Capit. 29.

No dexeis que vuestro hijo sea dueño
de sus acciones durante su niñez;
tened cuidado no solo de lo que hace;
sino aun de lo que piensa. Eccl. 30.
Enseñad à vuestro hijo, y èl os conso-
lará y será las delicias de vuestra
alma. Proverbios. Capitulo citado:·
Affm Affm Affm Affm Affm

Igualmente oenou Deus o fiemamento do Ceo, que o de sua Igreja: no do Ceo collocou o Sol, que presidisse ao dia, ea Luâ à noite: no de sua Igreja constituio ao Summo Pontifice Sol, que governasse a Luz do espirito; e ao Principe Catholico Lua que regesse as sombras do governo temporal.

Andrade.

nº 18.

Na gravidade, e valentia do gesto, com que o Artifice compoem a imagem lhe infunde o respeito. O retrato de hum Prîcipe naõ se inculca sómente pela eminencia da Coroa, tambem se dà a conhecer pela soberania da Magestade. O veneravel aspecto, e decente gravidade andaõ anexos ás mayores virtudes: ou para se inculcarem regias, ou para se divizarem soberanas: De pouco importa a fidalguia do lenho para os a geados da vontade, se desmerece pelo feitio, o que outro mais inferior avulta pela imagem. Andr.

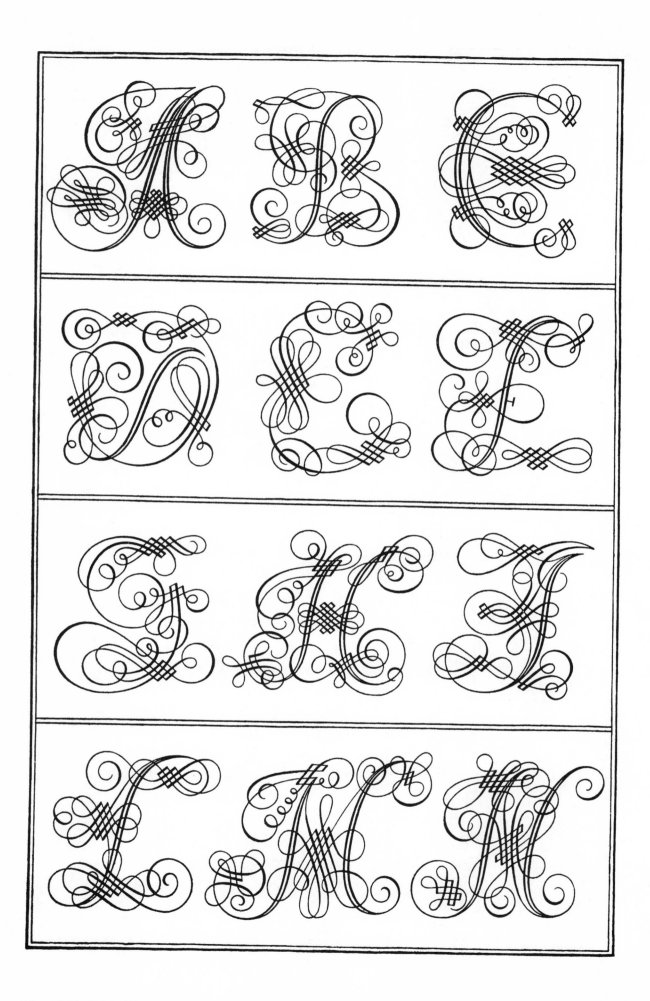

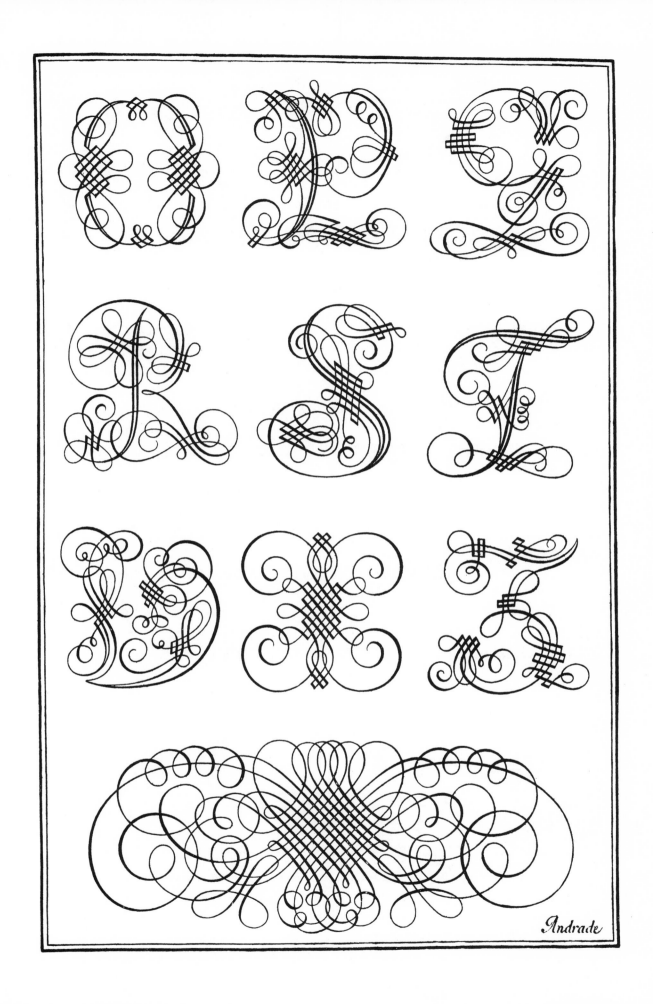

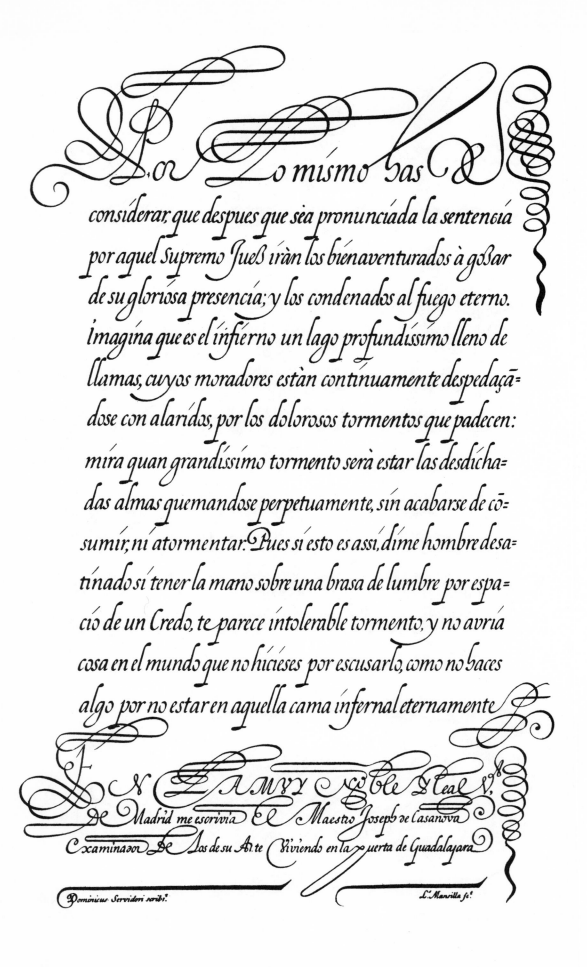

Lo mismo has

considerar, que despues que sea pronunciada la sentencia
por aquel Supremo Jueß iràn los bienaventurados à goßar
de su gloriosa presencia; y los condenados al fuego eterno.
imagina que es el infierno un lago profundissimo lleno de
llamas, cuyos moradores estàn continuamente despedaça=
dose con alaridos, por los dolorosos tormentos que padecen:
mira quan grandissimo tormento serà estar las desdicha=
das almas quemandose perpetuamente, sin acabarse de cō=
sumir, ni atormentar. Pues si esto es assi, dime hombre desa=
tinado si tener la mano sobre una brasa de lumbre por espa=
cio de un Credo, te parece intolerable tormento, y no avria
cosa en el mundo que no hicieses por escusarlo, como no haces
algo por no estar en aquella cama infernal eternamente

En la muy noble y leal V.ª
de Madrid me escrivia el Maestro Joseph de Casanova
Examinador de los de su Arte Viviendo en la Puerta de Guadalajara

Dominicus Servidori scribï. L. Mansilla fe.ª

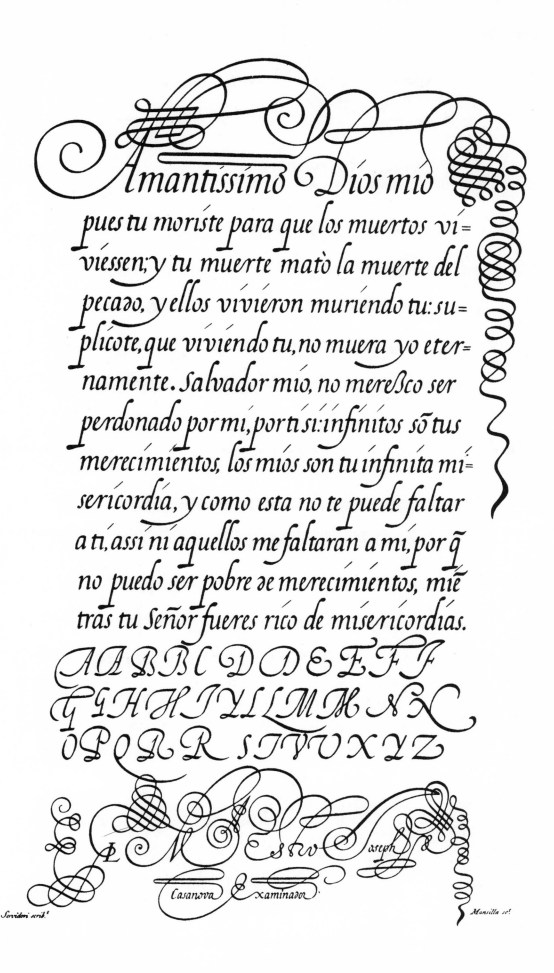

Amantissimo Dios mio
pues tu moriste para que los muertos vi=
viessen, y tu muerte mato la muerte del
pecado, y ellos vivieron muriendo tu: su=
plicote, que viviendo tu, no muera yo eter=
namente. Salvador mio, no merescco ser
perdonado por mi, por ti si: infinitos so tus
merecimientos, los mios son tu infinita mi=
sericordia, y como esta no te puede faltar
a ti, assi ni aquellos me faltaran a mi, por q̃
no puedo ser pobre de merecimientos, mie
tras tu Señor fueres rico de misericordias.

AABBC D DE FF
GGHHIYLLMM NN
OPQR RSTVVXYZ

Casanova Examinador

Servidori scrib.ᵗ Mansilla sc.ᵗ

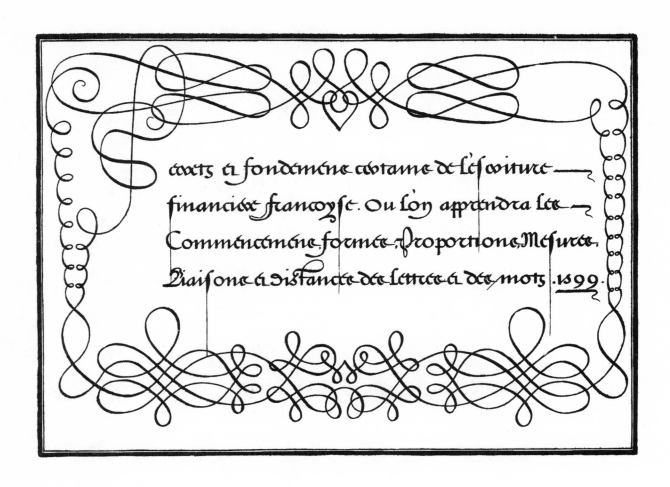

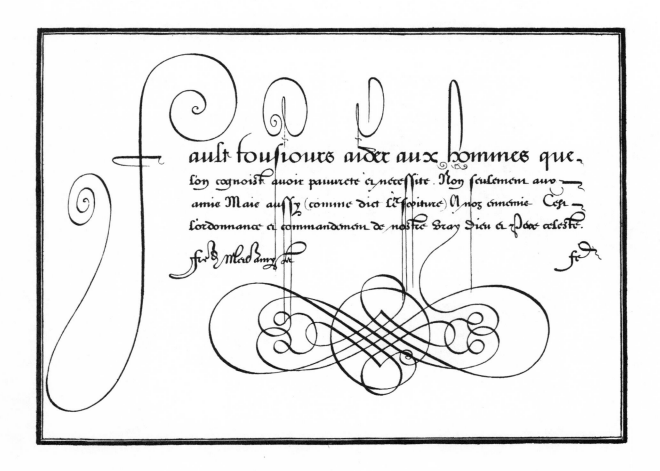

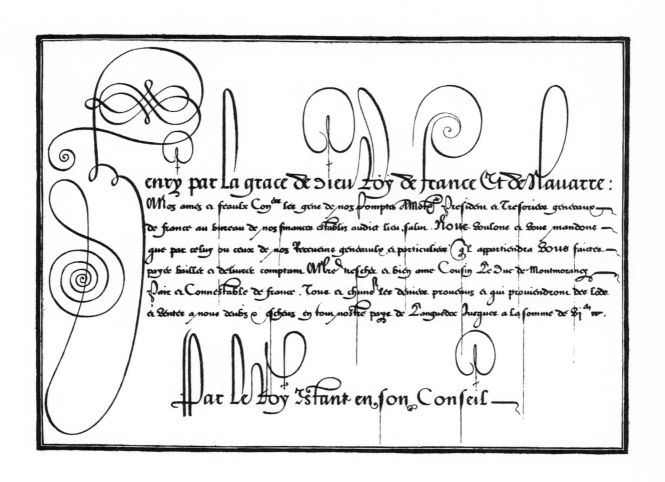

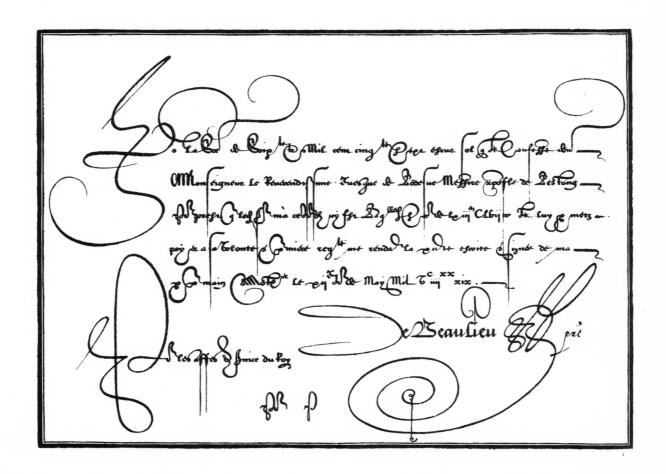

147. BEAULIEU, MONTPELLIER 1599

EXEMPLAIRES

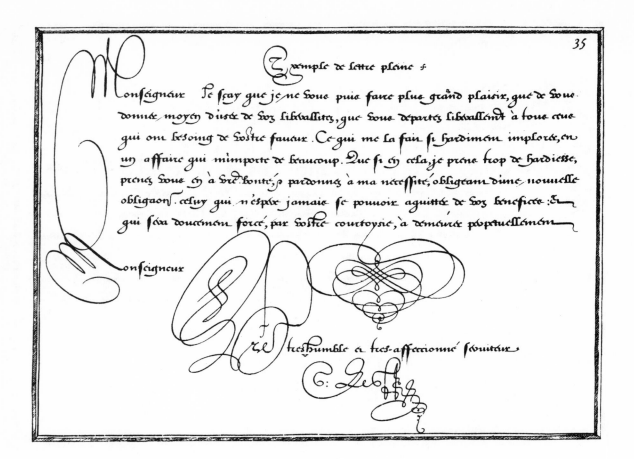

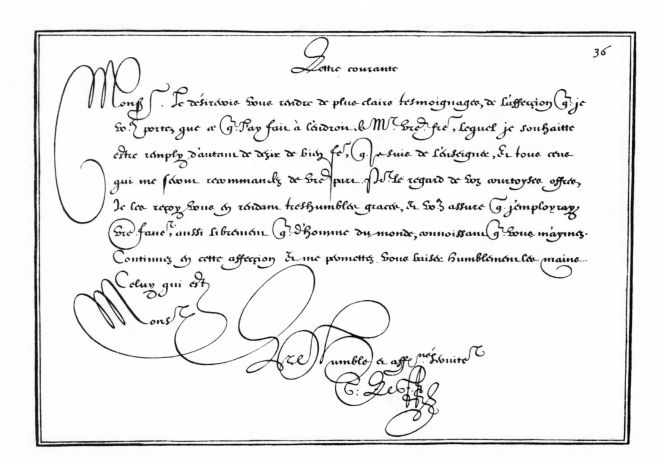

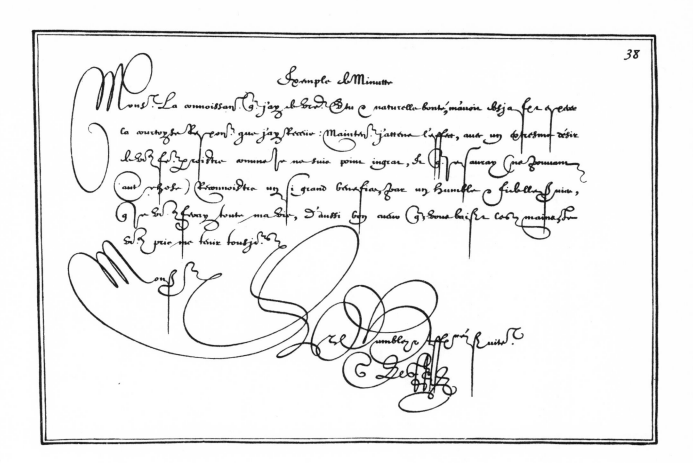

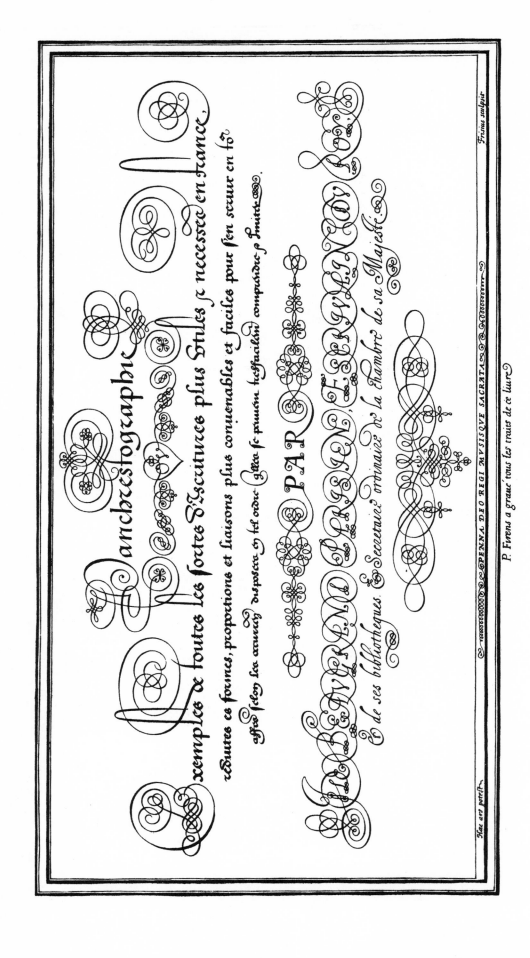

150. DE BEAUGRAND, PARIS 1601　　　　　　　　　PANCHRESTOGRAPHIE

POECILOGRAPHIE

153. DE BEAUGRAND, PARIS 1601

POECILOGRAPHIE

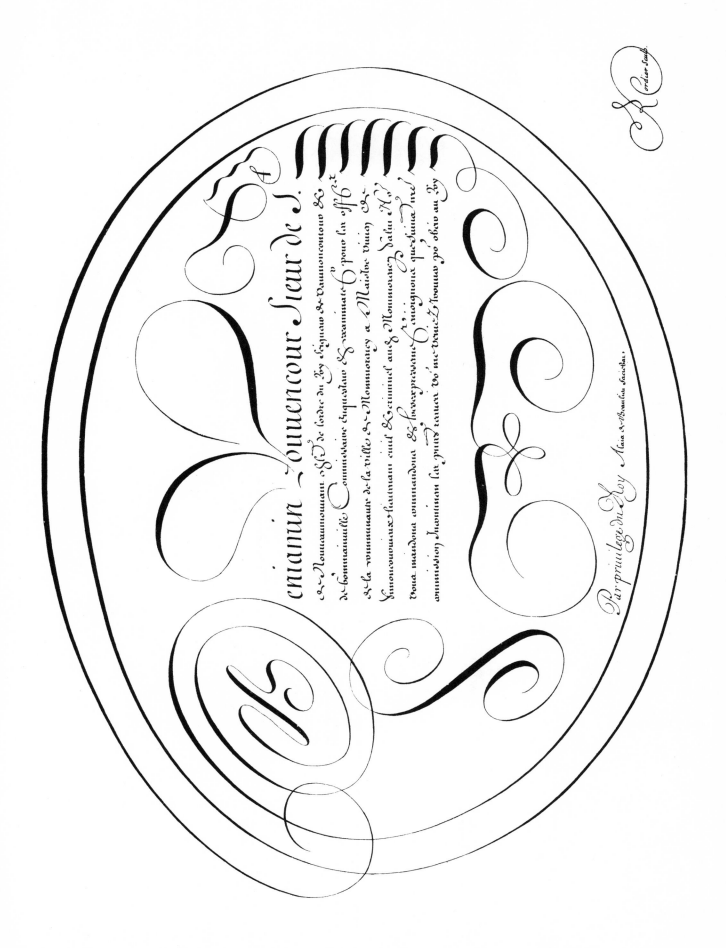

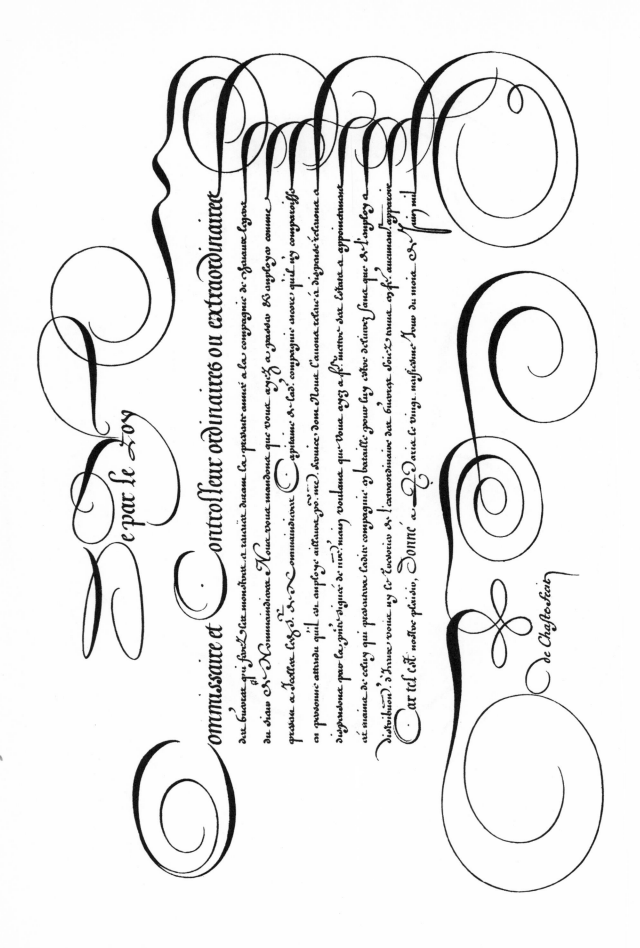

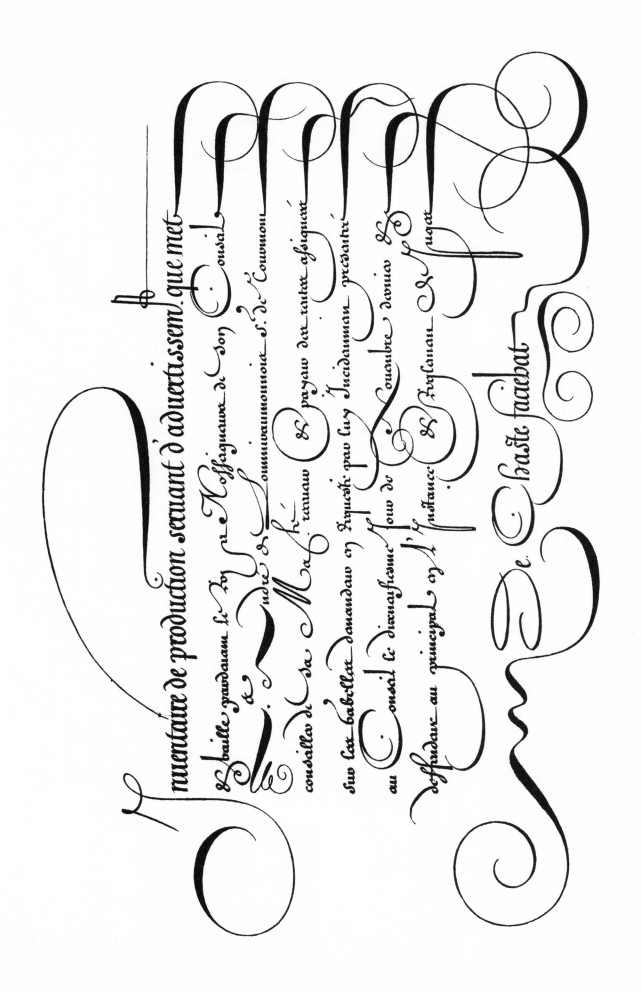

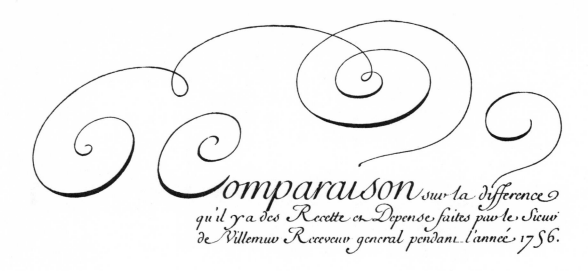

Comparaison sur la différence
qu'il y a des Recette et Depense faites par le Sieur
de Villemur Receveur general pendant l'année 1756.

8 Electionx dependance de la Generalité de Paris	Recette			Depense			Observations sur la Depense
	Principaux	4ˢ pour Livre	Totaux	Du Tres Royal	Appointemens	Totaux	
Janvier	128500. 10.	14160. 2.	80090. 10.	17501. 17.	51200. 12.	97000. 6.	Suivant le present
Février	617600. 3.	61707. 3.	91509. 11.	61702. 3.	60175. 16.	71576. 9.	Etat La Recette
Mars	780000. 2.	41000. 3.	81500. 6.	71606. 9.	71000. 9.	70000. 8.	Faite pendant l'année
Avril	617671. 3.	67081. 6.	7512. 10.	81700. —	6710. 7.	67600. 2.	1756 monte a la somme
May	780676. 4.	71061. 10.	6000. 6.	7100. —	100. 8.	71609. 6.	de
Juin	780507. 6.	6700. 7.	78710. 10.	510. 7.	58060. 2.	51609. 6.	En la Depense
Juillet	789000. 1.	17500. 8.	90000. 5.	17509. 6.	95160. 3.	95700. 7.	a celle &
Aoust	516070. 6.	60000. 1.	87599. 12.	87600. 7.	71578. 9.	67800. 7.	A vance
Septembre	780607. 11.	89761. 10.	51709. 6.	76809. 6.	71600. 6.	78760. 10.	Cta avance provian
Octobre	136609. 3.	58000. 1.	80976. 10.	80960. 10.	86789. 3.	18000. 7.	tant du precedant Comp.
Novembre	717800. 5.	10000. 6.	71959. 6.	75176. 10.	47158. 6.	78096. 9.	que dit Somme
Décembre	800000. 7.	60701. 10.	80075. 10.	6000. 7.	60972. 2.	71787. 10.	Employés et repris en restants a recouver
Totaux	7544045. 1.	558939. 7.	827799. 2.	63781. 2.	638510. 6.	839544. 7.	Le Parmurier Saulçin

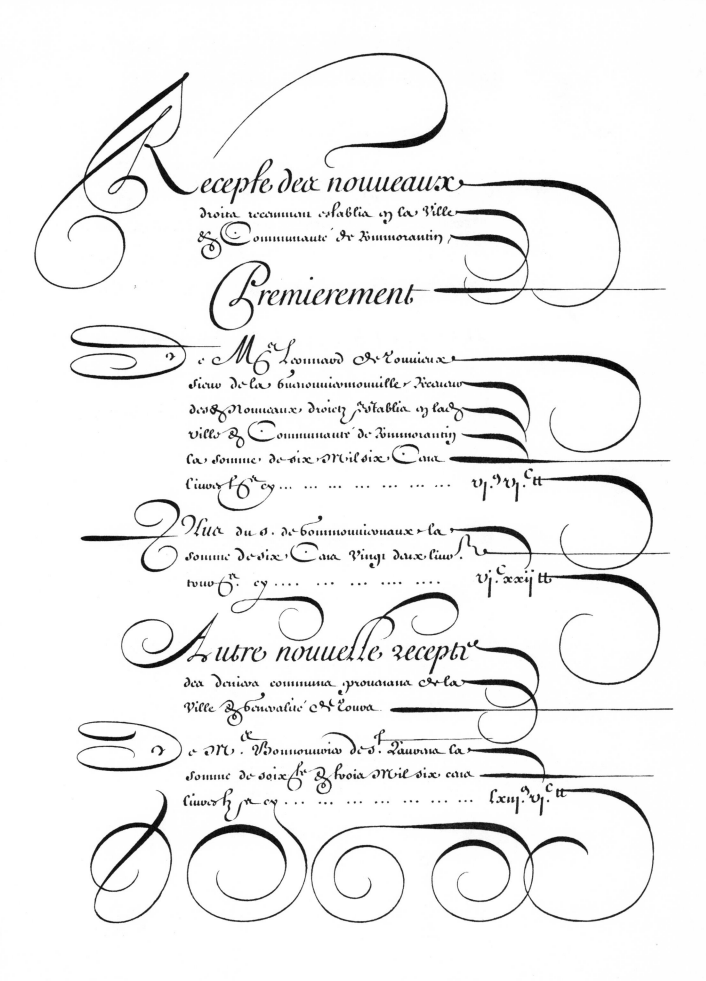

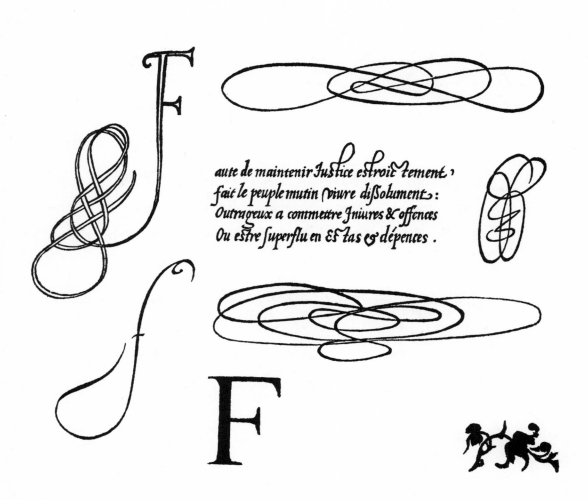

L'ESCRIPTVRE FRAN

coyse faicte selon le mode pendäte: laquelle on appelle Vieille Romaine.

Bienheureux sont Les poures d'esprit royame des cieux est à eux Bien · heureux sont ceux, qui plorent, car ils serunt consolex. Bienheureux sont Les de bonnaires, car ils possederunt La terre. Bienheureux sont les ceux, qui ont faim & soiff de iustice, car ils serunt saoulex. Bien · heureux sont Les misericordieux, car ils obtiendrunt misericorde. Bien= heureux sont ceux qui sont nets de cœur, car ils verront Dieu. & c.

A a b c d e f ff g h i k l l m n o p q r s s t. st u x y y z z ss st & et.

Am bm cm dm em fm gm hm sm km lm mn om pm qm rm sm tm vm xm ym zm &.

aute de maintenir Iustice estroictement,
fait le peuple mutin viure dissolument :
Outrageux a commettre Iniures & offences
Ou estre superflu en Es tas & dépences.

160a. NEFF, CÖLN 1549
160b. DE LA RUE, PARIS 1569

SCHATZKAMER DER SCHREIBKUNST
EXEMPLAIRES DE LETTRES

VNE ESCRIPTVRE FRĀ

coyse, laquelle on ──── vse en L ──── a Chancellerie.

Aduisez que nul ne vous surprenne par Philosophie & uaine deception, selon la traditi-on des hommes, selon les institutions du monde, & non point selon Christ. Car en luy toute plenté de diuinité gist corporellement: & testes complects en luy, qui est le chef de toute Principauté & Puissance. Par lequel aussi estes circoncis de Circon-cision faicte sans main, par le despouillement du corps des pechez, qui sont de la chair, ascauoir par la Circoncision de Christ, estans en seuelis auec luy par le

A a b c d e f g h i k l m n o p q r s ss t u v x y z &.

c acdegg l blkh. l ssfsfss st ß. i imntru xyz s sp ss st.

VNE AVLTRE ESCRIP-

ture Francoyse currant.

MortifieZ donc vos membres qui sont sur terre, paillardise, souillure, volupté, mauuaise con-cupiscence & auarice qui est Idolatrie. Pour lasquelles choses L'ire de Dieu vient sur Les enfans d'infidelité, esquelles aussi vous aueZ iadis cheminé, quand vous y viuieZ Et maintenant vous aussi osteZ toutes choses ire, indignation, mauuaistié, blasme, parolle des bonnes te de vostre bouche. Ne menteZ point L'vn à L'autre, ayas despouillé Le vieil homme auec ses faicts. & ayans vestu Le nouueau, Lequel se renouelle en La cogno issance de Dieu selon L'image de celuy qui L'a creé, ou n'y a Grec ne Iuif, Circoncisio

A a b c d d e f ff g h i j k l L m m n n o p p q r s sss t t u v x y z.

A A B C D E F G H I K L M N O P Q R S T V X Y Z &.

Lre droicte, pattée

Pour Conclusion, Je diray auecques Josephe Que les premieres Lettres,
et Karactaires commencerent des la creation du Monde. Et le Veriffieray, par
le Liure de la Prophetie d'Enoc septiesme homme, que Sainct Jude Apostre
allegue en sa Canonique. Tellement qu'il ne fault doubter, qu'Adam, & ses
premiers Enfans (qui estoient si sages) ayent esté premiers inuenteurs des Lres

.a. b. c. d. e. f. g. h. i. k. l. m. n. o. p. q. r. s. t. v. u. x. y. z. J.

E ij

Lettre couffuee.

Rien ne se peut trouuer en ce monde plus precieux que les Lettres, ou Karactaires, Sur
elles sont conseruaterices et garde trescertaine de toutes autres Jnuentions et Sans lesquelles.
nulle science ne se peult entretenir. Tesmoing que par icelles .les anges, les siecles, les
generations .les hommes. & leurs nobles extractions, sont ainsi rendues Jmmortelles.

.a. b. c. d. e. f. g. h. i. k. l. m. n. o. p. q. r. s. t. v. u. x. y. z. &.

Lre Jtalique ronde & commune.

Il en ya d'aultres tant Juifz que Cbrestiens, qui afferment Iceluy Moyse
estre le premier Jnuenteur des Lettres, D'autant qu'il fut plus ancien
qu'aucunes aultres Lres uy Escritures des Gentils, & le preuuent par
Les cinq premiers volumes qu'il ha diligemmant escritz de loix et polices
pour le gouuernemēt de son Peuple qui parauant n'auoit que sa Loÿ de nature

A.B C.D E.F G H.I.K.L.M.N.O.P.Q.R.S

Lre Plaisante

Kadmus selon les Grecz ha le bruict aussy d'estre le premier
composité, Mais cela n'est vray semblable Car il n'estoit que du
tems d'Othoniel, qui regna Due & Cappitaine sur Israel (succedant
e Josué, xlviij ans, apres que la Loÿ eut este escrite par Moyse
duquel il ha peu apprendre, Encores n'en porta il que xvi. karacteres en Grece

a.b c.d e.f g.h.i k.l.m.n.o p.q.r.s.t.v u.x.y.z.

D

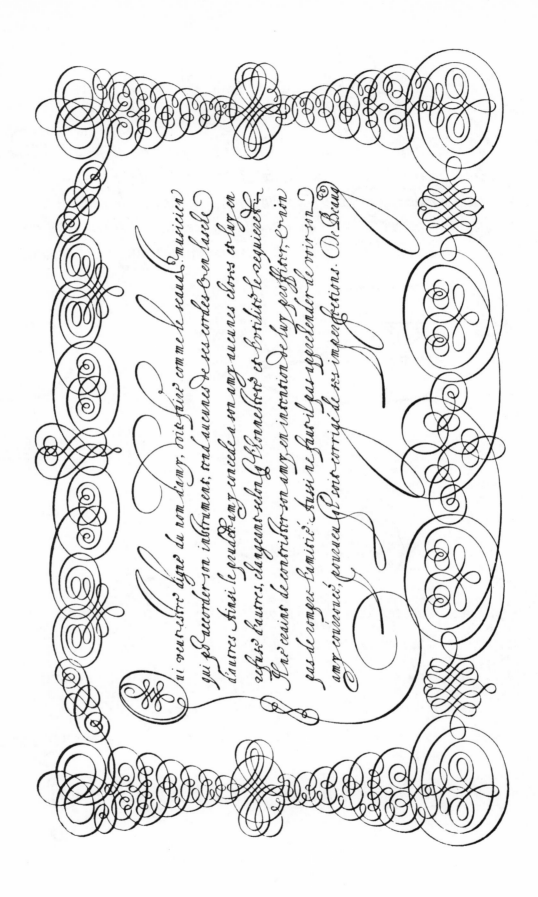

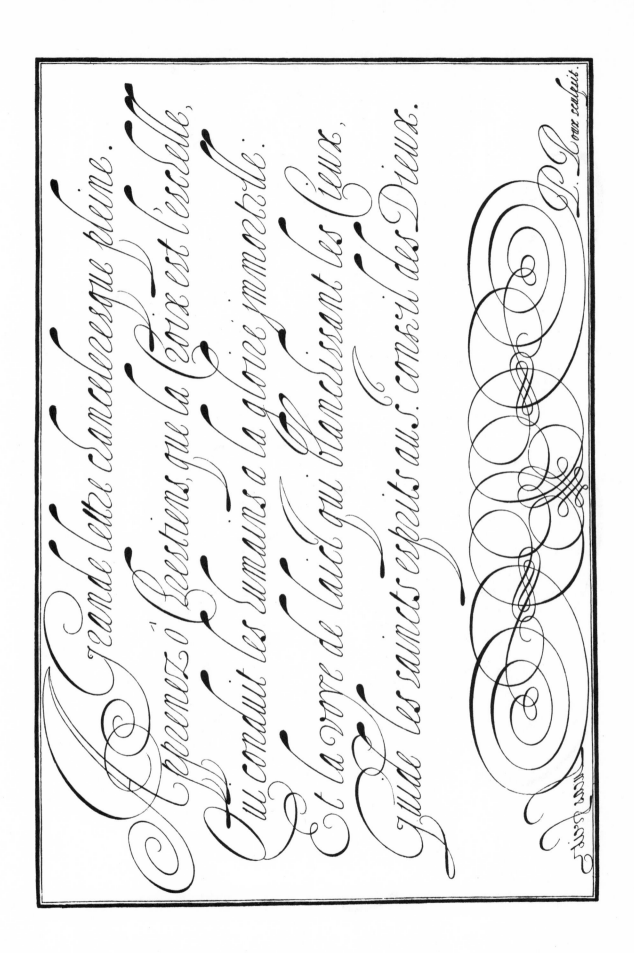

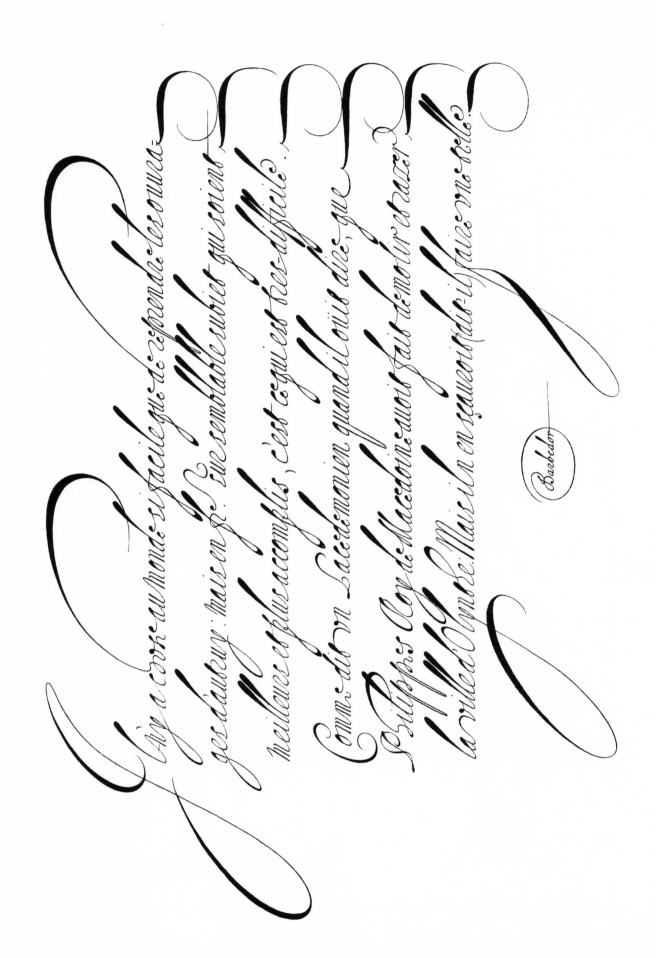

LES ESCRITURES FINANCIERE ET ITALIENNE BASTARDE

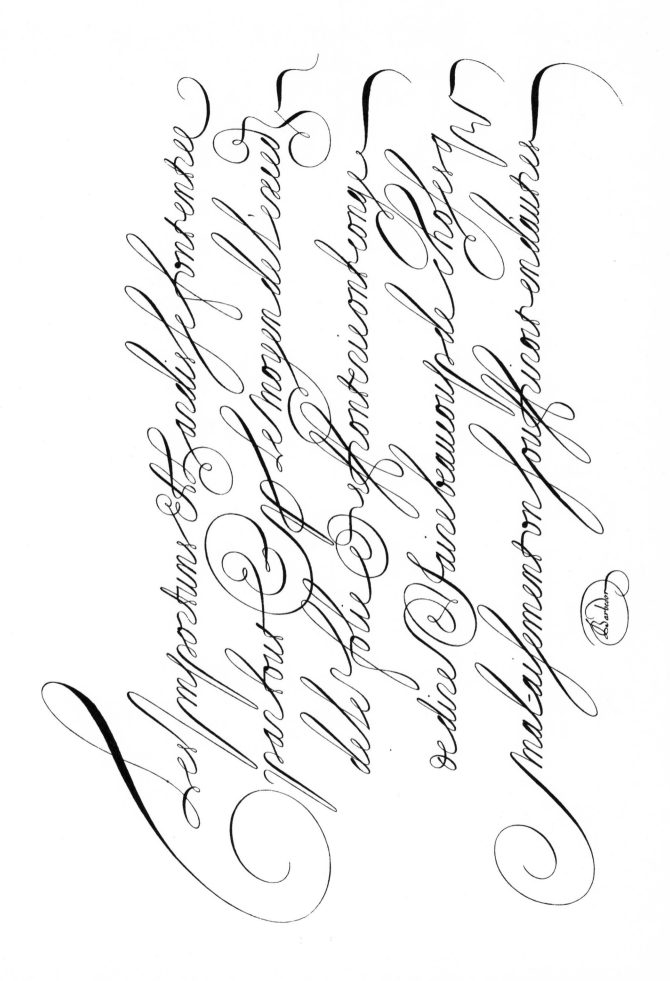

LES ESCRITURES FINANCIERE ET ITALIENNE BASTARDE

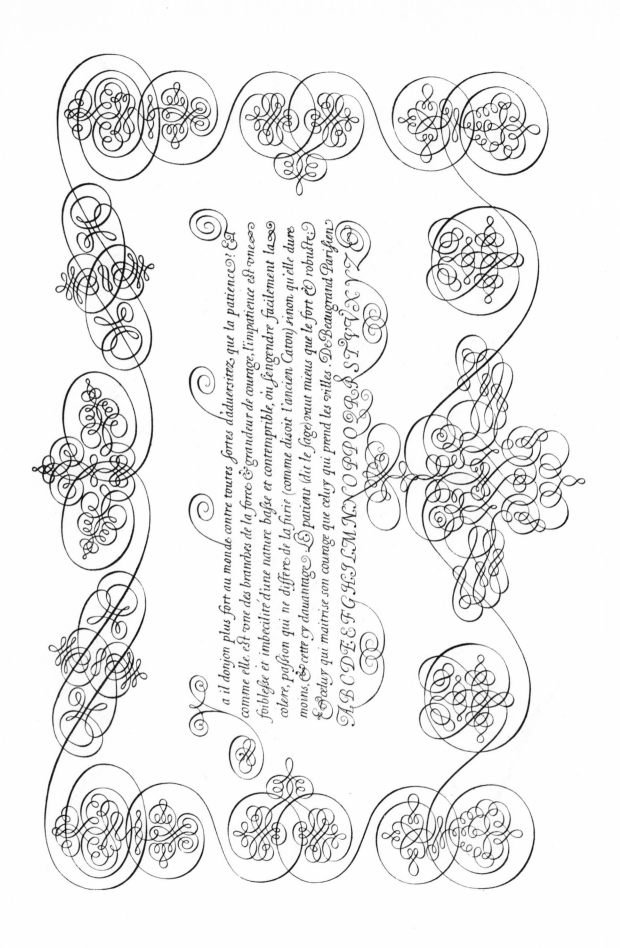

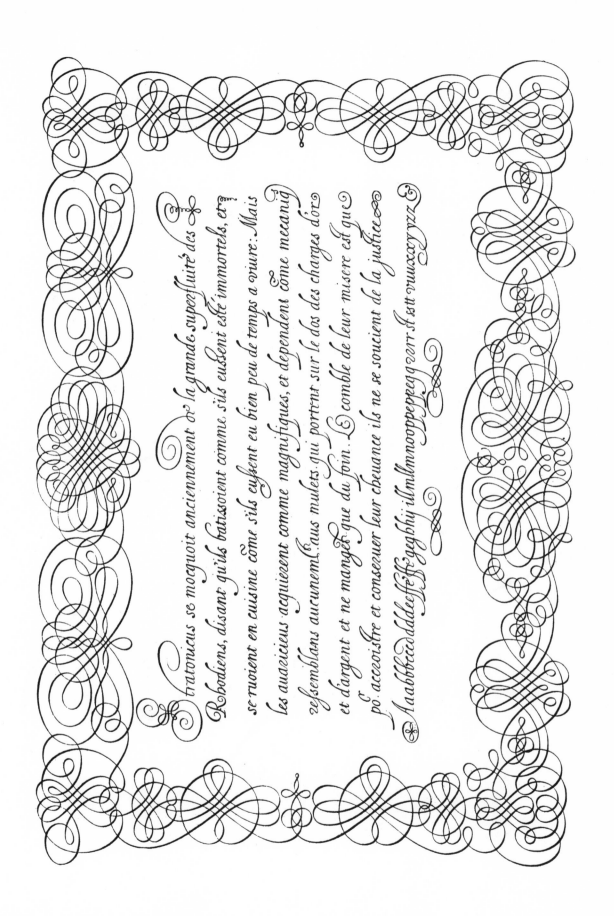

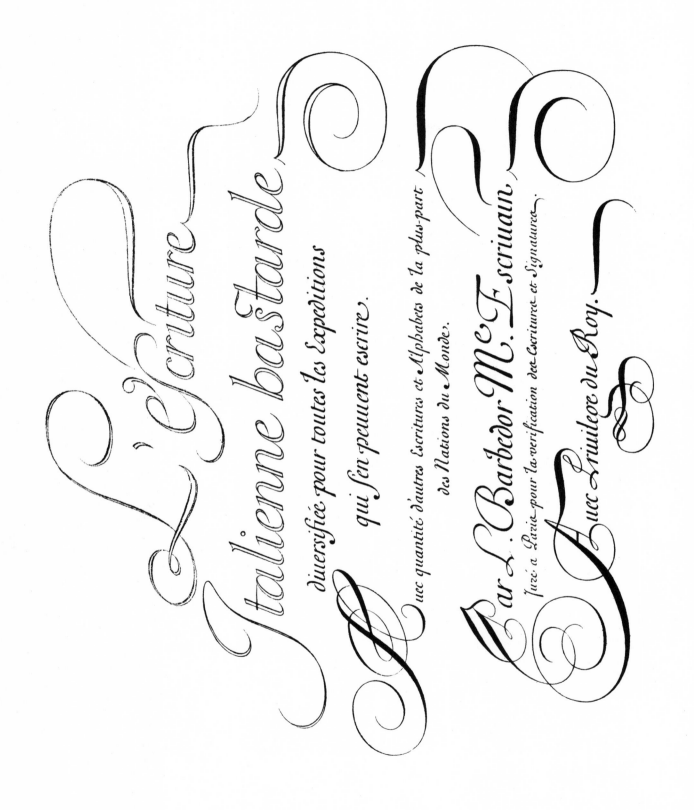

L'Escriture Italienne bastarde diuersifiée pour toutes les Expeditions qui s'en peuuent escrire. Auec quantité d'autres Escritures et Alphabets de la plus-part des Nations du Monde. Par L. Barbedor M.e E. scriuain. Iuré à Paris pour la verification des Escritures et Signatures. Auec Priuilege du Roy.

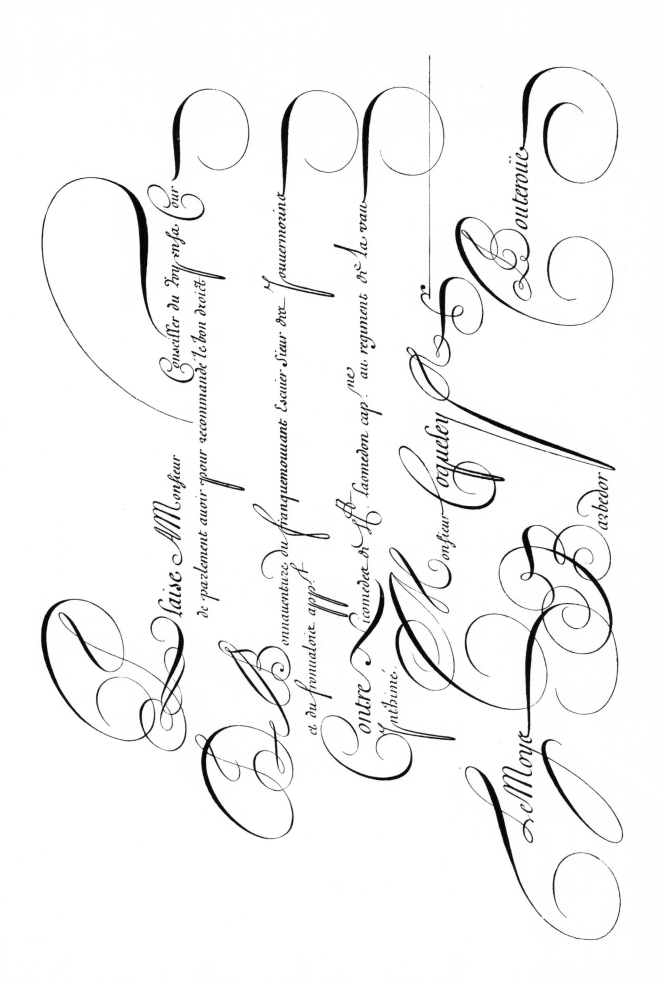

LES ESCRITURES FINANCIERE ET ITALIENNE BASTARDE

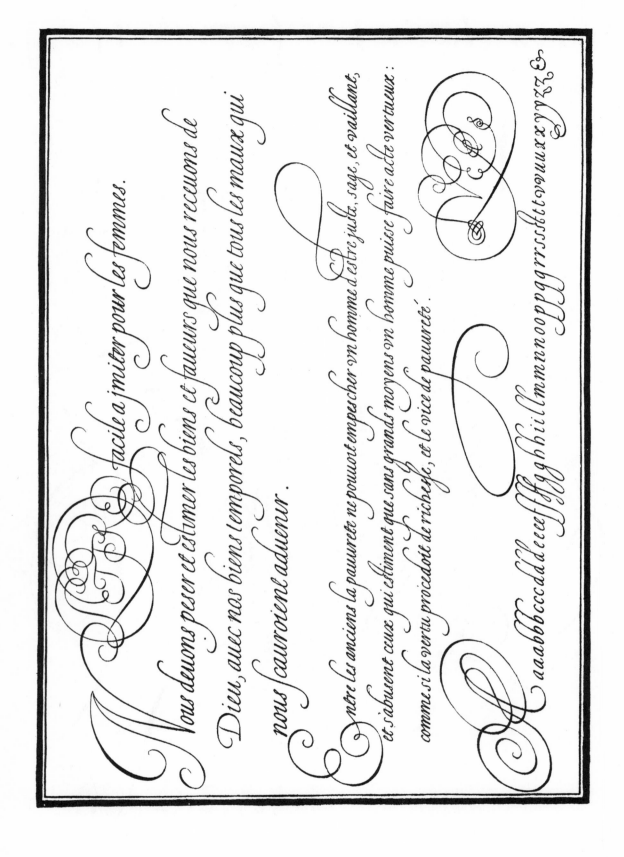

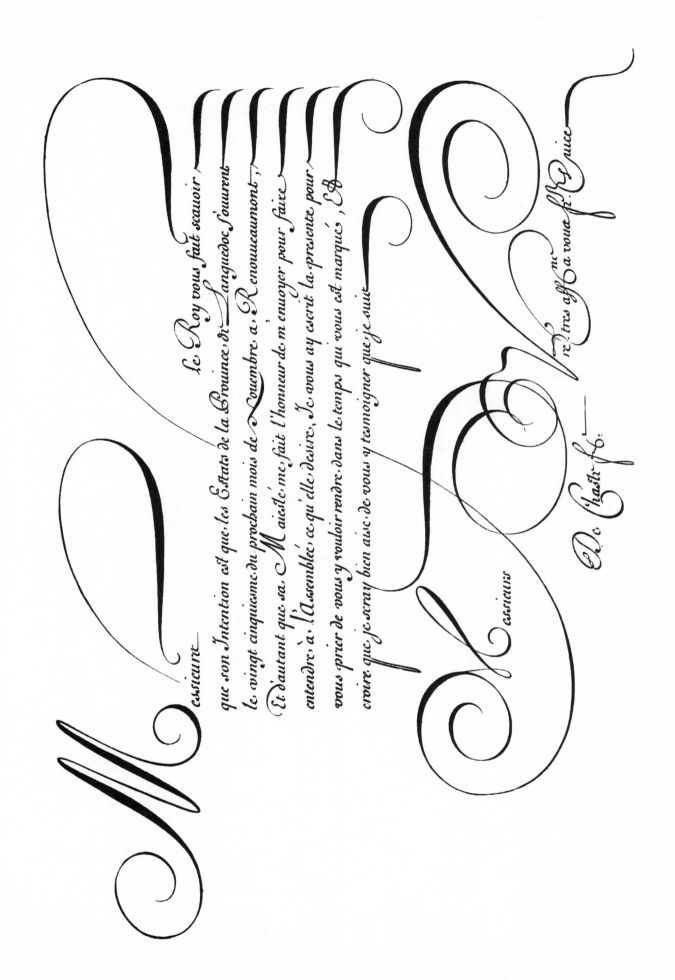

Messieurs

Le Roy vous fait sçauoir
que son Intention est que les Estats de la Prouince, de Languedoc s'ouurent
le vingt cinquiesme du prochain mois de Nouembre, a, Renouueaumont,
Et d'autant que sa Maiesté me fait l'honneur de m'enuoyer pour faire
entendre a l'Assemblee ce qu'elle desire, Ie vous ay escrit la presente pour
vous prier de vous y vouloir rendre dans le temps qui vous est marqué, Et
croire que je seray bien aise de vous y temoigner que je suis

Messieurs

vre tres affin̄é a vous fr. Rauuc

De Chasti fe:

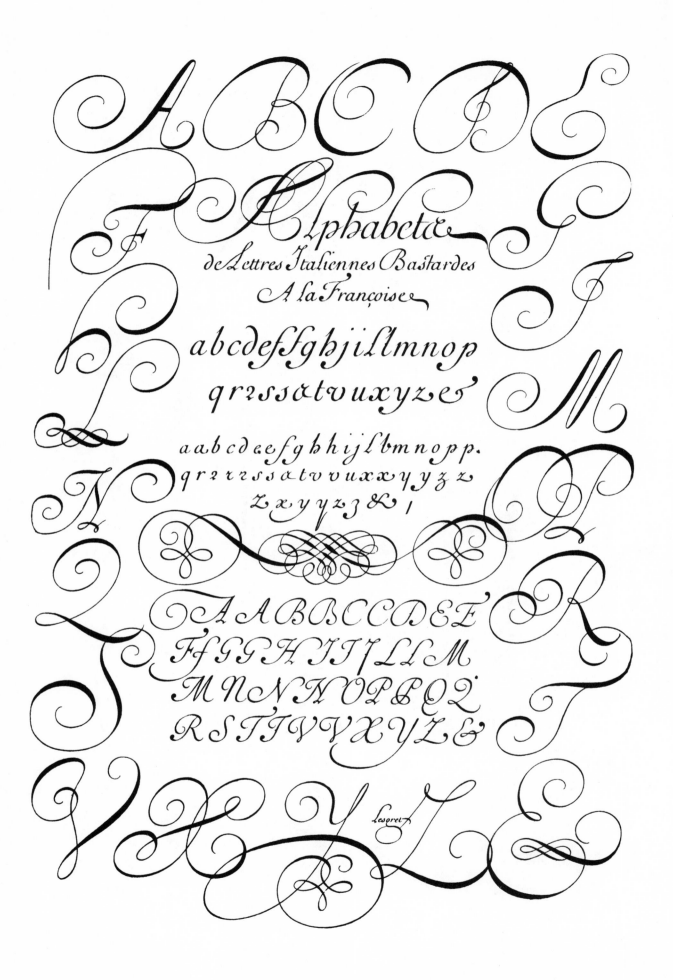

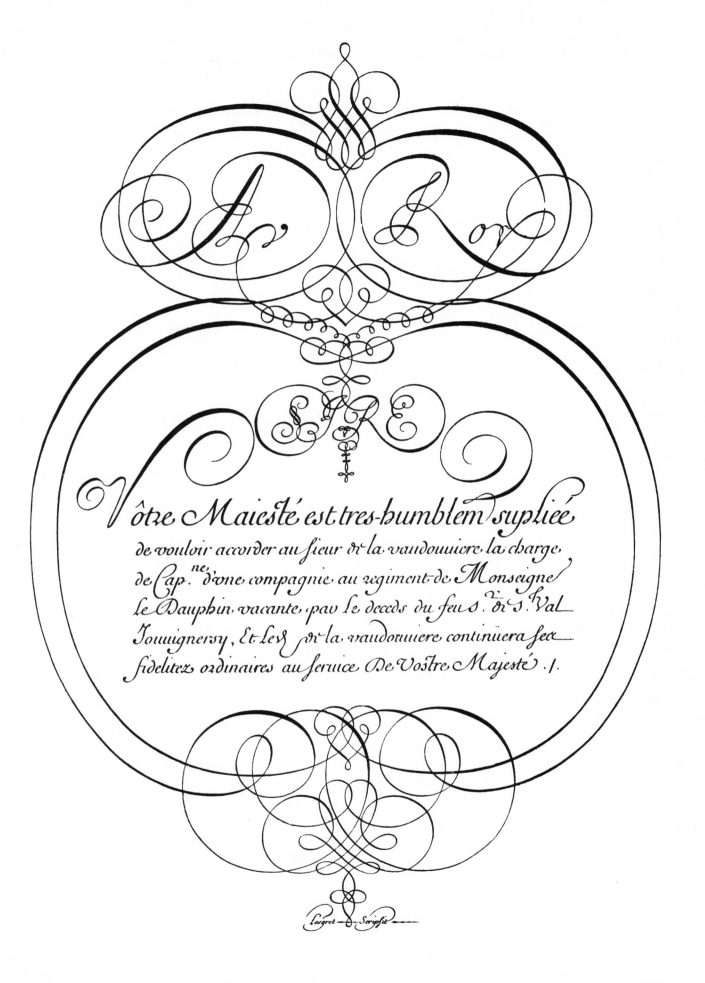

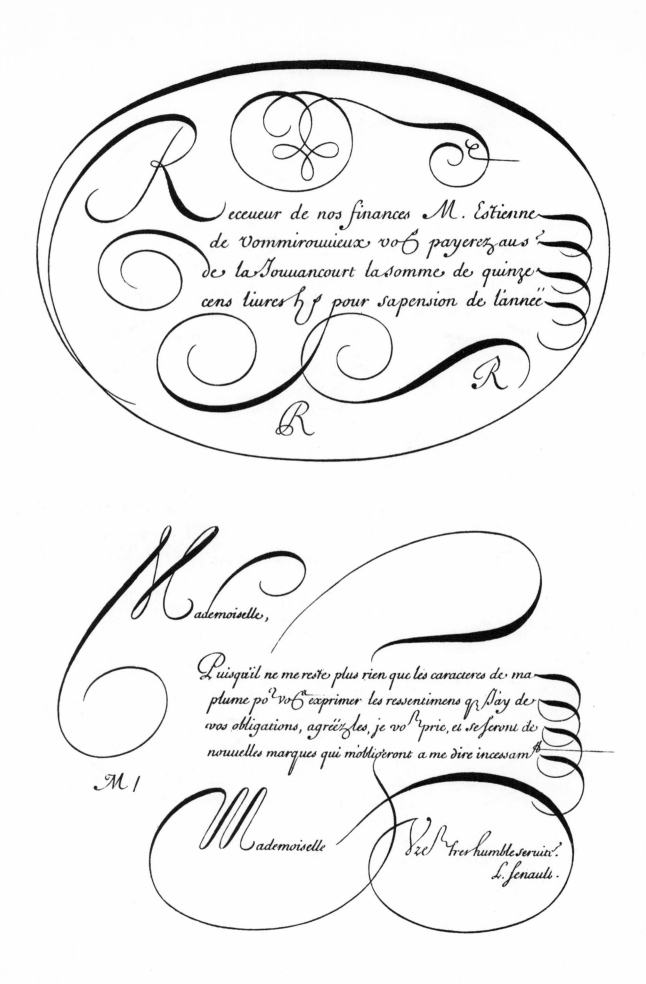

Receueur de nos finances M. Estienne
de Vommirouuieux vo⁶ payerez au⁶
de la Jouuancourt la somme de quinze
cens liures h⁶ pour sapension de l'annéë

Mademoiselle,

Puisqu'il ne me reste plus rien que les caracteres de ma
plume po² vo⁶ exprimer les ressentimens q̃ ſ'ay de
vos obligations, agréé̈z les, je vo⁶ prie, et se ſeront de
nouuelles marques qui m'obligeront a me dire incessam̃

Mademoiselle Vre tres humble ſeruir.
L. Senault.

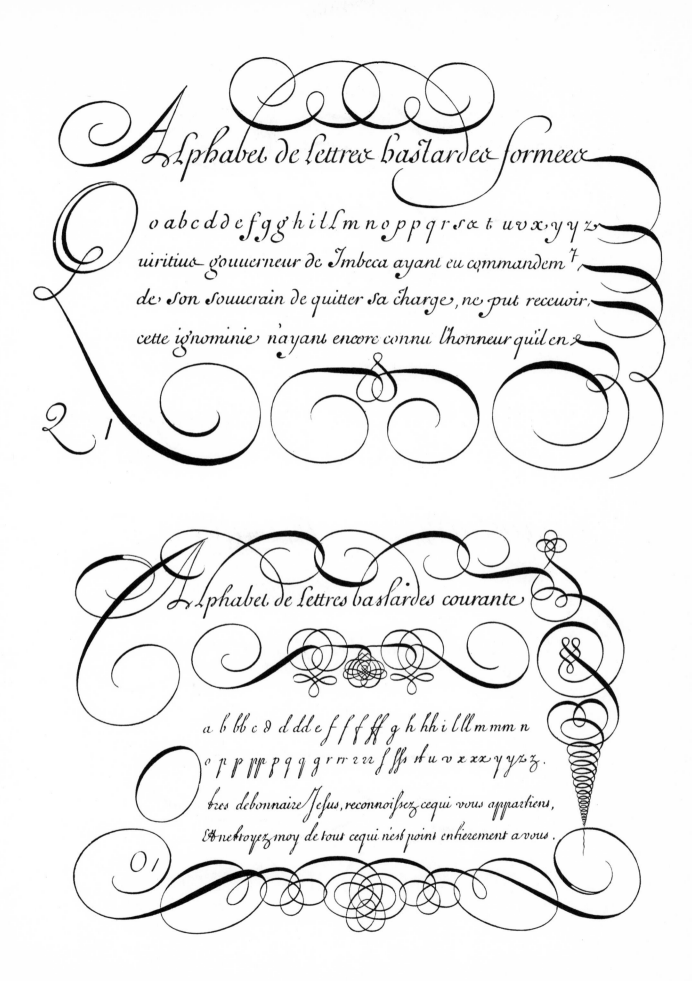

Alphabet de lettres bastardes formees

o a b c d d e f g g h i l l m n o p p q r s t u v x y y z

uiritiue gouuerneur de Imbcca ayant eu commandem[t]
de son souuerain de quitter sa charge, ne put reccuoir,
cette ignominie n'ayant encore connu l'honneur qu'il en x

Alphabet de lettres bastardes courante

a b bb c d d dd e f f f ff g h h hh i l lll m m m n
o p p p p q q q g r rr rr ss fff st u v x xx y y z.
tres debonnaire Jesus, reconnoissez cequi vous appartiens,
Et nettoyez moy de tout cequi n'est point entierement a vous.

Alphabet
d'Expédiée.

abcdefghijklmnopqrstuvxxyz

abcdefghijklmnopqrstuvxxyz

abcdefghijklmnopqrstuvxxyz

Bariolle Sculpsit *Bourgoin Scripsit*

A Paris chez Basset, Mᵈ d'Estampes, rue Sᵗ Jacques au coin de celle des Mathurins, N° 64.

178. BOURGOIN, PARIS CA. 1810 EXPÉDIÉES BATARDE, ANGLAISE COULÉE

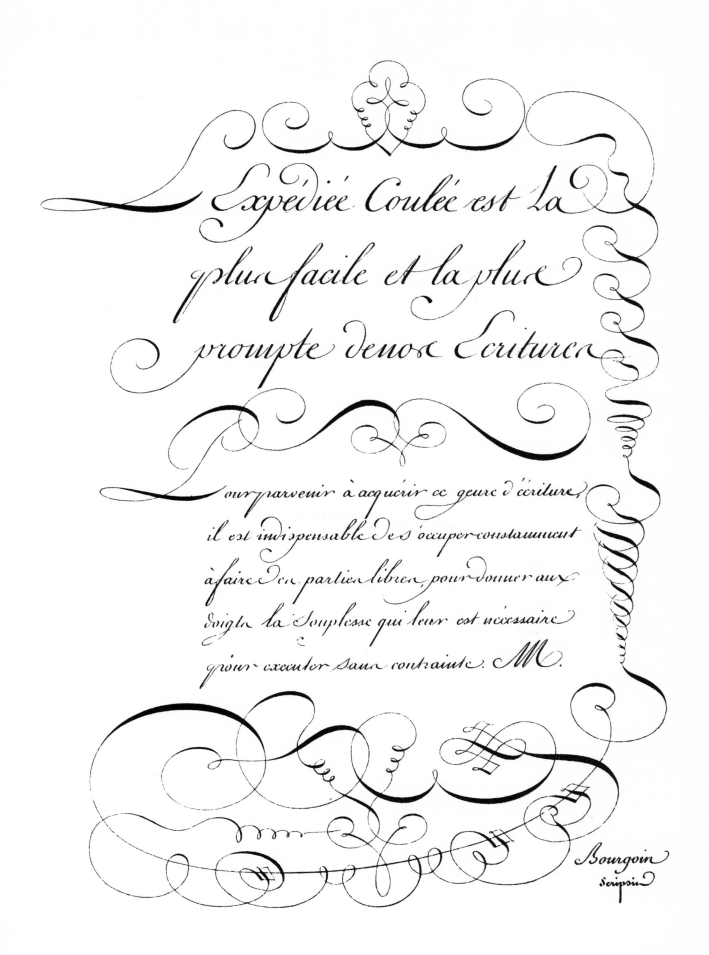

Expédiée Coulée est la plus facile et la plus prompte denos Écritures

Pour parvenir à acquérir ce genre d'écriture, il est indispensable de s'occuper constamment à faire de en partien libres, pour donner aux doigts la Souplesse qui leur est nécessaire pour exécuter sans contrainte. M.

Bourgoin
Scripsit

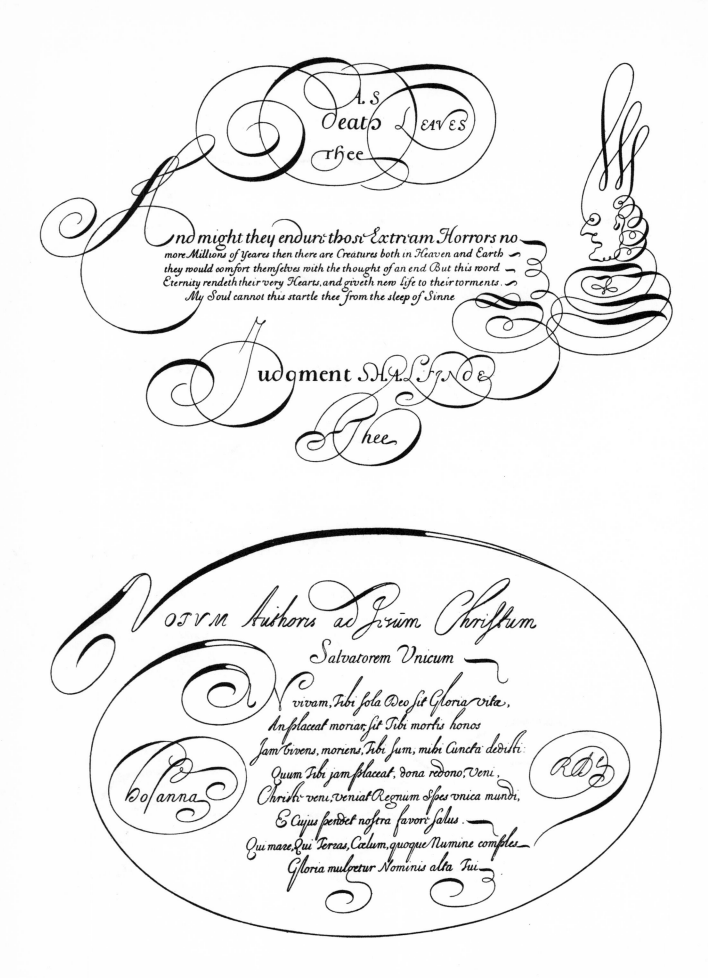

As
Death Leaves
Thee

And might they endure those Extream Horrors no
more Millions of Yeares then there are Creatures both in Heaven and Earth
they would comfort themselves with the thought of an end But this word
Eternity rendeth their very Hearts, and giveth new life to their torments.
My Soul cannot this startle thee from the sleep of Sinne

Judgment Shall finde
Thee

Votum Authoris ad Jesum Christum
Salvatorem Unicum

Ut vivam, Tibi sola Deo sit Gloria vita,
An placeat moriar, sit Tibi mortis honos
Jam vivens, moriens, Tibi sum, mihi Cuncta dedisti,
Quum Tibi jam placeat, dona redono, Veni,
Christe veni, veniat Regnum Spes unica mundi,
E Cujus pendet nostra favori salus.
Qui mare, Qui Terras, Cælum, quoque Numine comples
Gloria mulcetur Nominis alta Tui.

Hosanna

R.D.

Hear me my O Lord Attend unto my
prayer from the ends of y̆ Earth will I cry unto Thee
when my heart is overwhelmed Then lead me to the Rock
That is higher then I

For Thou hast been a Shelter for me, a strong Tower
from the Enemy I will abide in Thy house for ever.
and I will trust under the shadow of Thy wings.

From God is my Help and my Salvation is in Him. He only is my Rock
& my defence I shall not be greatly moved, All my Glory is in God. Thou hast
given me the heritage of those that fear Thy Name.

Wee have need of a faithfull frinde or sharp
Enemies Every One hath great need of a Monitor
Hee shall be no frind to me that is a frind to
my faults. And I am no frind to my selfe if I esteem
him my Enemy that telleth mee of Them.

Ubi Talis Amicus?

Laus Jehovae

Psalmes flow, when Grace tunes Natures harp, w.ch hath
Intrinsick Quintessence In Heauen'd by Faith
Angels blesse God, Because not only He
Crownes them with Glory to Eternitie

His Greatnesse Wisedome, Power, Their Wonders be
His Graciousnesse Springs Loues Actiuitie

But being the Source of Goodnesse to their King
They Hallelujah Hallelujahs Sing

Their Groilk to Ech Aboue are Clear, and Eu'n
Loues the Resplendency of Frindships Region Heau'n

Tour out of thyselfe, O my soul, and henceforth cling unto thy Savour and pray to be made one Spirit with Him by the grace of inward union, and Earth would awaken to love & make He weep bitterly that thou hast loved Him so little whom to love sufficiently thy best and mightiest love are most insufficient. My soul Consider the sweetness of Christ promises, the pleasantness of His comands, and the Infinitness of His Love. And how canst thou but for ever love Him.

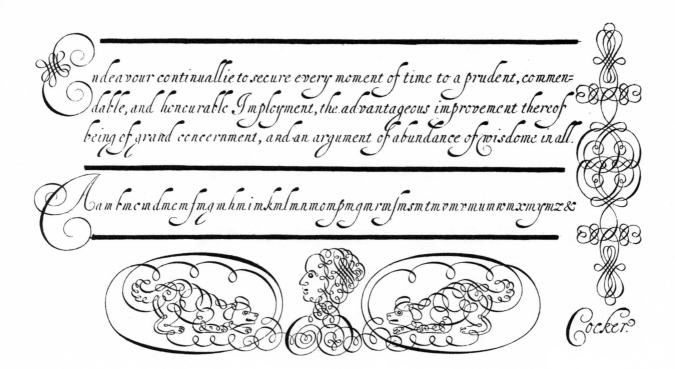

Endeavour continuallie to secure every moment of time to a prudent, commen=
dable, and honourable Imployment, the advantageous improvement thereof
being of grand concernment, and an argument of abundance of wisdome in all.

Aa am bm cm dm em fm gm hm im km lm nm om pm qm rm sm tm vm xm um vm xm ym z &

Cocker.

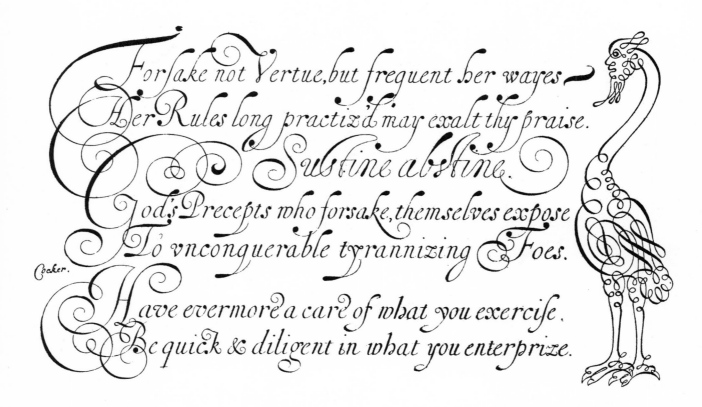

Forsake not Vertue, but frequent her wayes
Her Rules long practiz'd may exalt thy praise.
Sustine abstine.
God's Precepts who forsake, themselves expose
To vnconquerable tyrannizing Foes.
Cocker.
Have evermore a care of what you exercise.
Be quick & diligent in what you enterprize.

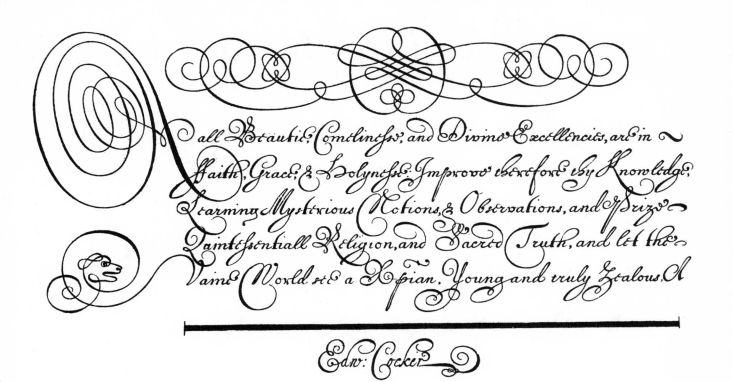

all Beauties, Comeliness, and Divine Excellencies, are in faith, Grace, & Holyness: Improve therefore thy Knowledge, Learning Mysterious Notions, & Observations, and Prize Quintessentiall Religion, and Sacred Truth, and let the Vaine World see a Xpian, Young and truly Zealous. A

Edw: Cocker

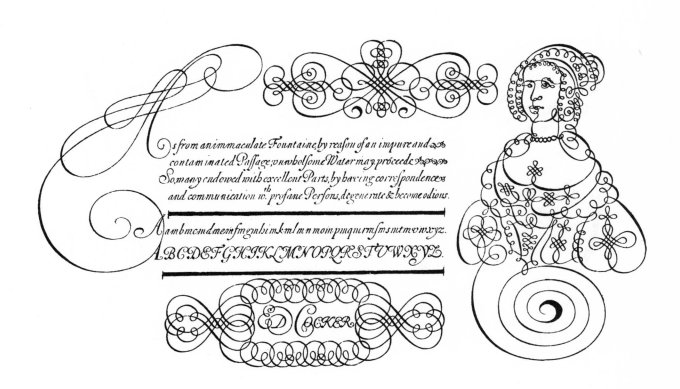

As from an immaculate Fountaine, by reason of an impure and contaminated Passage, unwholsome Water may proceede So, many endowed with excellent Parts, by haveing correspondence and communication wth profane Persons, degenerate & become odious.

Aa am bm cm dm em fm gm hi im km lm m n mom pm qm rm sm sm tm tm vm xyz.
A B C D E F G H I K L M N O P Q R S T U V W X Y Z.

ED Cocker

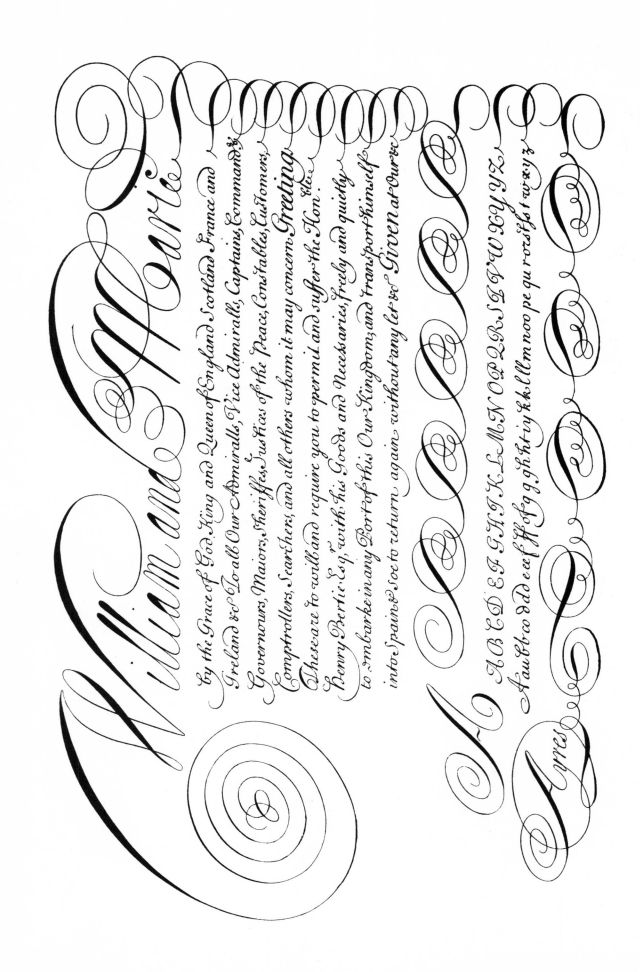

William and Marie

By the Grace of God, King and Queen of England, Scotland, France and Ireland &c. To all Our Admiralls, Vice Admiralls, Captains, Commanders, Governours, Maiors, Sheriffes, Justices of the Peace, Constables, Customers, Comptrollers, Searchers, and all others whom it may concern, Greeting. These are to will and require you to permit and suffer the Hon.ble Henry Bertie Esq.r with his Goods and Necessaries, freely and quietly to imbarke in any Port of this Our Kingdom, and transport himself into Spaine, & soe to return again, without any let, &c. Given at Our &c.

M

ABCDEFGHIKLMNOPQRSTVWXYZ
Aa Bb cc Dd ee ff Ff g g gh h t i y k k ll m noo pe qu r or ss ff s t vv x y z

Ayres

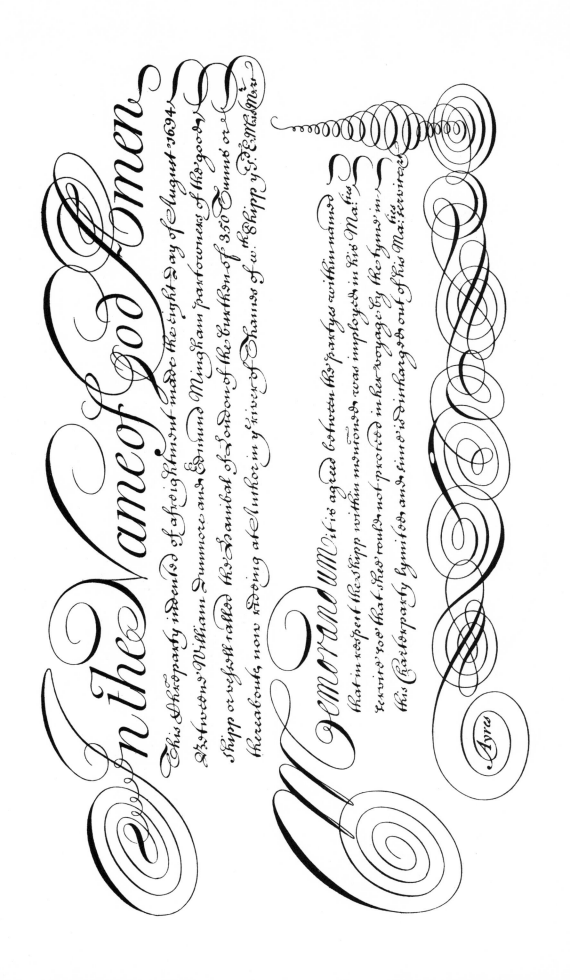

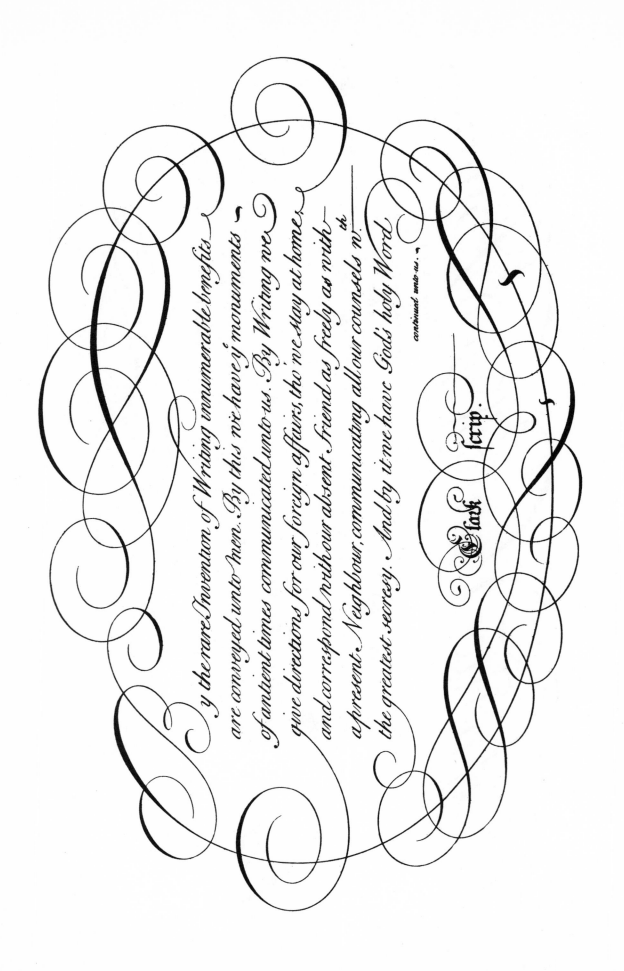

By the rare Invention of Writing innumerable benefits are conveyed unto men. By this we have y^e monuments of antient times communicated unto us. By Writing we give directions for our foreign affairs, tho' we stay at home, and correspond with our absent friend as freely as with a present Neighbour, communicating all our counsels w^th the greatest secresy. And by it we have God's holy Word continued unto us.

John Clark script

Clapham Octor. 6, 1722.

Dear Sir

As I received my Education in Writing and Accounts from you; and that you have left the Business of Teaching: I beg you'l give this Letter and the following Advertisement a place in the Book you are about to Publish; not only to acquaint the World that I Continue the School, with the best Conveniencies for Boarding of Young Gentlemen; but to make a Publick Acknowledgement, for your extraordinary Care in the instruction of

Your most affectionate

Brother and humble Servt.

James Nicholas.

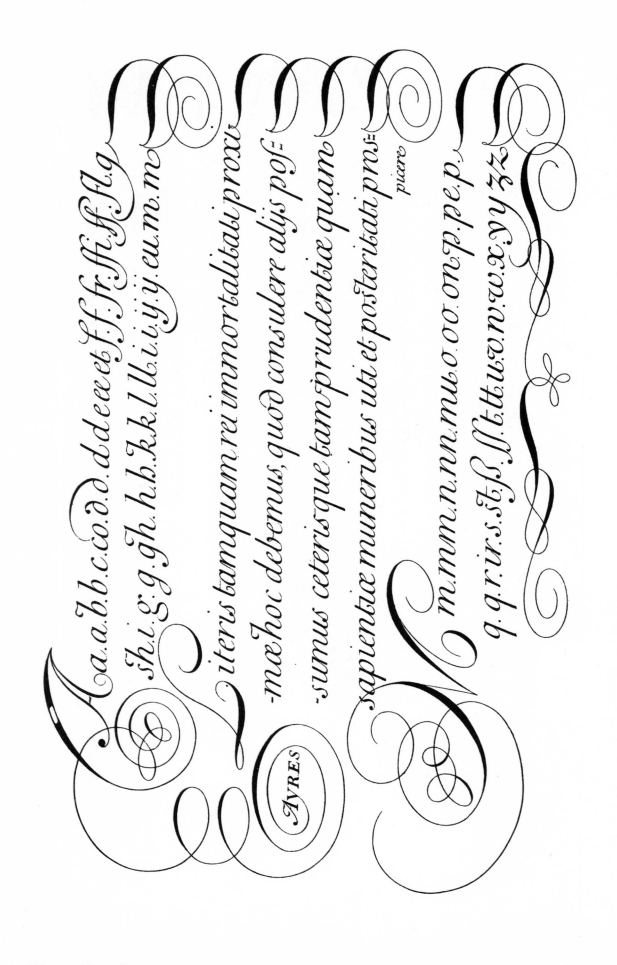

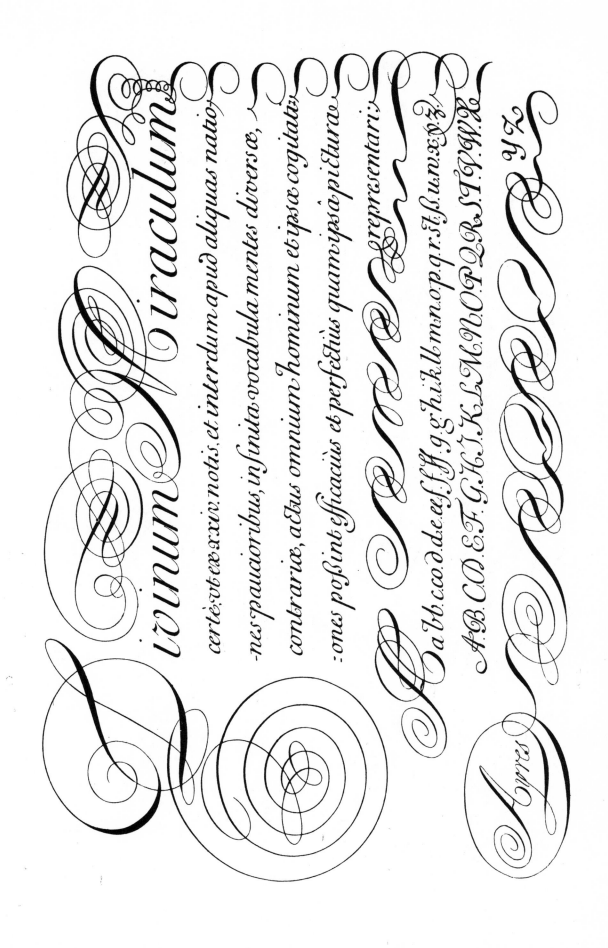

A TUTOR TO PENMANSHIP

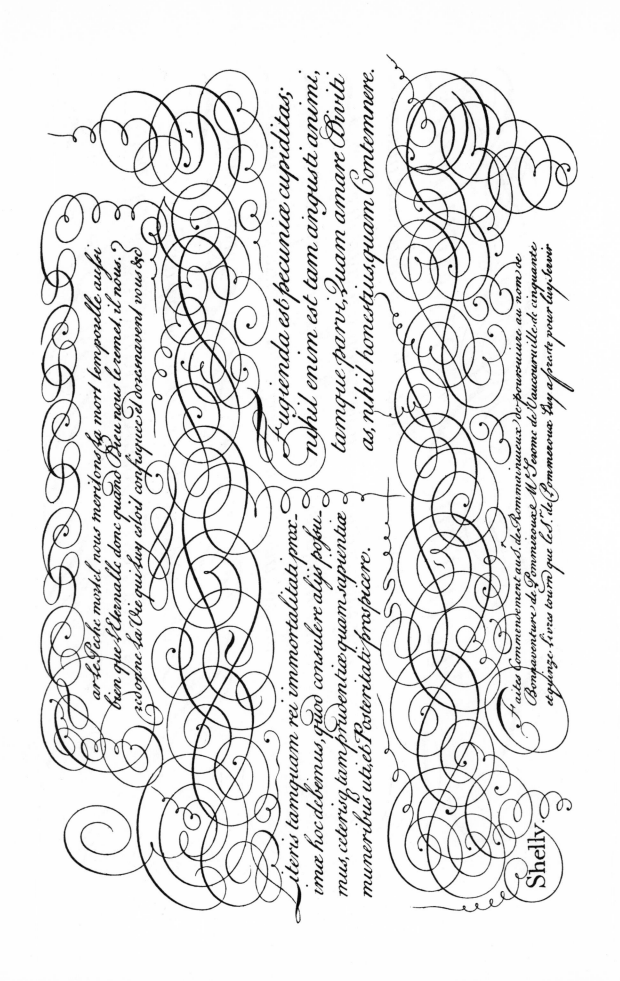

Shelly.

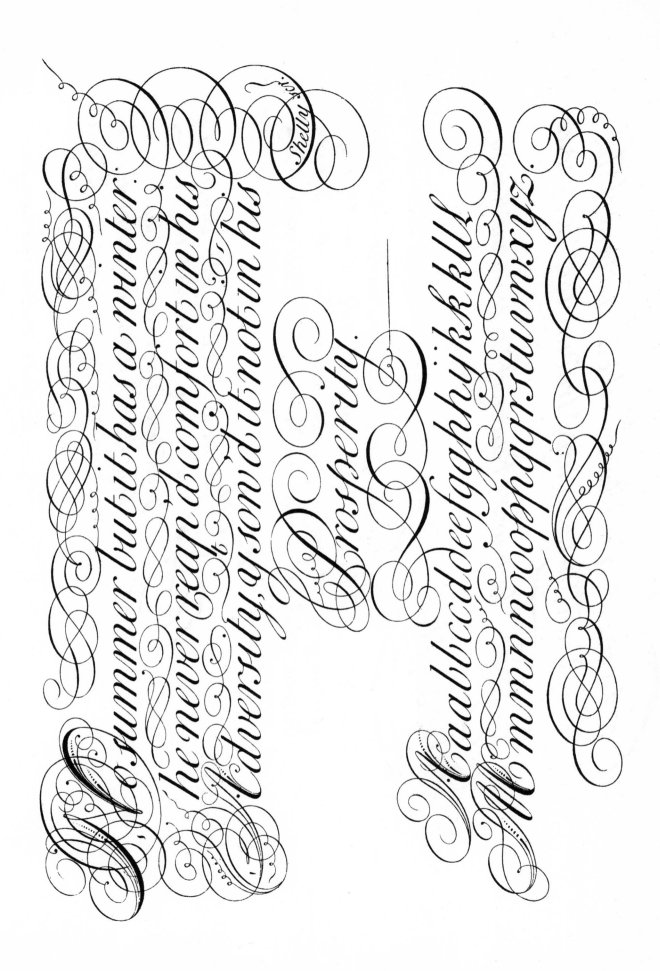

To the Right Hono.ble etc. the Directors of the English Company Trading to ye East Indies

The humble Peticōn of Fortunatus Hardy

Sheweth

That your Peticōner having been Educated A Scholar And having of late apply'd himself to learn Writings Arithmetisk & Accompts Humbly conceives himself qualified to serve yer Honrs as a Writer in any of yor Factories in the East Indies.

Your Peticōner therefore humbly prays that he may be admitted to the said Imployment wherein He will demean himself wth all diligence & faithfulnesse and give such Security as yor Honrs shall require.

And yo Peticōner shall Everpray &c.

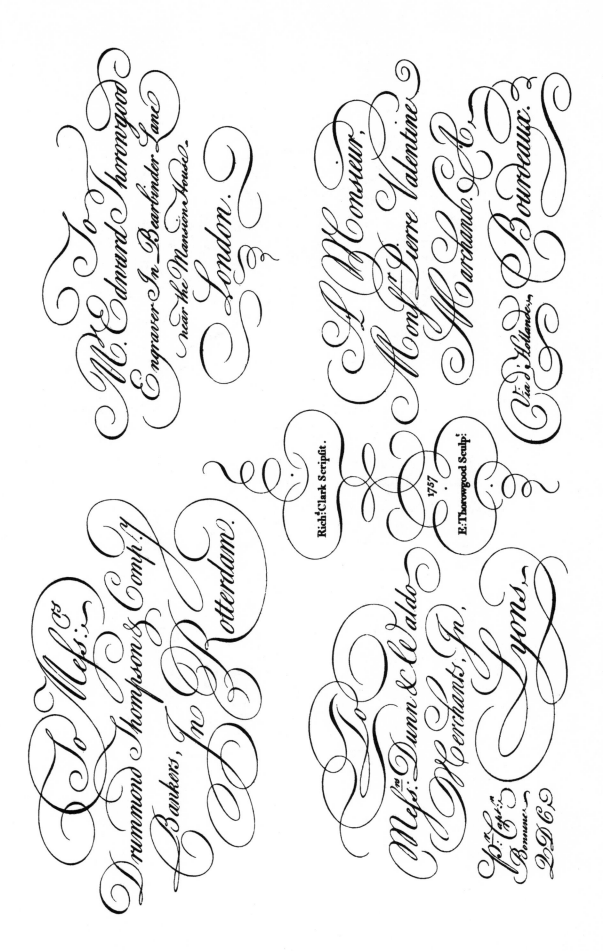

To
Mr Edward Norwgood
Engraver In Bearbinder Lane
near the Mansion House.
London.

A Monsieur.
Monsr Pierre Valentine
Marchand.
Via d. Hollander.
Bourdeaux.

Rich:dClark Scripfit.

1757

E:Thorowgood Sculpt:

To Mefs:rs
Drummond Thompson's Compy.
Bankers, In
Rotterdam.

To
Mefs:rs Dunn & Waldo
Merchants, In.
Lyons.

Bonnner.

Musick

Musick the Fiercest Grief can charm;
And Fates severest Rage disarm:
Musick, can soften Pain to Ease,
And make despair & madness please,
Our Joys below it doth improve,
And antedate the Bliss above.

What ravishes the Soul what charms the Ear
Is Musick, tho a various Dress it wear
Beauty is Musick too, tho in Disguise
Too fine to touch the Ear it strikes the Eyes
Tis Music heav'nly such as in a Sphere
We only can admire, but cannot Hear.

Clark, scripsit.

JKitchin

Sculpt 1757.

Men of Letters

The favouring and protecting men of letters, has been, in all ages and countries, one distinguishing mark of a great prince, it encourages good writers to labour with more emulation in the improvement of their several talents, and contributes to the instruction and embellishment of human society in particular. mm

R. Clark. Scripsit. At the Academy in Little Tower Street.

E. Thorowgood. Sculpsit 1748

197. RICHARD CLARK, PORTSMOUTH 1758

PRACTICAL PENMANSHIP

Invoice of 1 Bale containing 6 Long Bays ship'd on
board the Bonadventure Cornelius Nutty Command.ʳ
bound for Lisbon Consign'd to Mess.ʳˢ Aubury & Frome
on their proper Acco.ᵗ & Risque. Mark'd & Numb.ᵈ Viz.

	Nᵒ	Ells.
	1 Red	100.
	2 Sky	101.
⚓ (mark)	3 Poping	103.
	4 Mazarine	104.
	5 ½ Light ½ da Copper	104.
	6 ½ Scarlet ½ White	102.

For 6 Long Bays q/ 614 Ells at 17 ⅌ Ell	43 . 9 . 10 .	
Dying 5 Peices at	1 . 4 . — .	
Whitening ½	— . 7 . — .	
Dying ½ Scarlet	2 . 10 . — .	
Drawing at 8	— . 4 . — .	
Drying	— . 4 . — .	
The Sworn Measurer	— . 2 . — .	
Measuring Folding & Tacking	— . 9 . — .	
Filleting	— . 1 . 8 .	
Imbailing	— . 9 . — .	
Cocquet & Searchers	— . 4 . — .	
Boathire Wharfage Porterage & Carman	— . 3 . 6 .	
		5 . 18 . 2 .
	£	49 . 8 . 2 .

London 19 Febry 1728/9

Errors Excepted Bland

Bland Script.

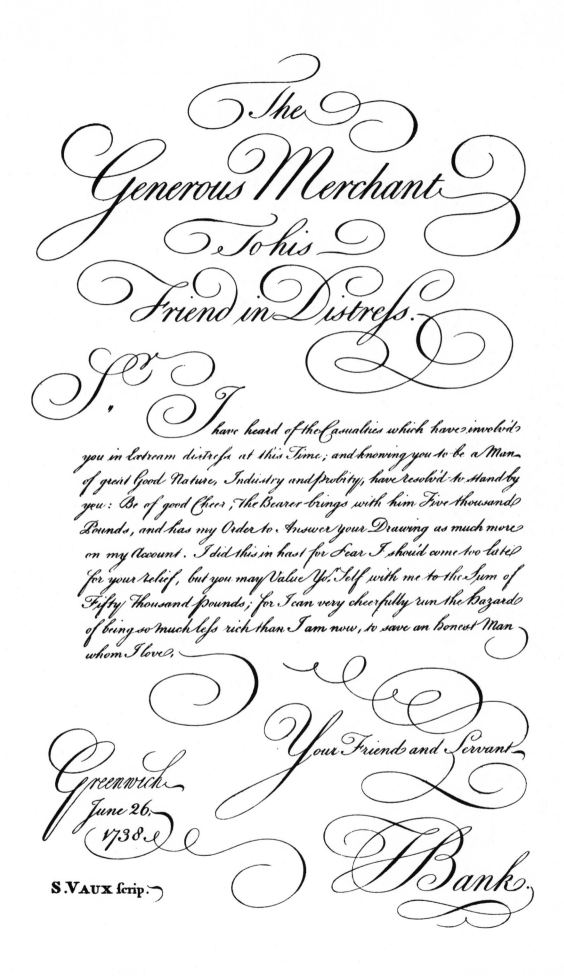

The
Generous Merchant
To his
Friend in Distress.

Sr. I have heard of the Casualties which have involv'd you in Extream distress at this Time; and knowing you to be a Man of great Good Nature, Industry and probity, have resolv'd to stand by you: Be of good Cheer, the Bearer brings with him Five thousand Pounds, and has my Order to Answer your Drawing as much more on my Account. I did this in hast for fear I shou'd come two late for your relief, but you may Value Yor. Self with me to the Sum of Fifty thousand pounds; for I can very cheerfully run the hazard of being so much less rich than I am now, to save an honest Man whom I love,

Your Friend and Servant

Greenwich
June 26,
1738

S. VAUX scrip.

Bank.

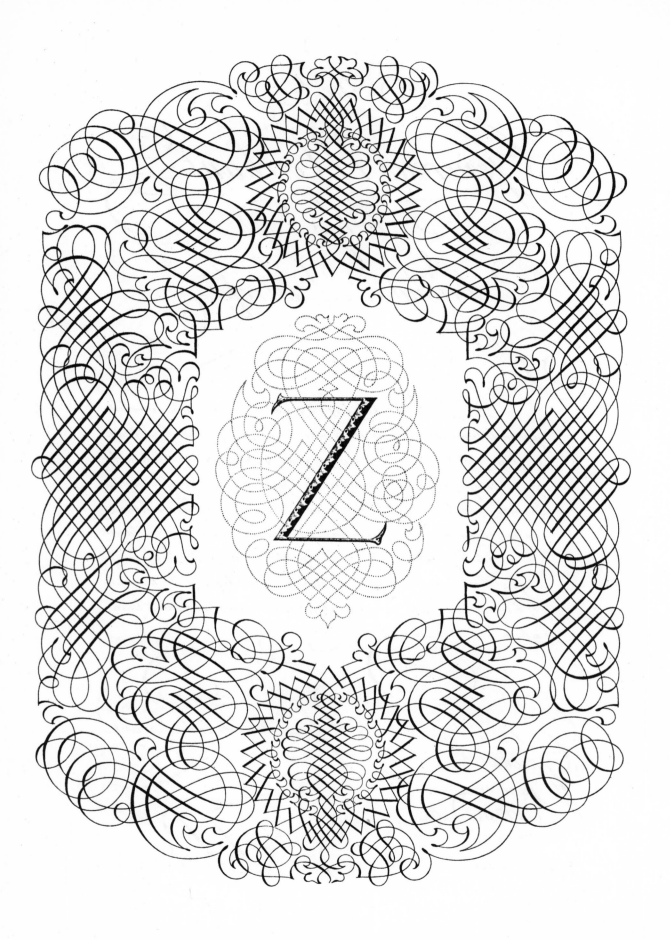

DISSERTATIO DE CALLIGRAPHIA